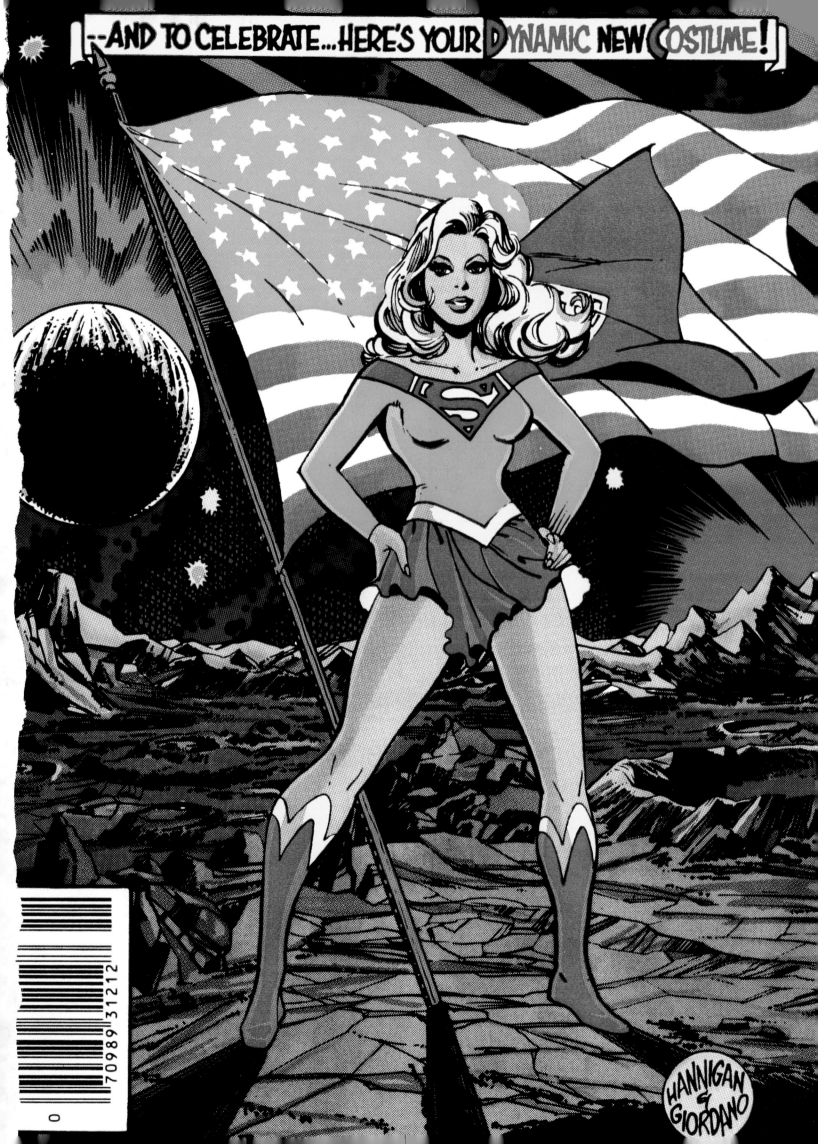

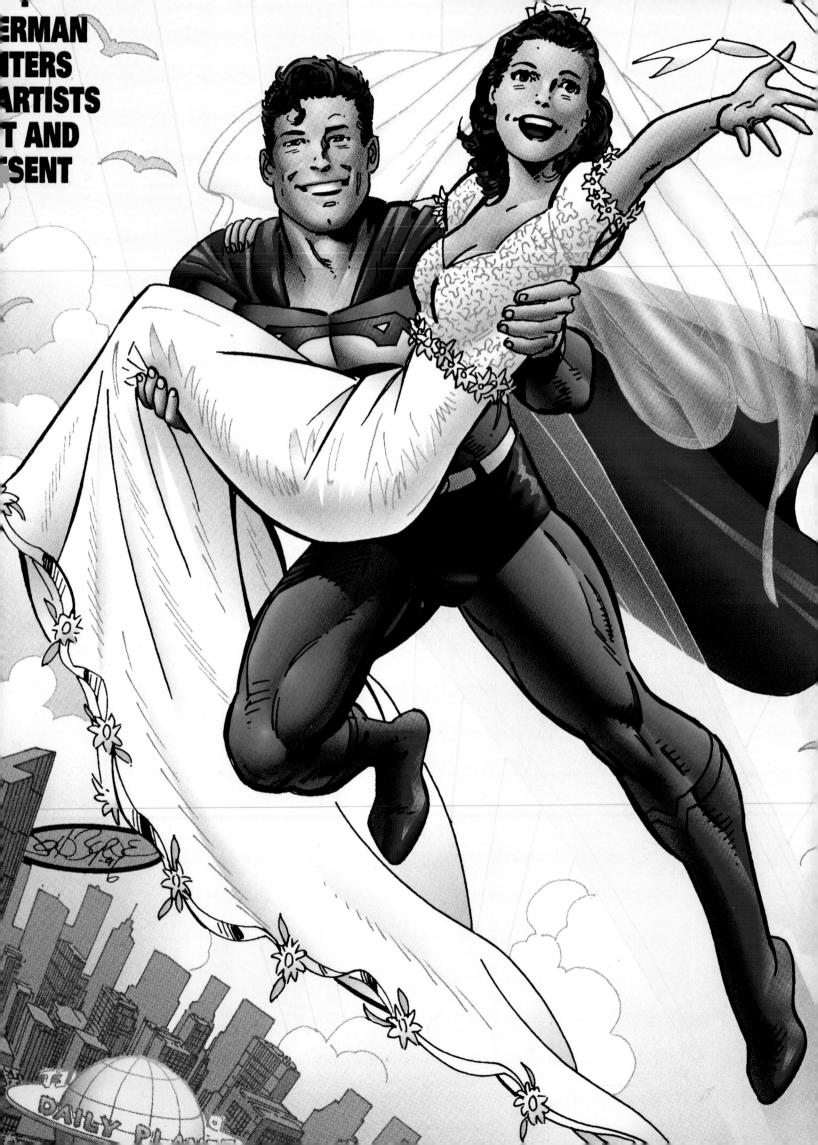

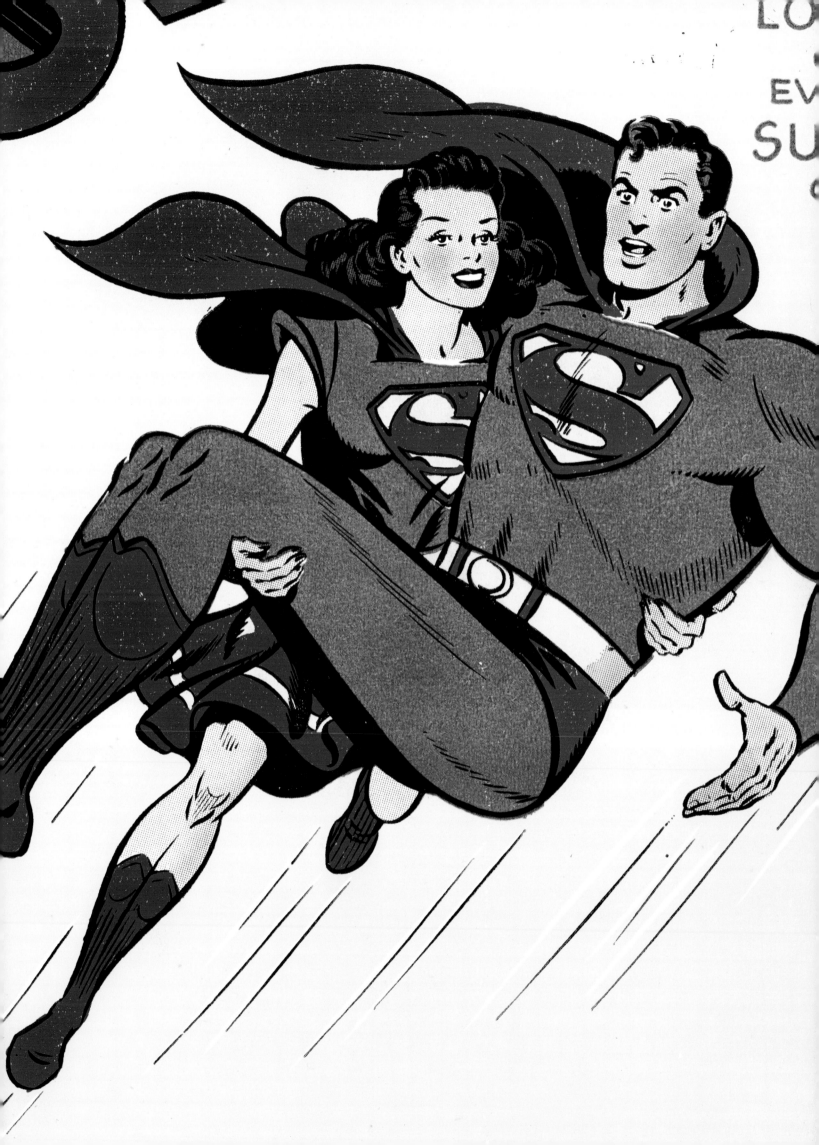

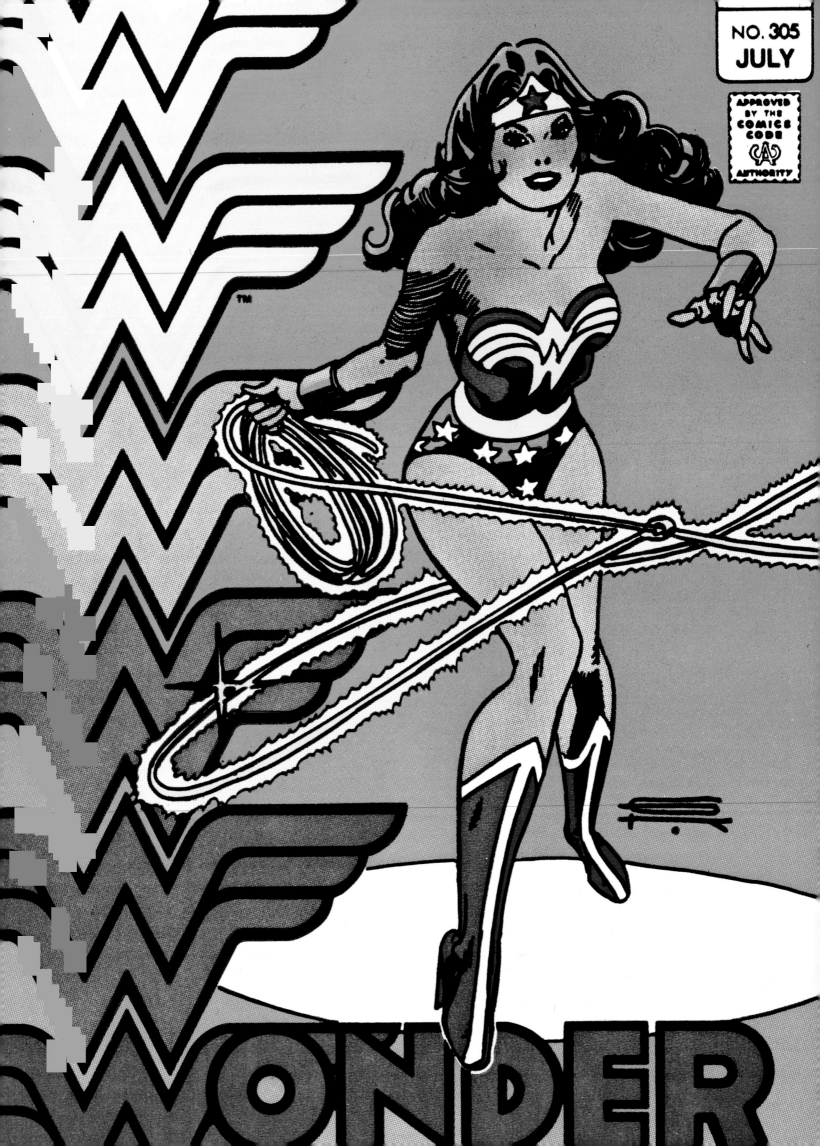

DC COMICS COVERGIRLS

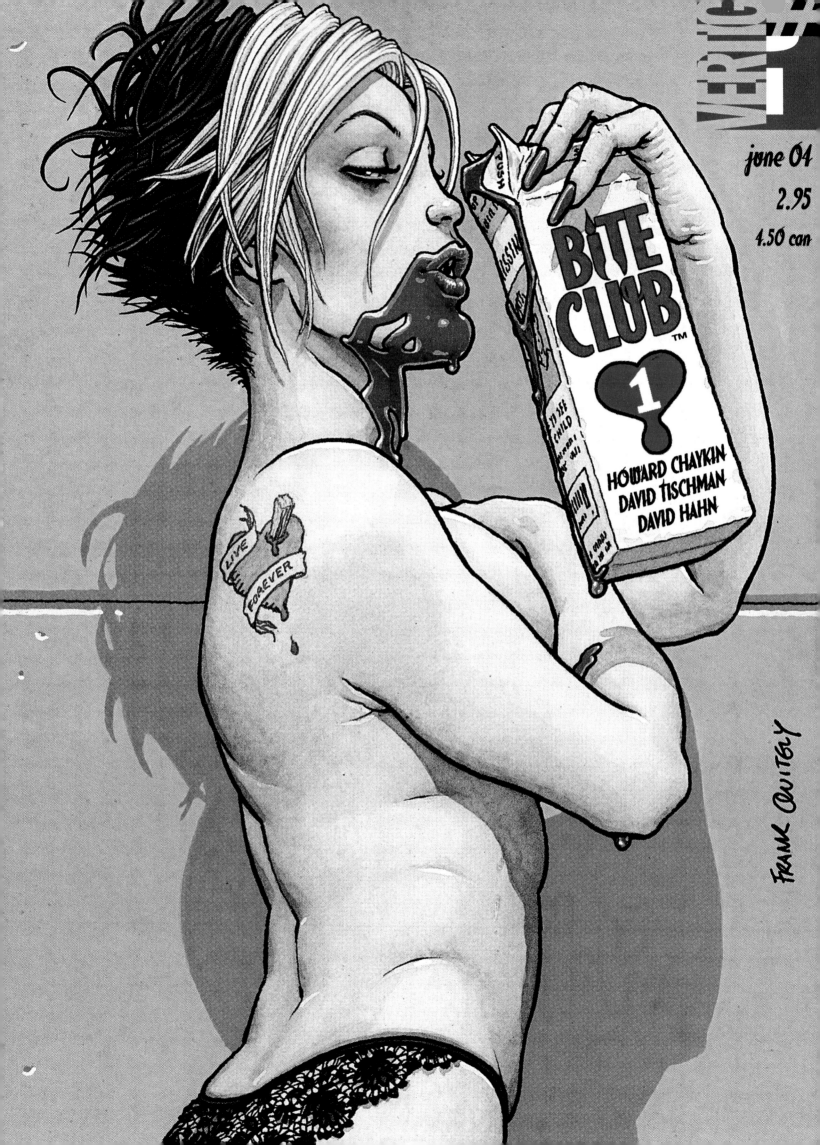

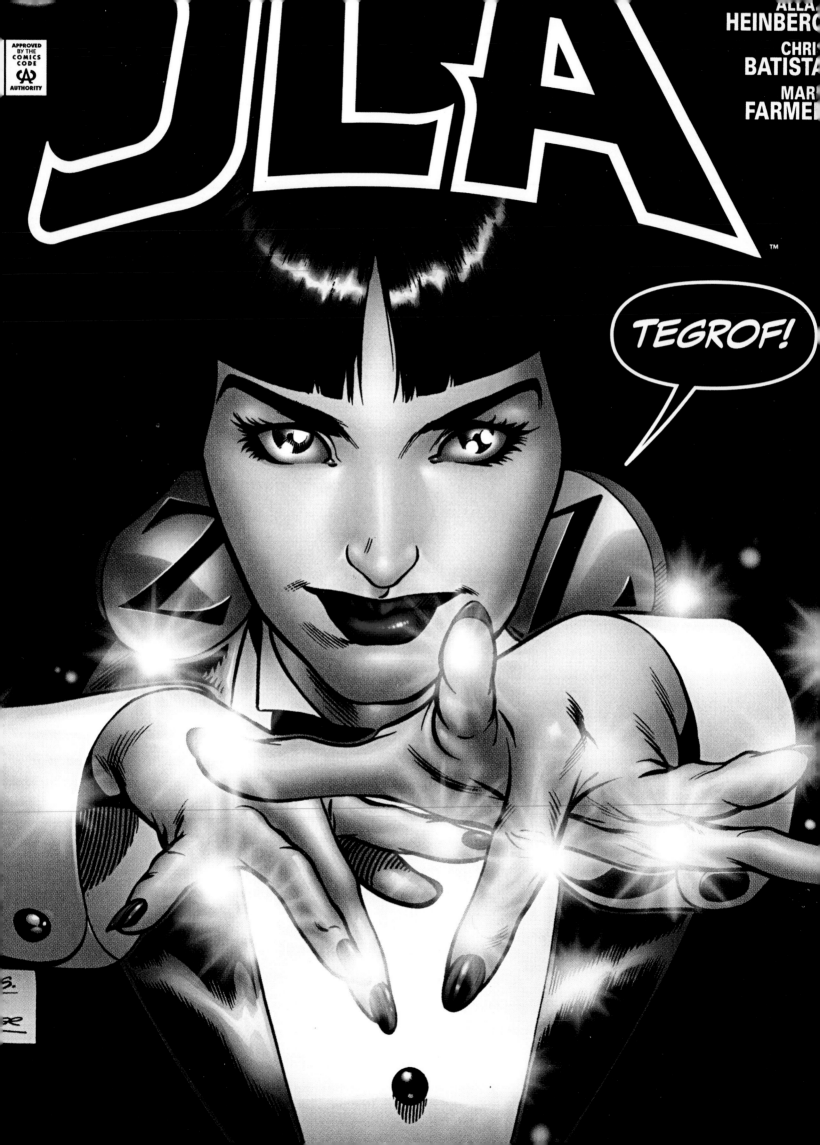

DC COMICS COVERGIRLS

Louise Simonson
Foreword by Adam Hughes

CHARTWELL
BOOKS

Quarto is the authority on a wide range of topics.
Quarto educates, entertains and enriches the lives of
our readers—enthusiasts and lovers of hands-on living.
www.quartoknows.com

This edition published in 2016 in arrangement with Universe Publishing,
a division of Rizzoli International Publications, Inc. by

CHARTWELL BOOKS
an imprint of Book Sales
a division of Quarto Publishing Group USA Inc.
142 West 36th Street, 4th Floor
New York, New York 10018
USA

10 9 8 7 6 5 4 3 2 1

ISBN 13: 978-0-7858-3436-6
ISBN 13: 978-0-7858-3495-3

Printed in China

Graphic Design: Mike Essl and Roy Rub
DC Comics Editor: John Morgan
Universe Editor: Jessica Fuller

Foreword

Study the history of the world, immerse yourself in philosophy, psychology, and punditry, explore all the myriad ways of mankind, and you'll discover that there is only one Truth. One Undeniable Truth for which there is no argument against, no subtle aspect of subjectivity to allow for the existence of any possible polar way of thought. And the Truth is: SEX SELLS.

I apologize if you were expecting something a hair more profound.

SEX SELLS. All caps, perhaps underscored and italicized for extra effect, with a subtle hint of boldface. _SEX SELLS_.

It doesn't matter if we're talking about television, movies, candy bars, or the Bible; a pretty girl will always help sell whatever it is you're selling. Even if you were trying to market homeliness and severe appearance deficits as a commodity, an attractive spokesmodel would probably nudge your difficult enterprise into the black.

Yes, it's awful that appearance matters. Life's rough; get a helmet. You can fight it, you can resist, but it doesn't make it any less true (and even less likely to go away). If you wrap something in an attractive package, people will be more likely to choose it over something substantially less easy on the eyes.

That brings us to the book you're holding. The subject? A highly specialized field of an already specialized industry: the art of comic book covers. But this tome takes you one step further into the Theater of the Bizarre, the even-more-highly-specialized field of the art of comic book covers with women as their subject.

This magnificent volume chronicles the labors of many wonderful artists and craftspersons over the last several decades, all struggling to make sure that DC Comics' stories are wrapped in more attractive packaging than the other comics on the market.

My theory about comic book covers is that they are the last line in advertising, and the first line in storytelling. It's the point where the baton is passed from the folks selling the comic to the folks telling the story. A good comic book cover simply does one thing: it makes you pick it up off the stands/racks/subway floor and say "Ooh! I wonder what THIS is all about!" Anything a comic book cover artist can do to get you to pick up the issue they are, uh, "covering" (wow, we don't have a good verb for what we do, I just realized), he or she should do.

And you should do what you do best. If you are, for example, Bernie Wrightson, Master of the Macabre, then you draw extremely active dead people bothering the high holy crap out of the living. If you're ME, you struggle with every aspect of art in all its endless complexities, and by some strange spandex osmosis, editors and art directors decide that what YOU do well is draw women. Abraham Lincoln once said: "Whatever you are, be a good one." I'm reasonably sure he wasn't talking about drawing the big hole in Power Girl's shirt, but when I'm forking over a five-dollar bill, I like to think Ol' Honest Abe is saying it to me.

What's that you say? "Surely, such a specialized career as comic book covergirl artist can't possibly exist!!!" Not only does such a field exist, but a few of us have managed to dodge unemployment and fry-cook opportunities in its pursuit. I know this for a fact; I'm one of the few who've been lucky enough to have this fabulous occupation. "Can you make a living at it?" I am always asked. Come by the mansion some day, I'll have the guards buzz you in at the gate and we can discuss it over cocktails and Cuban cigars on the veranda. Make sure you let the guards know you're here, though; otherwise I'll be forced to release the hounds.

Adam Hughes

OUT OF THE PULPS...

Covergirls began as enticing female figures on magazine covers. Some, like those on the fashion and home-making magazines in the late 19th century, were aimed at women readers. But other, often less wholesome images were designed to entice males.

By the beginning of World War I, "dime novels," short adventure stories aimed mainly at kids, had evolved into pulp magazines—larger, more complex anthologies published for adults. Pulps increased in popularity until they reached their heyday in the Great Depression.

On newsstands everywhere during the 1930s, covergirls, mostly scantily clad and in peril, sold pulp adventure titles in every genre: western, horror, fantasy, science fiction, detective, and even romance. Some pulps even featured comic strip characters, like Sally the Sleuth, the first comic strip adventure heroine. Appearing in *Spicy Detective* in 1934, Sally may have kicked ass in her comic strip, but on the cover, she was a damsel in distress.

Readers didn't need to know what Sally was actually like, editorial thinking went, as long as their visceral reaction made them pick up the magazine. Some other broad would be along to sell the next issue, anyway.

Comic books initially were pulp adventure anthologies in a graphic format, with covers that reflected their pulp roots. Harry Donenfeld, a canny printer-turned-publisher, published pulp magazines for over a decade before he began publishing comics, eventually becoming the owner of Detective Comics.

Especially in the upstart super-hero comics, pulp-like anthologies began to focus on the exploits of a single character. Soon, those lead characters acquired comics devoted totally to their adventures. With this shift, the role of the comic book covergirl became more complex.

above

Girls' Love Stories #3 — December 1949–January 1950
Art by Emerson Hall and Theda Hall
National Romance Group, DC Comics' early romance comic imprint, sometimes experimented with using photographs on their anthology romance covers, referencing the "true confession" magazines that were their inspiration.

opposite page

Wonder Woman (2nd series) #72 — March 1993
Art by Brian Bolland
Looking every bit the warrior princess, Wonder Woman poses before a Greek still life made up of the discarded implements of war. It's hard to imagine a more iconic image.

Everybody knows who a covergirl is—an alluring young woman posing on the front of a book or magazine. "C'mon, pick me up," she says. "If you like me, you'll like what you'll see inside!"

. . . AND INTO THE COMICS

A comic book covergirl's image must entice, of course. But it must also hint at her character, her past, her gestalt. It must make you want to not only pick up her comic book, but know her story.

In the beginning, every comic book covergirl was somebody's brainchild—a concept given the illusion of flesh and blood by a team of talented writers, artists, and editors. Since comics deal heavily in visual symbolism, their heroines are most often idealized physical types, reflecting the cultural preferences of their times. (What's the point of creating fantasy characters if they aren't iconic and beautiful?)

These perfect bodies are costumed to evoke intuitive responses. Because comic book stories are frequently morality tales—epics of good and evil peopled with recognizable archetypes—characters are designed to reflect universal archetypes, so that readers of this short, symbolic, and graphic form are able to "get" who the characters are at a glance.

Good guys look "good." Villains look "evil." Names and designs indicate what side the characters are on, so the readers will know immediately who to root for. Wonder Woman's red, white, and blue costume with its stylized golden eagle calls to mind the flag and American values. Yep, she's a heroine! On the other hand, while Catwoman's costume—with its cat-eared hood and green cape—may mimic the heroic Batman's cape and cowl, the whip she carries tells us right away that she's not on the side of the angels.

So these comic book covergirls are more than enticing visual symbols. They are also mythic characters—icons of Good and Evil, of Light and Darkness, and of the vast gray area in between. Their social and moral conflicts are acted out visually, because in comics actions generally speak more emphatically than words.

And, in many ways, our covergirls' actions reflect the social awareness and ethical dilemmas of their age.

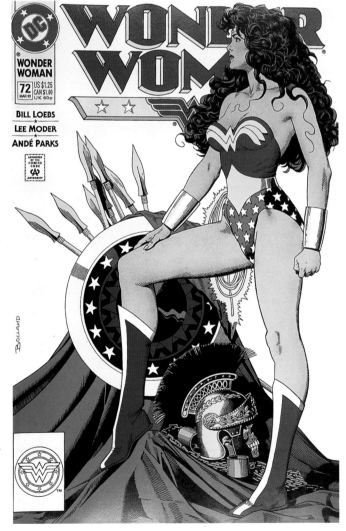

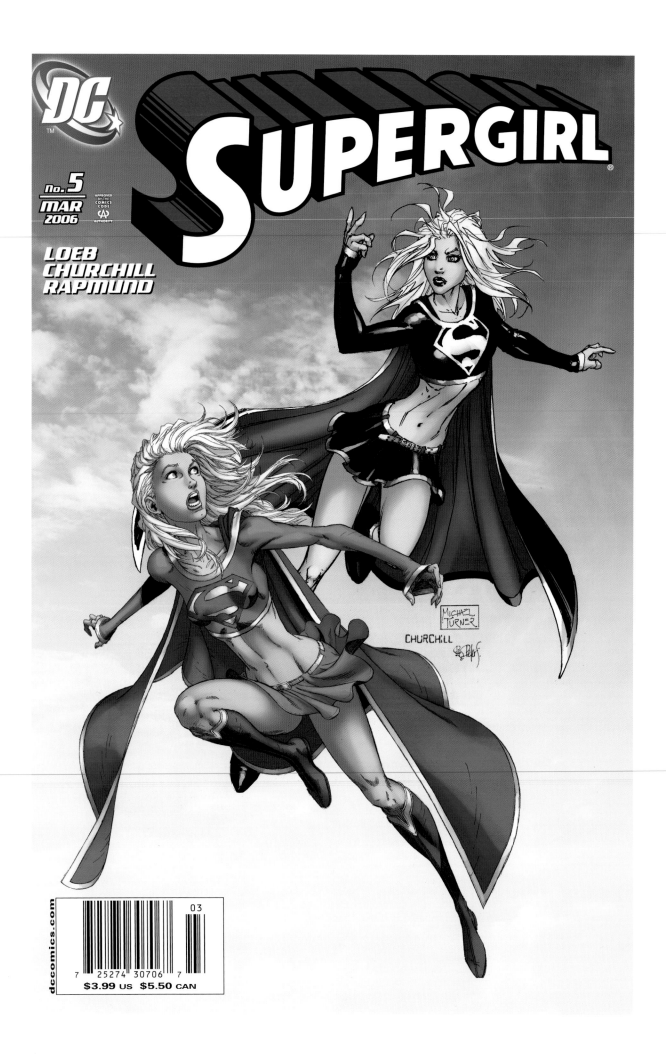

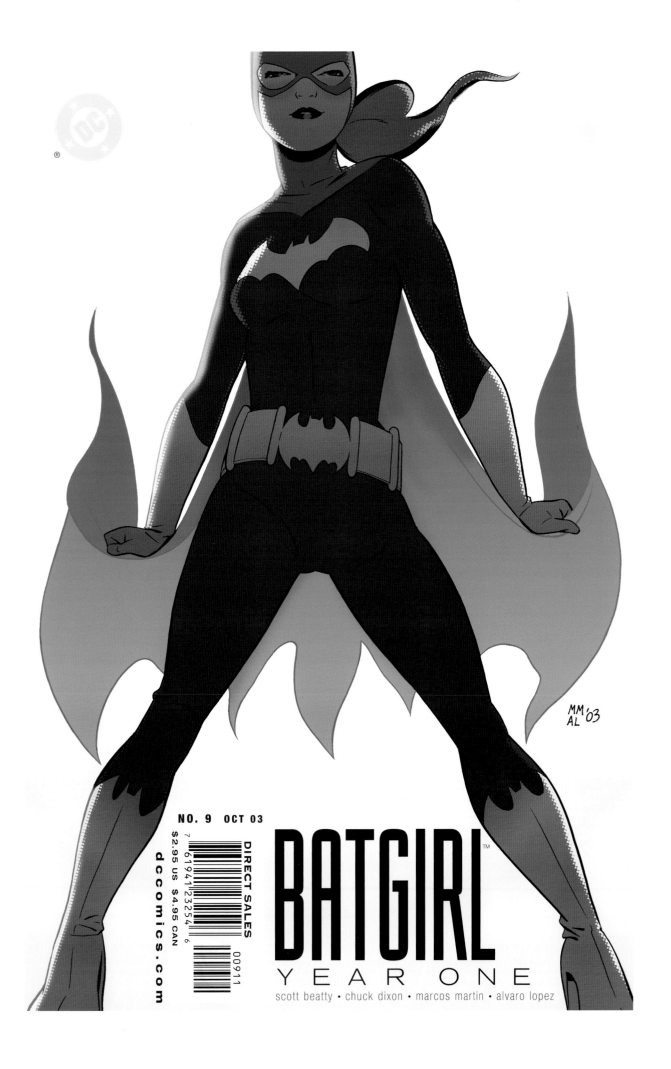

NO. 9 OCT 03

DIRECT SALES

$2.95 US $4.95 CAN

dccomics.com

BATGIRL™

YEAR ONE

scott beatty • chuck dixon • marcos martin • alvaro lopez

page 18

Supergirl (4th series) #5 — March 2006
Supergirl pencilled and inked by Ian Churchill
Dark Supergirl pencilled and inked by Michael Turner
In the sixty-odd years of DC Comics continuity there have been
several Supergirls. Here, two of them—Kara Zor-El,
Superman's cousin, and her evil alter ego—face off in a classic
"Character Against Herself" conflict, one of comics' tried-and-true
themes. Ian Churchill and Michael Turner have teamed up to
produce this "jam" cover—each artist pencilling and inking one figure.

page 19

Batgirl Year One #9 — October 2003
Pencilled by Marcos Martín, inked by Alvaro Lopez
Though Barbara Gordon, shot by the Joker and paralyzed, is no
longer Batgirl, she remains a hugely popular heroine. This miniseries
tells the story of her first year as a crime fighter.

right

Catwoman (1st series) #55 — March 1998
Art by Jim Balent
Artist Jim Balent features Catwoman—whip poised to strike—
in just one of the many versions of her costume!

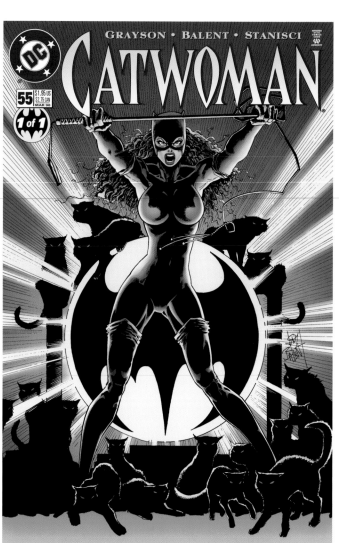

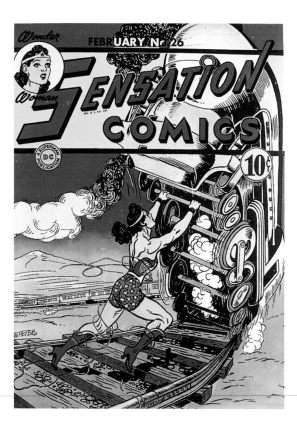

above

Sensation Comics #26 — February 1944
Art by Harry G. Peter
This Wonder Woman cover by Harry G. Peter proves Superman isn't
the only hero more powerful than a locomotive.

right

Wonder Woman (2nd series) #150 — November 1999
Art by Adam Hughes
This gorgeous cover by Adam Hughes showcases Wonder Woman
and shows just how iconic a costume can be.

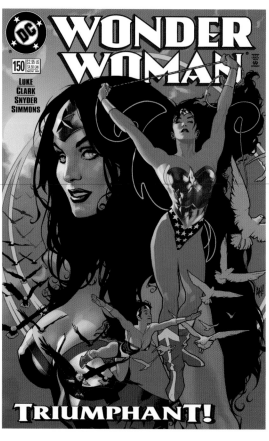

AND MAN CREATED SUPER HEROINE

Every female character featured on these covers had male creators. But then, from the beginning, super-hero comics have been a male-dominated field.

Most super heroes are male. And surveys suggest that 75–95 percent of readers are male, too. But that doesn't mean that the super-hero universe belongs to the male of the species alone.

Way back in 1938, when writer Jerry Siegel and artist Joe Shuster introduced Superman, the world's first super hero, they also introduced Lois Lane, intrepid reporter. Lois was there from the beginning, appearing alongside Superman in *Action Comics* #1 as Clark Kent's professional rival and Superman's love interest.

A year later, Bob Kane and Jerry Robinson presented Batman in the anthology title *Detective Comics* #27. In 1940, when Batman was given his own title, Bob Kane and Jerry Robinson introduced the beautiful jewel thief The Cat—soon to be known as Catwoman, Batman's first and foremost female nemesis.

And then there was Wonder Woman, created by William Moulton Marston in 1941. A powerful Amazon who could equal any hero in character and power, it is no surprise that she has become DC Comics' greatest super heroine.

THROUGH THE AGES

The Golden Age of Comics began with the creation of Superman and other Depression era/pre-World War II super heroes and heroines. Wonder Woman, Lois Lane, and Catwoman were introduced as strong, independent women with challenging lives and minds of their own. Outside of comics, Rosie the Riveter was a dominant female motif. Women contributed in areas outside the home, keeping America going when so many of its men were away at war, and the strong female characters in comics reflected that reality. Throughout World War II, super-hero comics increased in popularity, outstripping even the well-liked funny animal, western, teen humor, and jungle genres.

But comic books are not a stable, static environment. As they changed to reflect the changing times, so our covergirls evolved to reflect the shifting paradoxes of their eras. The men who created them and then told their stories were part of a social context. They were faking it like the rest of us, feeling their way into a rapidly changing future, with all the confusion that entails.

By the late 1940s, most women relinquished their jobs to the returning soldiers and went back to the home. Early 1950s America was a golden land of peace, prosperity—and paranoia. Communist conspiracies, Cold War suspicion, and witch-hunts by the House Un-American Activities Committee dominated the headlines. Children were taught to "duck and cover" to avoid being obliterated by falling atom bombs.

Some comic book companies, the famous EC Comics foremost among them, began to reflect this mood with lurid tales of science fiction and gory stories of suburban horror.

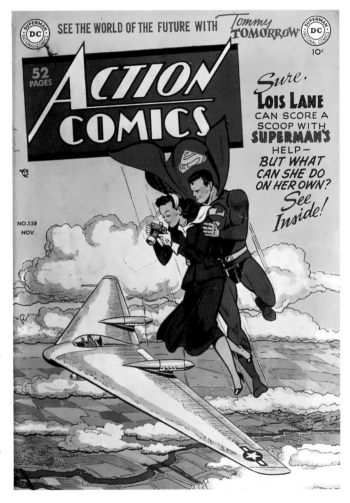

above
Action Comics #138 — November 1949
Art by Al Plastino
Here Superman, drawn by Al Plastino, helps Lois get the scoop, even though his alter ego, Clark Kent, is her professional rival.

above

Comics Code Label

The Comics Code seal appeared on covers during the mid-50s and afterwards, assuring parents that the comics it adorned were child-friendly and promoted positive values.

opposite

Superman's Girl Friend Lois Lane #86 — October 1968
Pencilled by Neal Adams, inked by Al Pastino
In her dreams, at least, Lois would do anything to marry Superman—even make a deal with the devil.

page 24

New Fun Comics #3 — April 1935
Art by Clem Gretter
This wonderful 1935 comic, published by National Allied Publications (which would later become DC Comics), is historic for several reasons. While still in the large-size 10″ x 15″ format originally used for newspaper comics reprints, it was the first series to feature "all new, all original" stories and to have some material printed in color. It shamelessly reveals its pulp science fiction origins while graphically announcing its special comic book content. And it is the first DC Comics cover to feature a woman. Interestingly, the hero Don Drake, who has leaped to defend the beautiful Betty from the tentacled monster, seems to be more imperiled than the heroine.

page 25

Secret Hearts #28 — July 1950
Art by Tony Abruzzo
A classic romance cover—a broken hearted girl looking on while another woman steals her man! During the mid-50s, many romance comics were drawn by artists who later became renowned in their field. Among them are Jack Kirby, Neal Adams, Gene Colan, Vince Colletta, John Romita, Alex Toth and Wally Wood. But the list also includes the fantasy painter Frank Frazetta and E. R. Kinstler, portraitist to six presidents. Pop-artist Roy Lichtenstein cadged his "artificial" comic book images from the pages of romance comics.

In 1954, psychiatrist Dr. Fredric Wertham published *Seduction of the Innocent,* a polemic inveighing against violence and what he perceived as sexual and homosexual subtext in comics. Wertham appeared before the Senate Subcommittee on Juvenile Delinquency and argued that comic books were a major cause of criminal behavior in the young. He suggested Batman and Robin were homosexual lovers and Wonder Woman was a lesbian, among other unsubstantiated allegations.

Faced with parental furor and plummeting sales, some comic book companies folded while others banded together to form the self-policing Comics Code Authority. Under its tenets, blood, excessive violence, and sexually suggestive images were banned; realistic depictions of criminal activities were forbidden; and respectful treatment of established authority figures was compelled. Good must always triumph, the Code stated, while evildoers must be punished.

In 1955, EC Comics folded as a company. That same year, publisher Bill Gaines converted his satirical humor comic *MAD* into the wonderful and astonishingly successful teen-humor anthology *MAD Magazine.* Super-hero comics survived in a sanitized form. And, for a while, comic books became mainly a kids' medium.

The Golden Age of Comics was over and the Silver Age of Comics had begun.

With the realistic depiction of robberies and murders forbidden, comics increasingly shifted their story focus to other kinds of conflict.

Romance was an acceptable motif. Lois Lane began to obsess not about getting the story, but about proving that Clark Kent was Superman and luring him into marriage. Batwoman, created by Bob Kane in 1956, swooned for Batman even as she battled the criminal underworld. And even Wonder Woman mooned over the handsome Steve Trevor.

Science fiction provided another Code-approved plot device. Stories focusing on the schemes of mad scientists, marauding space aliens, and super-spies abounded. Supergirl, Superman's cousin from a Kryptonian city floating in space, appeared in 1959. And in 1960, Wonder Woman teamed up with Superman, Batman, the Flash, Aquaman, Green Lantern, and the Martian Manhunter to form the Justice League of America. From their high-tech headquarters, DC Comics' greatest heroes battled a series of sci-fi and costumed menaces including the alien Queen Bee and Superwoman, a member of the Crime Syndicate.

The 1960s through the early 1970s was a time of burgeoning sexual freedom, women's liberation, inexorable and compelling movement toward social justice and equality, and the confusion of a disputed war. Artist Roy Lichtenstein's "artificial" comic book images hung on the walls of museums, while comics themselves were considered not-quite-respectable and the campy 1966 *Batman* TV show played super heroes for laughs. But however they were played, the comic book super-hero genre in the 1960s got its second wind and DC Comics' rival Marvel Comics launched its own super-hero line.

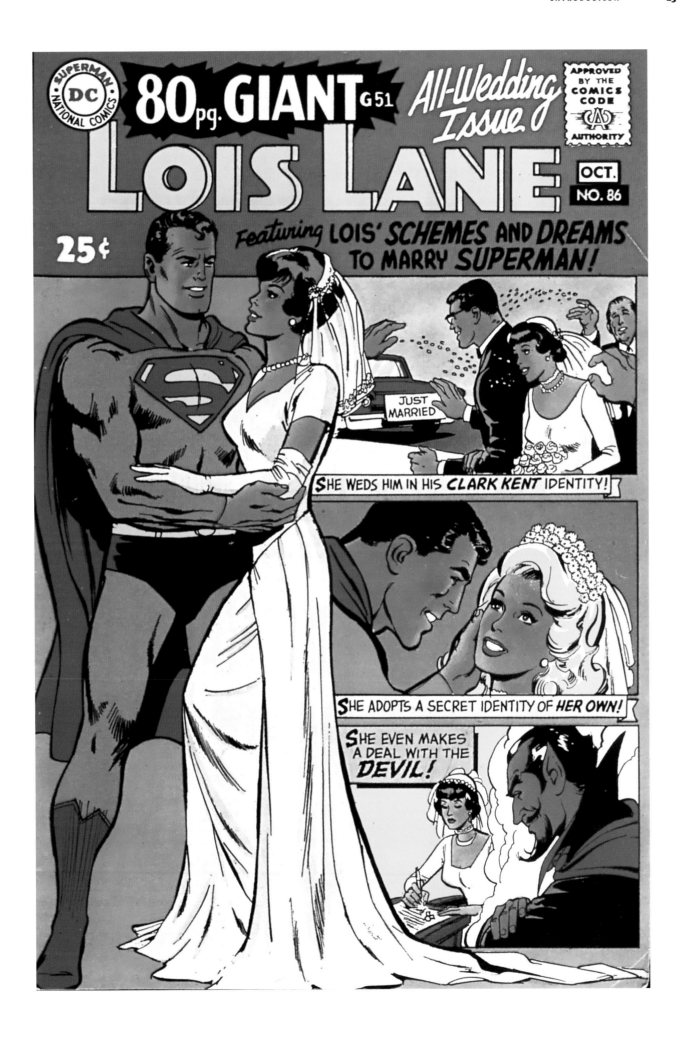

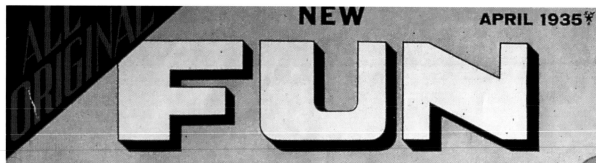

NEW
FUN

THE BIG COMIC MAGAZINE

10 CENTS

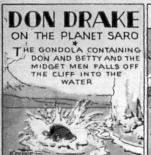

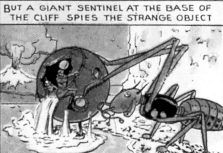

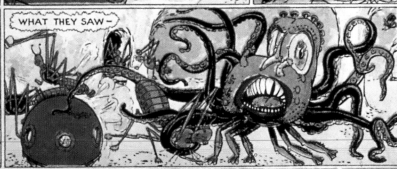

NOW IN COLORS · ADVENTURE-FLYING-MYSTERY
COMIC STRIPS · STORIES-MOVIES-SCIENCE · PRIZES

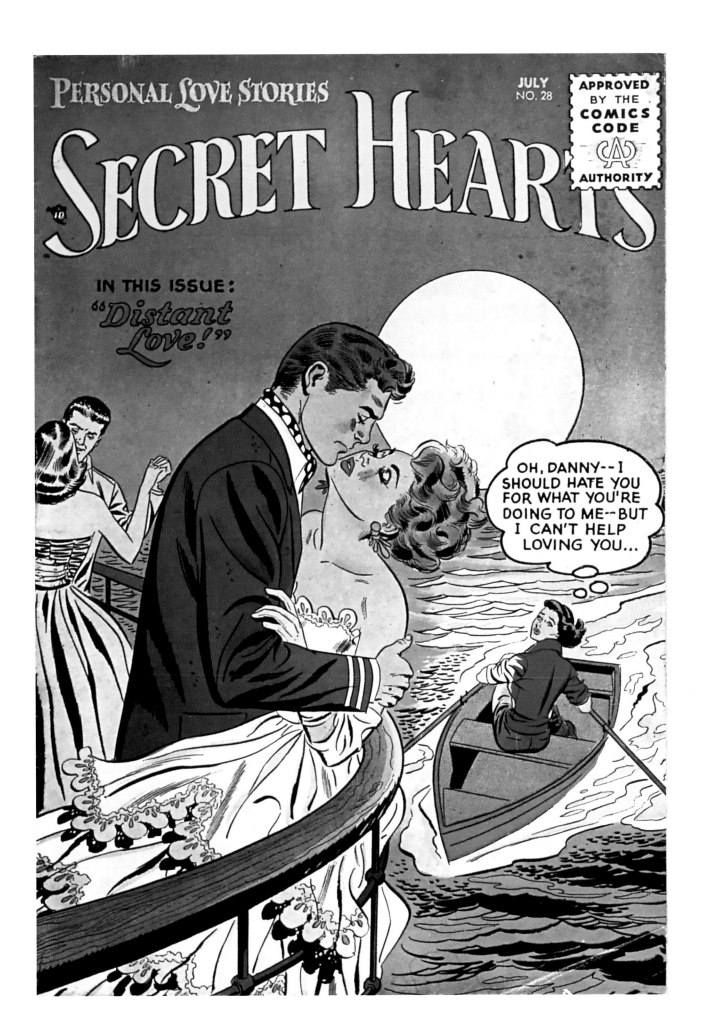

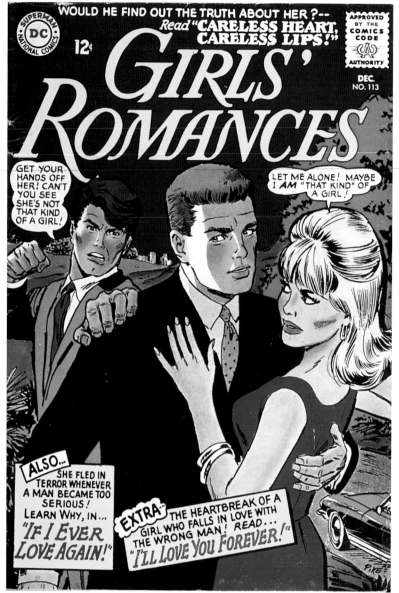

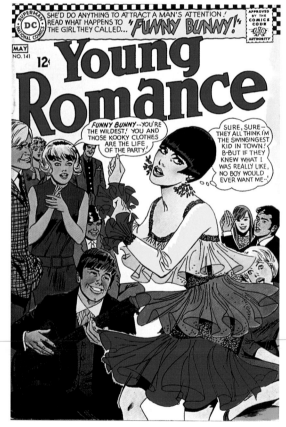

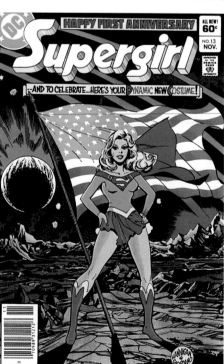

left

***Girls' Romances* #113** — December 1965
Art by Jim Pike
Though nearly all romance comics were written and drawn by males, they reached a predominantly female audience with universal themes of fidelity, identity, jealousy, and finding true love. The ultimate goal in most stories was marriage, and they often ended with a kiss and the promise of happiness ever after.

below

***Young Romance* #141** — May 1963
Art by Tony Abruzzo
Young Romance, created in 1947 by Joe Simon and Jack Kirby, was inspired by women's "confessions" magazines and spawned an entire comics genre. The *Young Romance* title was eventually sold to Prize Comics, who sold the title to DC Comics. In 1963, *Young Romance* joined DC Comics' other romance titles aimed at teenage girls with issue #125. *Young Romance* #141 continues the tradition with first person stories involving the complications of love and reflecting the evolving fashions and universal concerns of young romance.

left

***Supergirl* (1st series) #13** — November 1983
Pencilled by Ed Hannigan, inked by Dick Giordano
Except for the later addition of a headband, this was Supergirl's final costume before she was killed in *Crisis on Infinite Earths*.

In 1968, Wonder Woman's writers and artists tried to create more realistic stories that would showcase a liberated woman who, like Batman, was powerful by her own choice. They generated a plotline in which Wonder Woman abandoned her Amazon powers. No longer a costumed super heroine, she resigned from the Justice League, dressed like television's *Avengers* icon Emma Peel, ran a boutique, learned martial arts, and battled a range of villains from supernatural entities to super-spies.

These stories, created with the best of intentions, offended feminist Gloria Steinem, who put the heroine back in her classic costume on the cover of the first *Ms. Magazine* in July 1972.

Steinem lobbied for Wonder Woman's return as a super heroine and, in 1973, the Amazon's powers were restored and Wonder Woman resumed crime fighting in her iconic costume.

In 1971 the Comics Code was rewritten. This led to a revival of fantasy and horror comics, which lured emerging young talent, excited by the widening possibilities for storytelling. Thanks to an editorial climate that appreciated their efforts, DC Comics once again became an exciting place to work. And by the mid-1970s, the Modern Age of Comics had begun.

By the mid-1980s, DC Comics' *The New Teen Titans* by Marv Wolfman and George Pérez, with its strong female team members, competed for sales with Marvel Comics' best-selling *X-Men*.

DC Comics had maintained its complex and often contradictory continuity through the use of many parallel Earths. This science-fiction concept of alternate dimensions explained, for example, how the feisty Lois Lane of the 1940s, the marriage-obsessed Lois of the "Superman's Girl Friend" years, and the more modern Lois were "true stories" of different individual Loises residing on separate but analogous worlds.

By the 1980s, this system had become both confusing and unwieldy and, in 1985, DC Comics' miniseries *Crisis on Infinite Earths* destroyed the multiverse, reducing it to a single Earth. Some characters like Supergirl died. Wonder Woman was devolved. And whole storylines were wiped from continuity as if they had never existed.

And a single DC Universe was born.

The stories of the characters who lived were retold from this new beginning. In this simplified continuity, Lois Lane had always been a feisty female reporter. Wonder Woman was born anew. And, eventually, several Supergirls appeared as well.

This movement toward rebirth and renewal, as well as DC Comics management's decision to allow writers and artists to participate in the profits made by the comics and the characters they created, led to a comic book renaissance, sometimes called a second Golden Age, which continued into the 1990s.

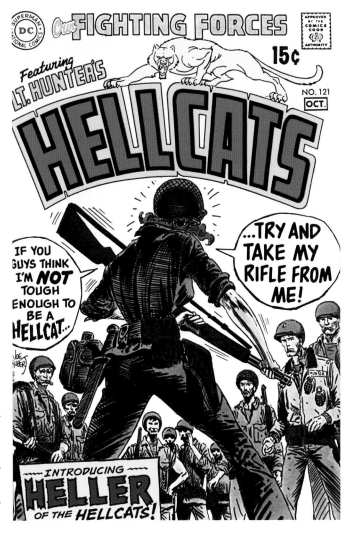

above

Our Fighting Forces #121 — September–October 1969
Art by Joe Kubert
One of modern comics' strongest icons is the fighting heroine. Here, in this very cool Joe Kubert cover, we have a late sixties image of the evolving modern woman, as red-haired Heller challenges her male counterparts for the right to do battle as one of Hunter's Hellcats.

page 28

Wonder Woman (1st series) #181 — March–April 1969
Pencilled by Mike Sekowsky, inked by Dick Giordano
Diana, a heroine in mod clothing, battles the agents of the evil Dr. Cyber in the imaginary European nation of Bjorland.

page 29

The New Teen Titans #23 — September 1982
Pencilled by George Pérez, inked by Dick Giordano
Starfire, the last Teen Titan left standing, faces her sister Blackfire in a cosmic battle rife with sibling rivalry.

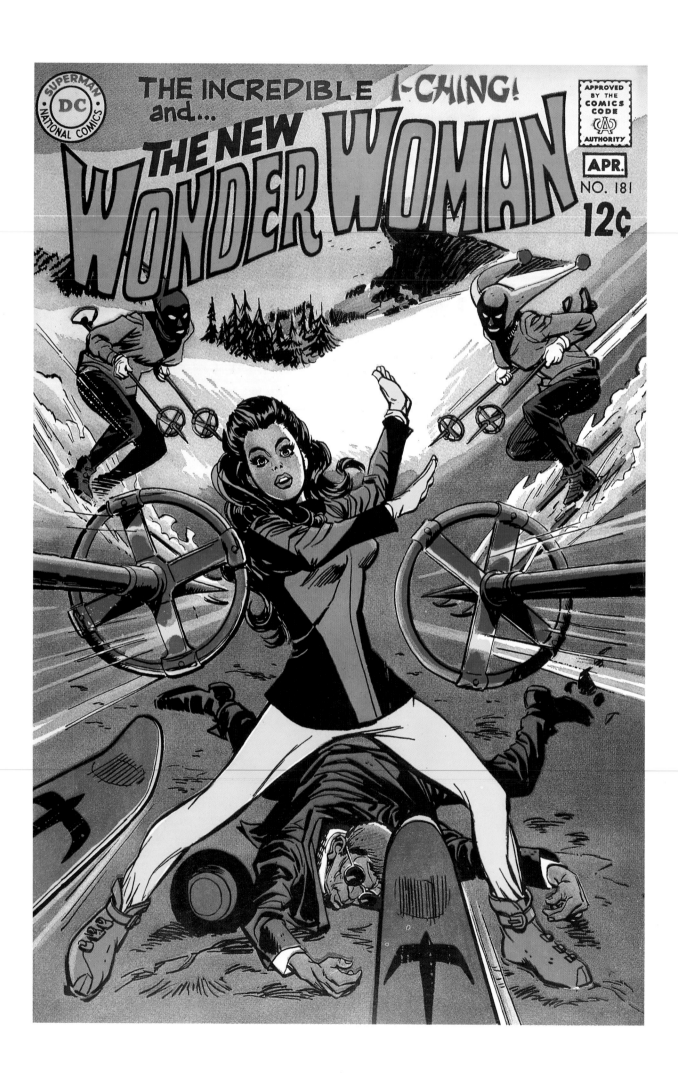

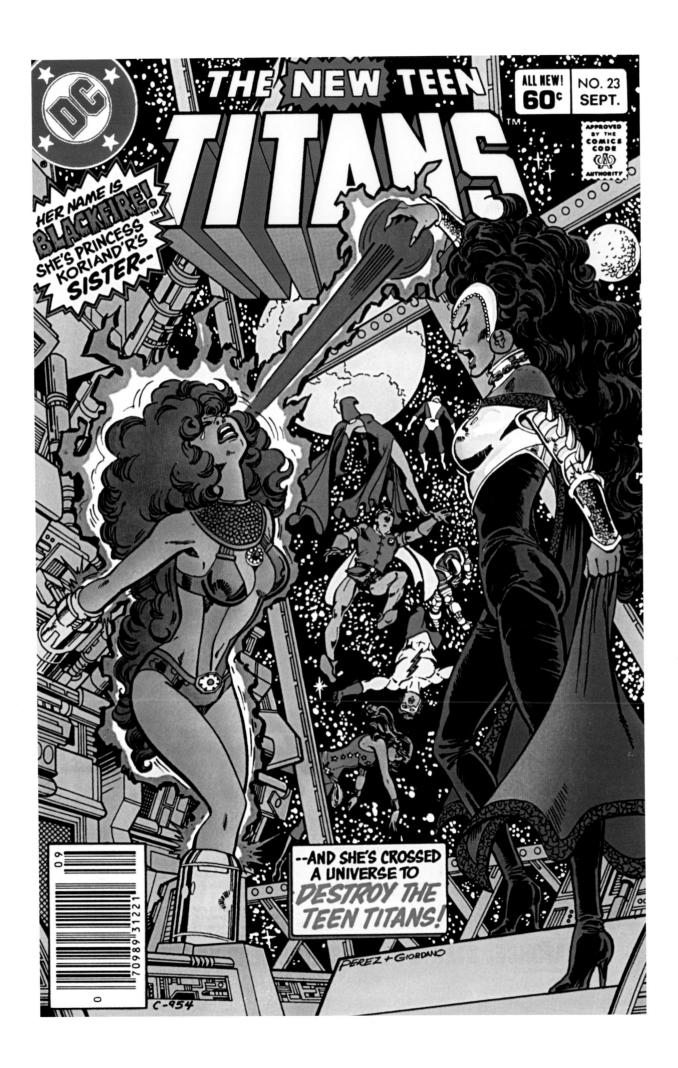

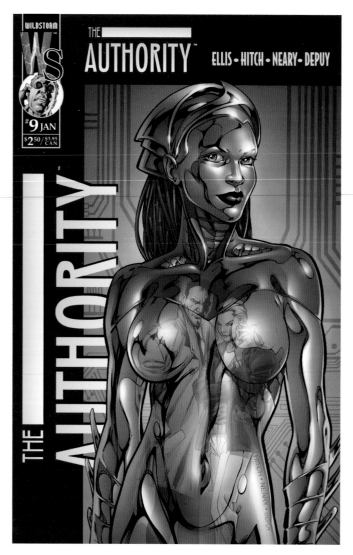

above
The Authority #9 — January 1999
Pencilled by Bryan Hitch, inked by Paul Neary
The Authority, a hugely influential comic at the turn of the
millennium, made cover penciller Bryan Hitch a superstar.
It featured numerous strong female characters,
including the Engineer, shown here.

opposite
Crisis on Infinite Earths #7 — October 1985
Art by George Pérez
One of the most famous DC Comics covers ever by fan favorite
artist George Pérez marks the first Supergirl's shocking death in this
DC Universe-spanning miniseries.

Characterizations became more sophisticated in male and female characters alike, reflecting the expectations of an older audience. Complex story "crossovers" ranged through a number of titles. New characters appeared. Super-hero bodies became more exaggerated and costumes more revealing. Creativity burgeoned and profits soared.

An upstart group of mostly Marvel artists broke away from mainstream comics to form Image, a conglomerate of creator-owned imprints under a single publishing entity. Foremost among these was WildStorm, an imprint that was acquired by DC Comics in 1998.

BEYOND CLASSIC SUPER HEROINES

It was becoming increasingly obvious that comics had acquired adult fans with different requirements than the traditional kid audience. Responding to this changing marketplace, comics began to be sold through specialty shops. And DC Comics began to focus some of its titles on appealing to this more mature readership.

Burgeoning creativity followed. A plethora of new superhero characters (and new lives for old characters) emerged. Fresh titles and innovative imprints followed.

Responding to the more mature interest in horror, fantasy, and antihero protagonists, DC Comics introduced the sophisticated Vertigo imprint in the early 1990s. Vertigo's complex stories appealed to older readers who felt edgy characters like those in *100 Bullets* reflected more clearly than super heroes the complex times in which they lived.

DC Comics also acquired the WildStorm Comics line, with its more adult-oriented characters. The powerful modern heroines portrayed here were self-directed and complex characters—often clothed in ultra-idealized bodies—and their adventures ranged through the super-heroic, through fantasy, and into science fiction.

Many of Vertigo's mature titles, like *Y: The Last Man,* contained complex explorations of gender and sexuality. Others, like the vampiric *Bite Club,* were a deliberately disturbing mélange of sex, religion, and violence. Obviously, they expanded the comics genre in ways that did not have the approval of the Comics Code Authority.

Like other publishers, DC Comics now had a range of titles in different genres, designed to appeal to a wide spectrum of ages and tastes, from the kid-oriented *Justice League Unlimited* to the mature-labeled *The Authority.*

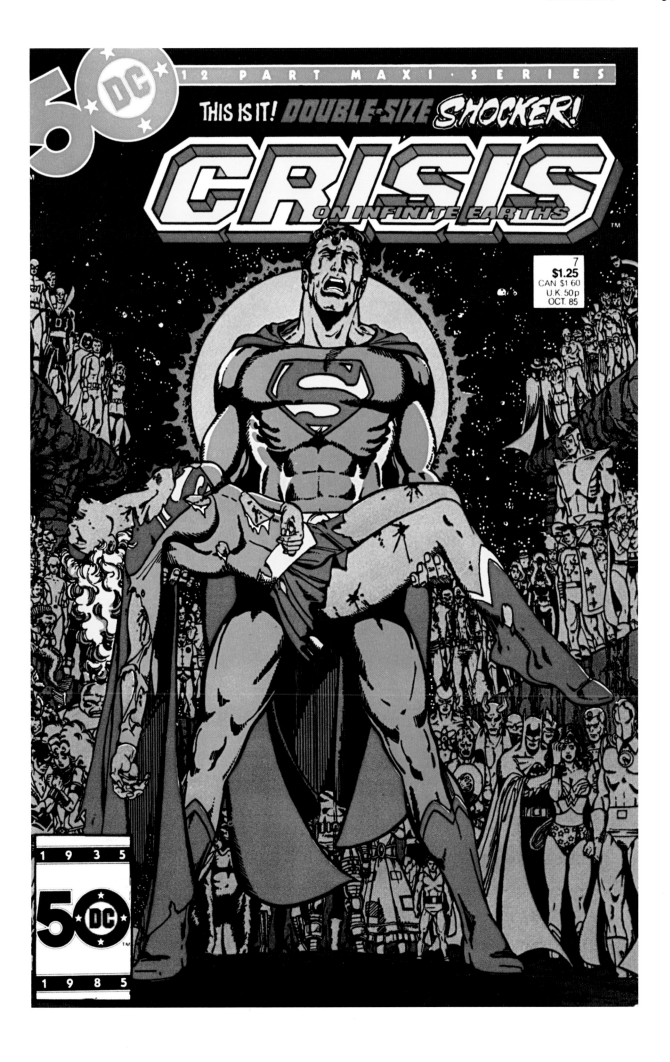

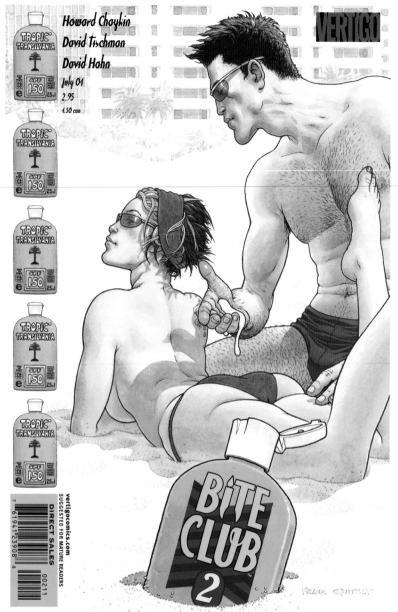

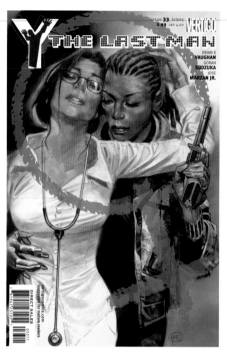

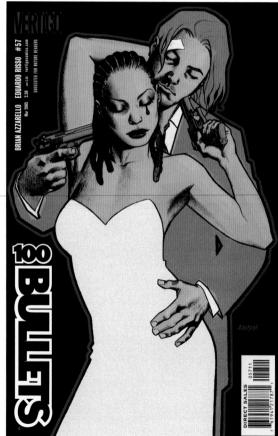

above
Bite Club #2 — July 2004
Art by Frank Quitely
What this cover image doesn't tell you is that these characters are brother and sister. He's also a catholic priest, struggling with both his vampirism and his incestuous feelings for his manipulative sibling.

above right
Y: The Last Man #33 — July 2005
Art by Massimo Carnevale
With only a single man left alive on Earth, lesbianism has become an important plot component in *Y: The Last Man*.

right
100 Bullets #57 — March 2005
Art by Dave Johnson
This beautifully drawn and highly designed cover by artist Dave Johnson highlights the links between sex and violence in this morally ambiguous noir series.

ICONS OF THEIR AGES

The covergirls featured in this book can be looked at as gender stereotypes, as cultural artifacts, even as Jungian archetypes: the Hero, the Wise Woman, the Trickster, the Eternal Child. They are among the most iconic of comic-book women. Many have been around for decades and during their long reigns as the premier heroines (and antiheroines) of the DC Universe, a succession of creators have added to their stories.

As much as our covergirls spring from the individual fantasies of their creators, they also reflect the history and the mores of their times. Who the character is, what she does, and how she reacts to challenges is influenced by the era in which she appears.

Like any works of fiction, comics are an interaction between creators and readers. Some characters grow in the popular imagination until they almost seem to take on lives of their own. The fans of these characters know them and believe in them. Just Google any one of them and you'll find numerous fan websites devoted to her, complete with pictures and histories. Message boards abound with passionate arguments about her abilities, motivations, exploits, critiques of her adventures—and even her costume and hairstyle.

Fans care intensely how their favorite heroines are depicted. It's almost as if, on some level, they believe these characters are real people—and the creators who write and draw their stories are simply chronicling the continuing adventures of living, breathing individuals who exist beyond their two-dimensional appearances on comic book pages.

That's the wonder of fiction: that even though readers know what's real and what's not, somehow, during the unfolding story, they put what they know aside and enter the fictional world of the characters they love.

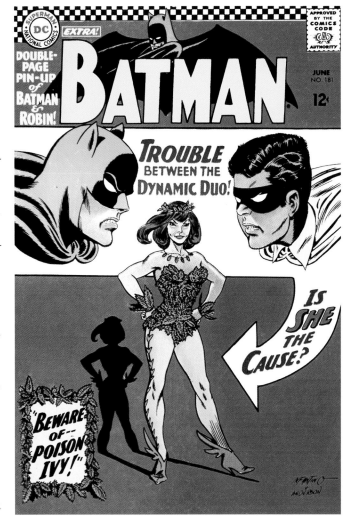

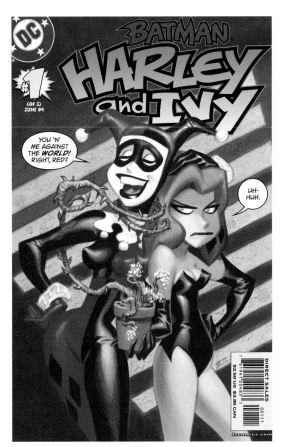

above right
Batman #181 — June 1966
Pencilled by Carmine Infantino, inked by Murphy Anderson
Poison Ivy, one of Batman's most famous foes, has often been
portrayed as a dark seductress.

right
Harley & Ivy #1 — June 2004
Art by Bruce Timm
In Jungian terms, the jester-costumed Harley Quinn (co-created by
cover artist Bruce Timm for *Batman: The Animated Series*) is a
Trickster character. Here, Poison Ivy tricks the Trickster, illustrating
the rocky relationship of the sometimes-friends.

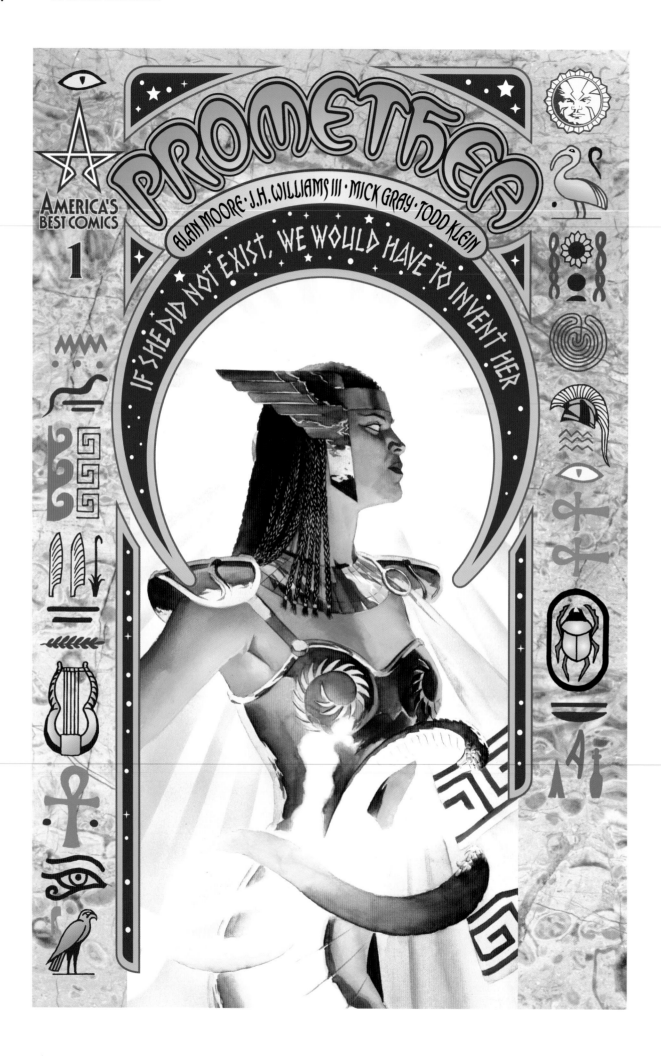

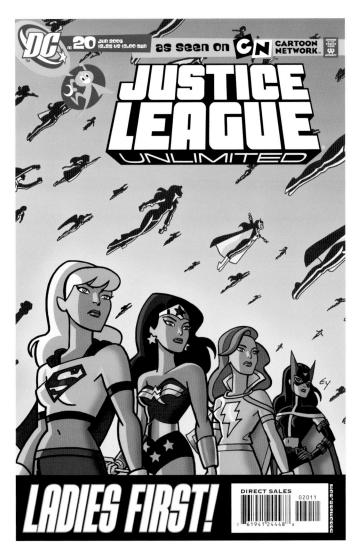

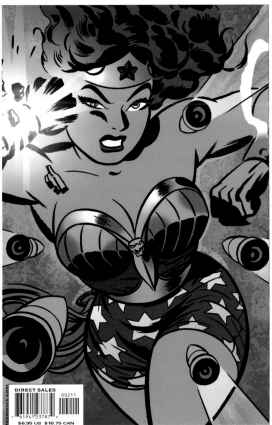

opposite

Promethea #1 — August 1999
Art by Alex Ross
Artist Alex Ross lends his considerable talents to Alan Moore's mythological heroine, who explores the various iterations and interpretations of magic in the world.

left

Justice League: Unlimited #20 — June 2006
Art by Ty Templeton
The animated *Justice League Unlimited* has featured dozens of characters from the comics. In this issue, based on the animated series, the focus is on the women of the DC Universe.

below

Wonder Woman (1st series) #34 — March–April 1949
Art by Irwin Hasen and Bernard Sachs
You've seen it here, folks! Wonder Woman's bracelets can deflect death rays and missiles as well as bullets.

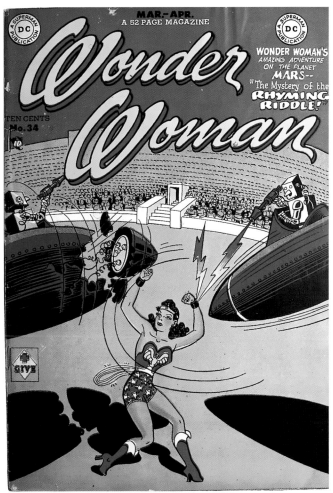

left

New Frontier #2 back cover — April 2004
Art by Darwyn Cooke
New Frontier was a wonderful miniseries by Darwyn Cooke, former storyboard artist on *Batman: The Animated Series*. Cooke placed re-imagined DC Comics heroes at major periods in America's past. His Wonder Woman was a tough warrior who protested for peace, and this dynamic image (actually the back cover of this issue) captures her determination.

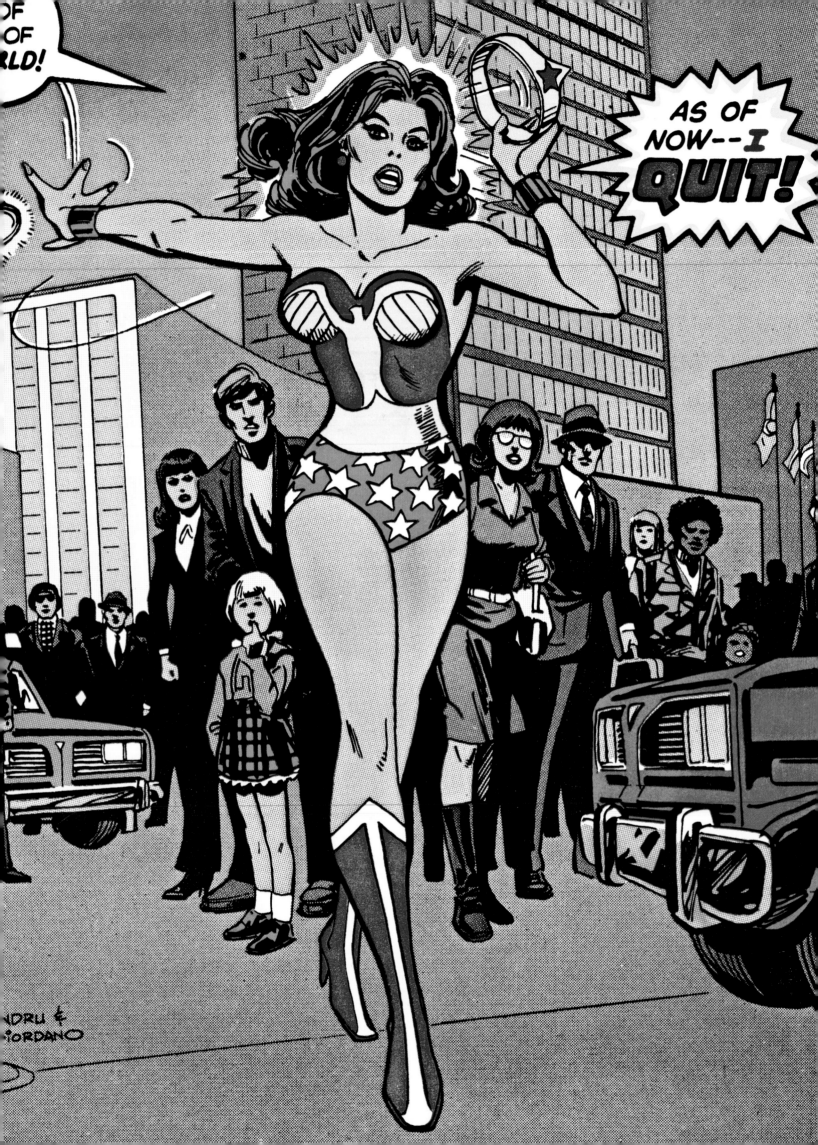

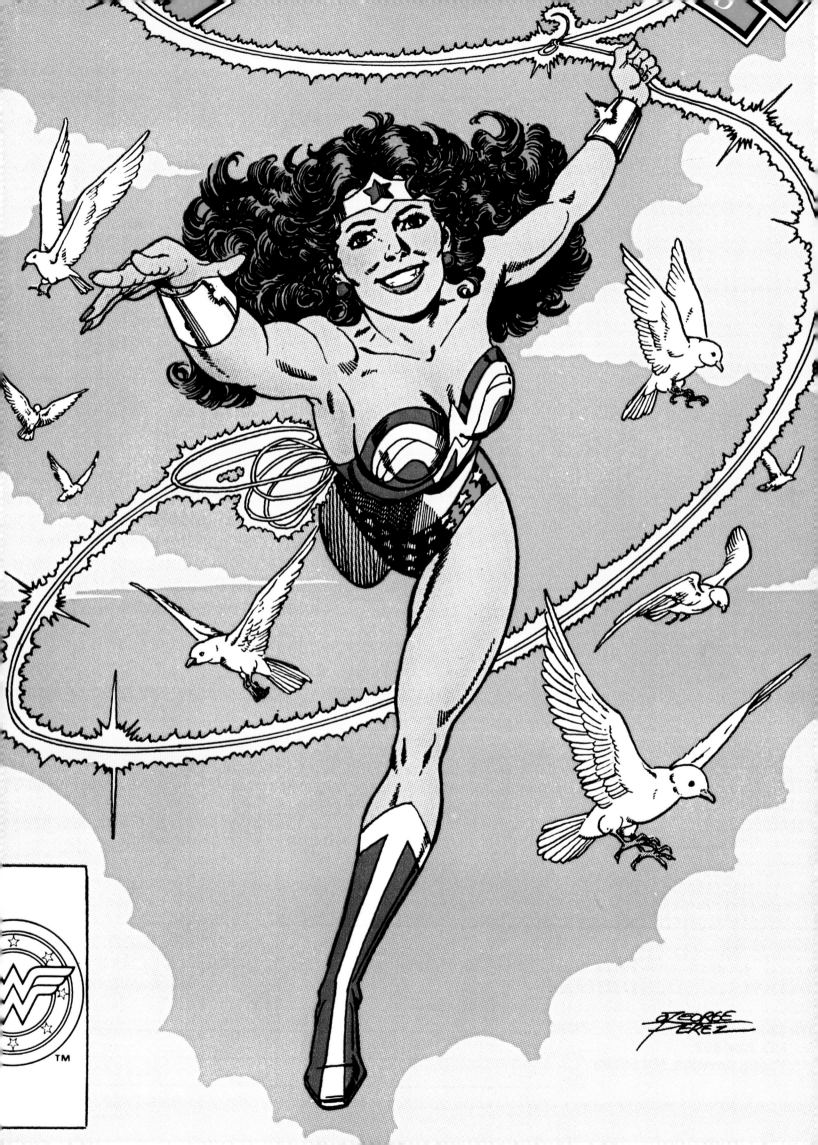

Wonder

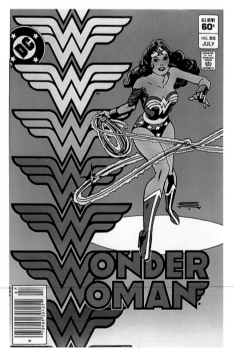

above
Wonder Woman (1st series) #305 — July 1983
Art by Gil Kane
Inside the story, Wonder Woman is attacked by the Man-Beasts of
Circe, but on this cheery cover, she has things under control.

opposite
Sensation Comics #1 — January 1942
Art by Harry G. Peter
Wonder Woman arrives in America, ready to battle the enemies of
democracy wherever they might strike.

The creation of comic books involves separate but interlocking universes—the publishing company, the creators, the fictional lives of the characters, and the fans' reaction to it all. These in turn influence and are influenced by the alternate realities of movies, animation, and television.

In no character is the interconnectedness of these overlapping realties more apparent than Wonder Woman.

"Great Minerva!
What sort of fool's trap am I in now?"

—Wonder Woman, *Sensation #26* (February 1943)

Wonder Woman burst onto the scene in 1941 in a story written by Charles Moulton, the pseudonym of psychologist William Moulton Marston (1893–1947).

Her creator was a man of paradoxical impulses. In many ways an idealist and a seeker of scientific truth, he was also a shameless manipulator of people's perceptions. He was a visionary who believed in the equality (and in some ways, the superiority) of women. And yet his stories are filled with images of women in bondage. And, perhaps strangest of all, he was an intellectual who loved the new art form of comic books.

Marston was a psychologist with a law degree who had trained at Harvard. By all accounts, he was a complex individual, brilliant at a number of endeavors, genial, outgoing, with eccentric theories and an unconventional home life. Marston may have had more than his share of kinks but his themes catapulted Wonder Woman to instant stardom.

Woman

"Beautiful as Aphrodite, wise as Athena, stronger than Hercules and swifter than Mercury, Wonder Woman comes from Paradise Island where Amazons rule supreme..."

—Introductory caption, *Sensation Comics* #18 (June 1943)

Marston was one of the originators of the lie detector; his interest in uncovering the truth was spurred during his service in the U.S. Army's psychological division during World War I.

During the Roaring Twenties, Marston taught at several prestigious universities but as the Great Depression deepened, his teaching career evaporated. His unusual lifestyle might have influenced his lack of success in conservative academia.

In 1915, he had married Elizabeth Holloway. In the late 1920s, Marston met Olive Byrne Richard, a student at Tufts University, where he was then teaching. She became his assistant and soon moved in with Marston and his wife. The three lived happily together and Marston later had two children by each woman. Elizabeth named her daughter after Olive.

"Get strong! Earn your own living...! Remember the better you can fight, the less you'll have to!"

—Wonder Woman to a "weak girl" entrapped by the villain Dr. Psycho, *Wonder Woman* #5 (June–July 1943)

Marston understood better than most the value of self-promotion, and his successful media manipulation led directly to the creation of Wonder Woman.

In 1937, in an interview in the *New York Times*, he espoused the view that within the next century America would become a matriarchy: "...a nation of Amazons in the psychological rather than physical sense."

This attracted the attention of the publishers of the women's magazine *Family Circle*, who hired Marston as a consultant and columnist.

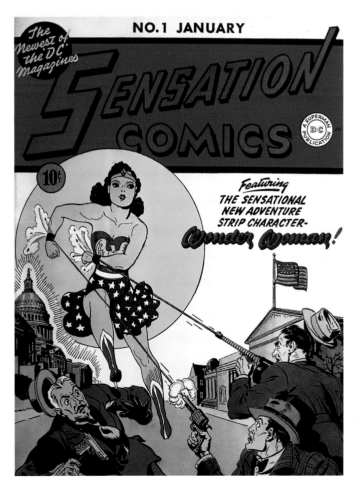

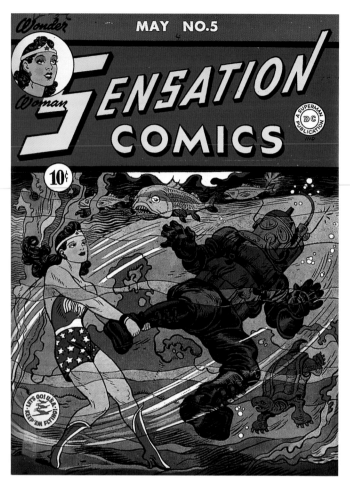

above
Sensation Comics #5 — May 1942
Art by Harry G. Peter
Soon after her first appearance, Wonder Woman's flippy skirt was
replaced with shorts, which were deemed more modest attire for the
athletic heroine.

Marston's October 1940 column in *Family Circle* featured the fledgling comic book industry and specifically mentioned All American Comics publisher M. C. Gaines. Flattered, Gaines invited Marston to join the board of All American and its sister company National Periodicals as an editorial advisor.

National Periodicals already had a multimedia sensation with Superman, who first appeared in 1938 in *Action Comics*. Batman, debuting a year later in *Detective Comics*, was so popular that, in 1940, National was in the process of changing its name to Detective Comics, or DC, and National/DC was looking for another hit property.

In February of 1941, Marston submitted a script to editor Sheldon Mayer introducing a young princess trained to physical perfection by a race of Amazons and given special gifts by the gods.

"A man! A man on Paradise Island! Quick! Let's get him to the hospital."

—Princess Diana, *All Star Comics* #8
(December 1941–January 1942)

Mayer bought the story and Marston's clout, as an expert from another field, allowed him to choose his own artist, magazine illustrator Harry G. Peter.

Wonder Woman's origin story appeared in the anthology title *All Star Comics* #8 (December 1941–January 1942). This was followed almost immediately by a second tale, the lead story in *Sensation Comics* #1 (January 1942).

Wonder Woman was an immediate success. She was so popular that, several months later, she was given her own eponymous series.

These early comics told Wonder Woman's back story and origin and set the stage for her future adventures. In them, Queen Hippolyta rules the Amazons, a race of immortal women who live on Paradise Island, a realm from which men are forbidden. Desiring a daughter, Hippolyta sculpts a statue of a little girl, which the goddess Aphrodite brings to life. The child is named Diana.

As a young woman, Princess Diana saves the life of Steve Trevor, an injured U.S. Army officer whose plane has crashed on Amazon Island. The goddesses tell Queen Hippolyta that it's time for an Amazon to journey to Man's World to fight the Nazis.

Hippolyta holds a contest to choose the Amazons' champion. Against her mother's orders, Diana disobeys and, wearing a mask, secretly enters the tournament. Stronger, faster, and more skilled than the other combatants, she wins every contest.

Diana reveals her true identity and her mother relents, allowing Diana to go to Man's World as the Amazon's emissary, Wonder Woman. Diana takes the special costume with its magic bracelets that can deflect bullets and an enchanted golden lasso, which forces anyone bound by it to tell the truth.

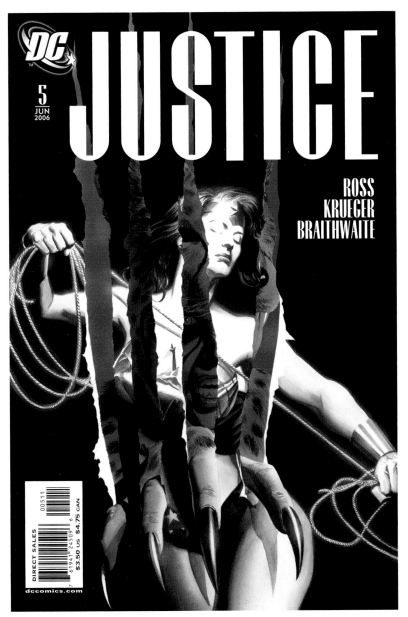

page 42
Wonder Woman (2nd series) #156 — May 2000
Art by Adam Hughes
Even these days, Wonder Woman can end up chained—this time by
the monstrous villainess Devastation, a dark version of Diana created
by the Titan Chronos. Appearing sometimes as a child and
sometimes as a woman, Devastation is lethal in either guise.

page 43
Wonder Woman (1st series) #68 — August 1954
Art by Irv Novick
Irv Novick's beautiful Wonder Woman in bondage, menaced by a
torpedo so phallic it had to be labeled!
Obviously a pre-Comics Code Authority cover.

left
Justice #5 — June 2006
Art by Alex Ross
In the *Justice* limited series, the "bad guys" battle the members of
the Justice League in order to save Earth from preordained
destruction. In this beautiful Alex Ross cover, Wonder Woman faces
the most recent incarnation of the feral Cheetah.

below
Wonder Woman (2nd series) #22 — November 1988
Art by George Pérez
The Amazons have voted to open Themyscira to the outside world!
Surrounded by doves of peace and welcoming us with a smile, Diana
beckons us onto Paradise Island.

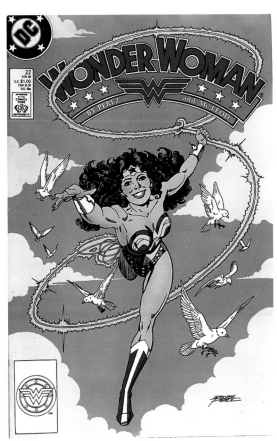

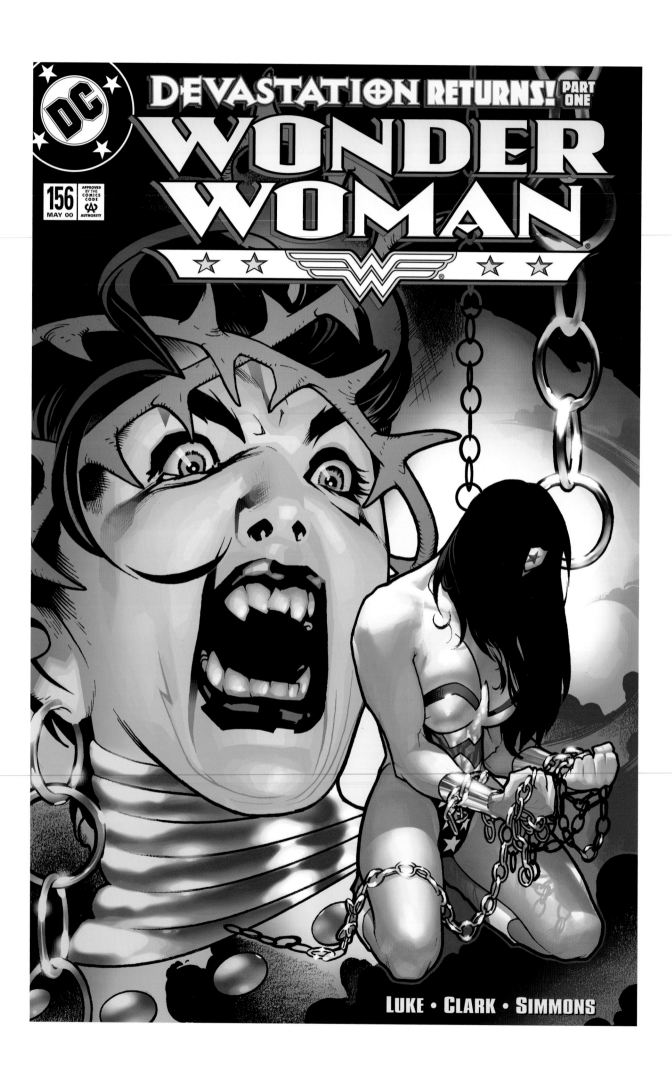

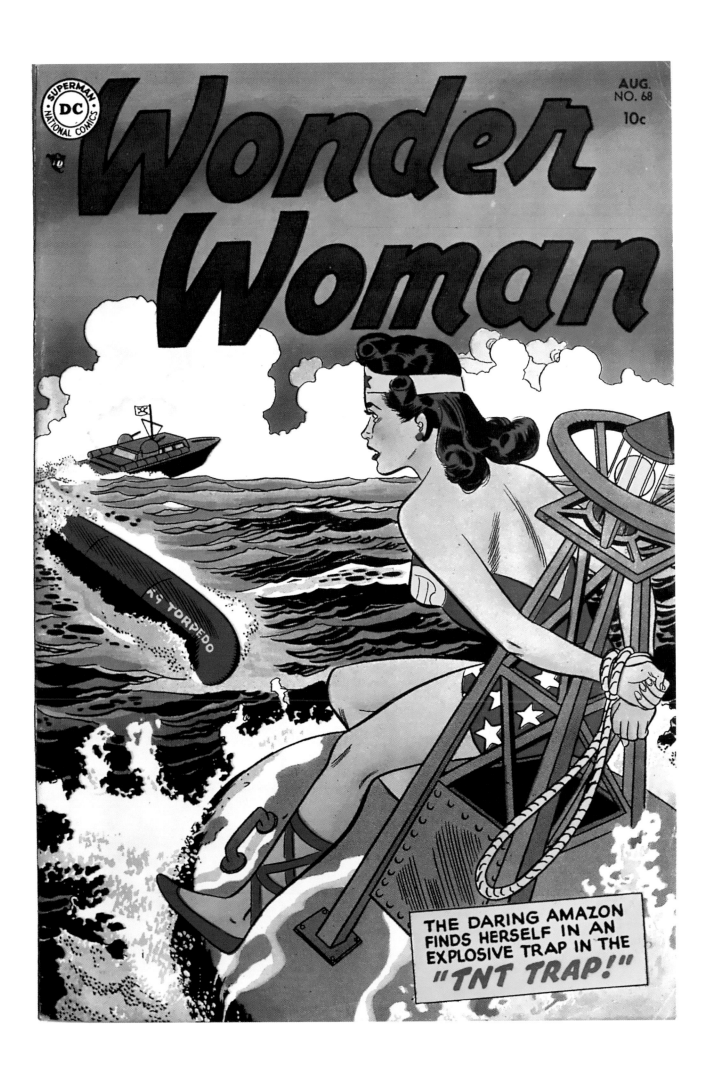

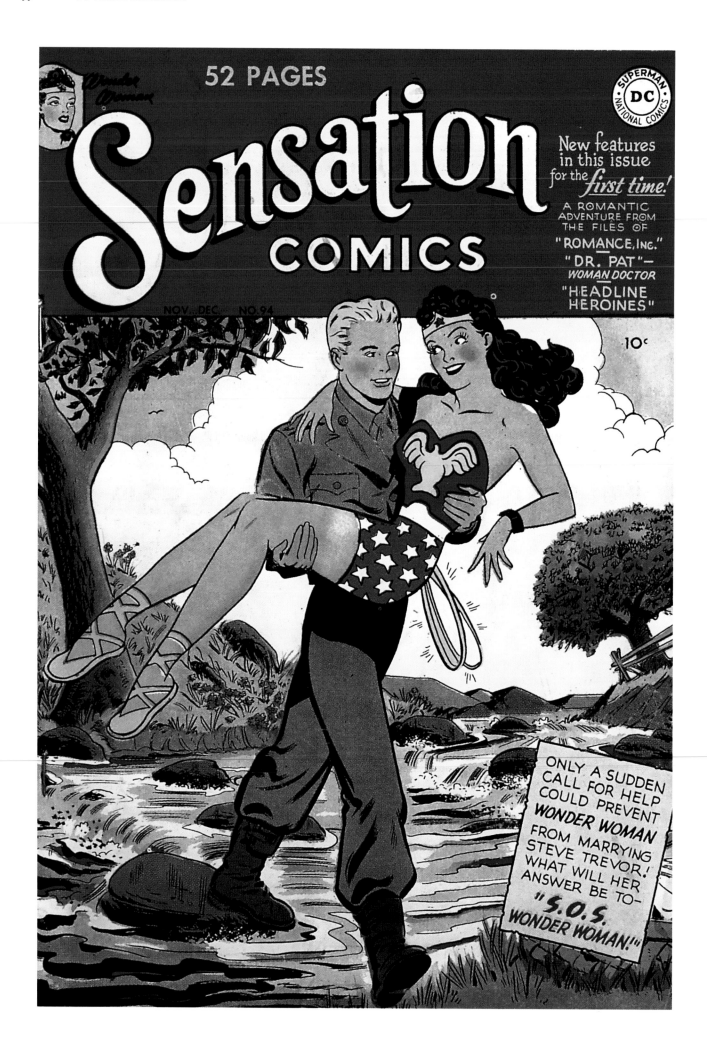

In her invisible plane, she flies the injured Steve Trevor to a hospital in Man's World. There she assumes the identity of nurse Diana Prince so she can be near him as he recovers. Soon Steve Trevor, hoping to win her heart, joins Wonder Woman in her fight against evil.

"A spirit tells me my hour of vengeance is at hand! Women shall suffer while I laugh—Ha! Ho! Ha!"

—Dr. Psycho, *Wonder Woman* #5 (June-July 1943)

After arriving in America, Wonder Woman fought a variety of foes from costumed villains like the Cheetah and Dr. Psycho (and his ectoplasmic doppelgangers) to Mars, God of War, to Nazi spies like the Baroness Paula Von Gunther. Aiding America in its battle against its enemies was a Marston theme that bolstered the Amazon's popularity during the War years.

In 1928, Marston wrote a pop-psychology book, *Emotions of Normal People*, which discussed dominance and submission—subjects that had long fascinated him.

"Men have welded chains to my bracelets . . . ! I've lost my Amazon strength!"

—Wonder Woman, *Wonder Woman* #17 (May–June 1946)

Every Wonder Woman comic written by Marston (and he wrote all the Wonder Woman stories until his death) contained a scene where Wonder Woman was bound in some way. Readers quickly learned that, when her bracelets were chained together, she lost her Amazon powers.

Yet Marston also gave the Amazon princess Diana her own implement of bondage—that magical golden lasso, which compelled anyone bound by it to tell the truth.

A blatant use of comic book visual imagery, the lasso cleverly combined Marston's dominant themes: the search for truth and his fascination with compulsion and submission as symbolized by bondage.

"I shall make you tell the truth— while bound with this golden rope you must obey me!"

—Wonder Woman, *Sensation Comics* #20 (August 1943)

Marston's bondage/captivity concepts were controversial. He answered his critics in a letter to publisher M. C. Gaines: "Since binding and chaining are the one harmless… way of subjecting the heroine to menace and making drama of it, I have developed elaborate ways of having Wonder Woman and the other characters confined."

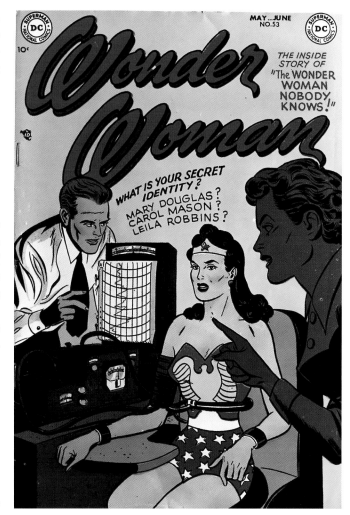

above
Wonder Woman (1st series) #53 — May–June 1952
Art by Irv Novick
Psychologist William Marston crafted an early form of the lie detector even before he invented Wonder Woman and her golden lasso. Here, his two creations share a cover.

opposite
Sensation #94 — November–December 1949
Art by Irwin Hasen
During the post-World War II era, romance was in the air and Wonder Woman toyed with relinquishing her powers to become longtime boyfriend Steve Trevor's bride.

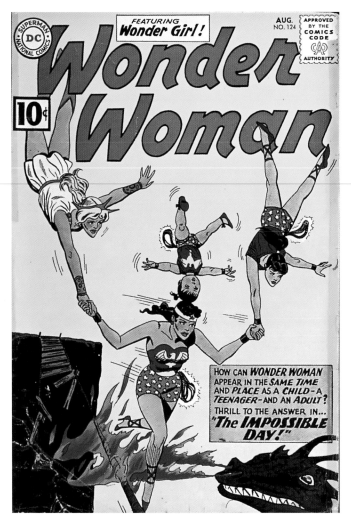

FEATURING
Wonder Girl!
AUG.
NO. 124

Wonder Woman

10¢

HOW CAN *WONDER WOMAN* APPEAR IN THE *SAME TIME* AND *PLACE* AS A *CHILD* - A *TEENAGER* - AND AN *ADULT?* THRILL TO THE ANSWER IN...
"The IMPOSSIBLE DAY!"

above

Wonder Woman (1st series) #124 — August 1961
Pencilled by Ross Andru, inked by Mike Esposito
Wonder Woman, Queen Hippolyta, Wonder Tot, and Wonder Girl often appeared together in "Impossible Tales." The fact that Wonder Woman, Wonder Girl, and Wonder Tot were the same Diana at different ages, brought together by Amazon magic, confused readers and comics professionals alike and led to the inclusion of Wonder Girl in the Teen Titans.

opposite

Wonder Woman (2nd series) #188 — March 2003
Art by Adam Hughes
Fan favorite writer-artist Phil Jimenez bids farewell to Wonder Woman in this "A Day in the Life . . ." story, with a poignant cover by Adam Hughes

In the end, there was a lot of squawking about the issue, but no one did much about it. *Wonder Woman* sales were sensational. The American public obviously enjoyed watching the good and powerful Wonder Woman break free from the bondage of evil men. Whatever Marston was doing, it was just too popular to change the winning formula. Nevertheless, Marston was not well. As World War II was coming to an end, he developed polio. Confined to a wheelchair he continued to work until he died of lung cancer on May 2, 1947.

Without Marston, Sheldon Mayer felt uncomfortable in his role as Wonder Woman's editorial director. He quit to return to his first love, cartooning, where he created the charming and successful humor strip about those talkative tikes, Sugar and Spike.

"I-I feel strange! Great Hera! I've been changed into a gorilla!"

—Wonder Woman, *Wonder Woman* #170 (May 1967)

For the next twenty years, Robert Kanigher was the writer/editor in charge of Wonder Woman's adventures.

Post-war super-hero comics had begun losing ground to crime, western, romance, and even horror genres. Kanigher tried to stop the hemorrhaging sales by transforming Wonder Woman again and again.

Soldiers had returned from World War II, love was in the air, and Kanigher's stories began to focus on romance. But marriage between Wonder Woman and Steve Trevor remained a tantalizing impossibility since, if Wonder Woman married, she could "no longer remain an Amazon."

Wonder Woman became a less quirky, more conventional super heroine—she even journeyed to Hollywood to become an actress. And when she joined the Justice Society of America, it was as its secretary, though eventually she did acquire full member status. She rescued explorer Steve Trevor from monsters in Atlantis and astronaut Steve Trevor from the sorceress Circe but it seemed that nothing could improve the comic's bottom line.

Following Dr. Fredric Wertham's appearance before the Senate Subcommittee on Juvenile Delinquency and the creation of the Comics Code, *Sensation* and *All Star Comics* were cancelled but *Wonder Woman* still remained.

In 1958, Wonder Woman's longtime illustrator Harry G. Peter died. Kanigher brought in the art team of penciller Ross Andru and inker Mike Esposito, high school friends who would continue to work together for five decades.

"Suffering Sappho! The Roc! He's flying away with my lasso! If I don't recover it— all my efforts will be for nothing!"

—Wonder Girl to the Mer-boy Ronno, *Wonder Woman* #107 (July 1959)

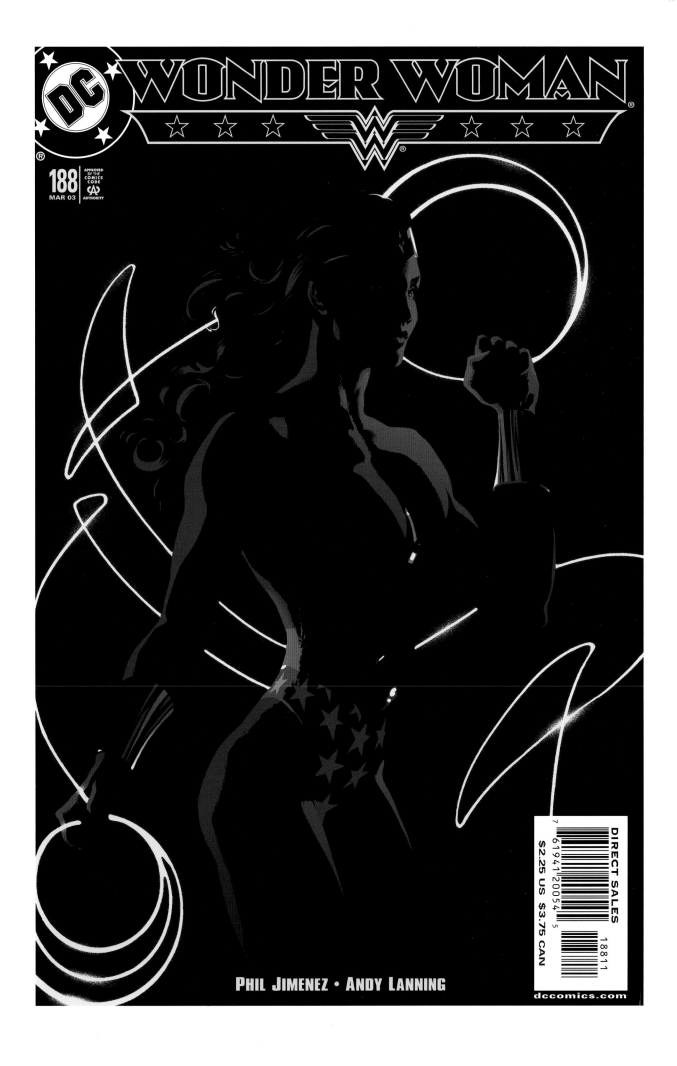

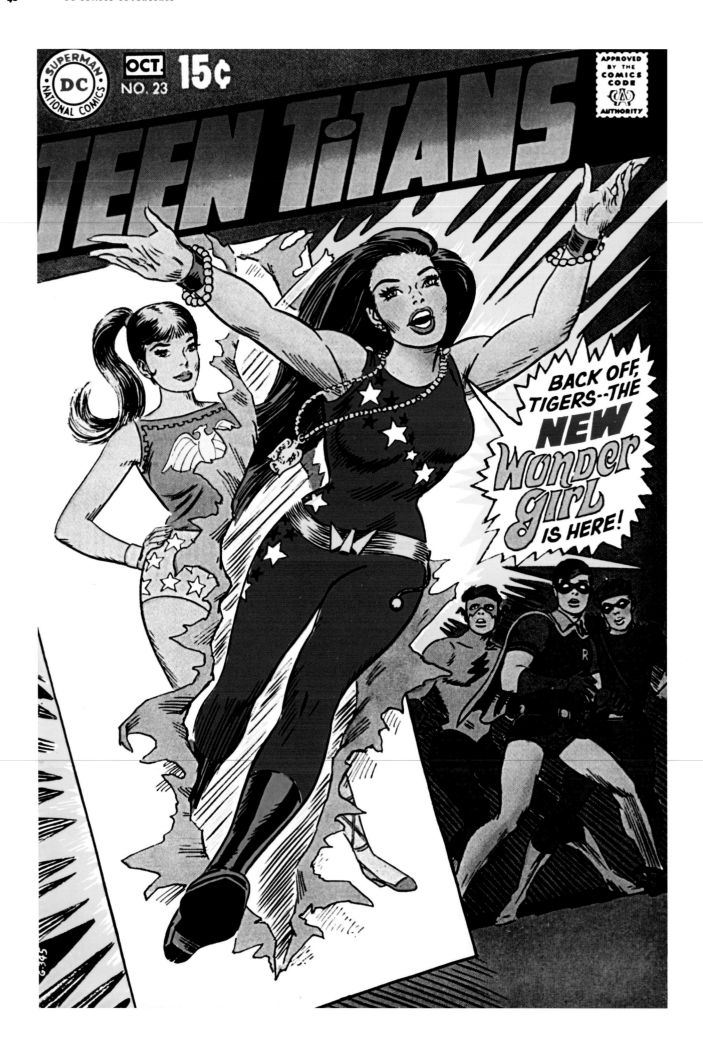

Inspired by their slick and beautiful art, Kanigher developed stories that focused on Wonder Woman's past and the history of Paradise Island. He revised her origin and told tales of her teenage adventures as Wonder Girl. He gave her a mer-boyfriend called Ronno and introduced Bird Boy, Ronno's rival for her affections. Finally, Kanigher brought in young Steve Trevor— teenage test pilot, in stories that became so popular that Wonder Girl was often featured on the covers.

Then further inspiration struck. In 1961, Kanigher began to write about Wonder Tot—Wonder Woman as a toddler.

"I'm getting—younger—younger . . . I—Wonder Tot!"

—Magnetized to the "Age-Clock," Wonder Girl regresses to become Wonder Tot, *Wonder Woman* #122 (May 1961)

As a grand finale, he created a series of Wonder Family tales in which Wonder Tot, Wonder Girl, and Wonder Woman (the same Princes Diana at different ages) appeared simultaneously along with Queen Hippolyta in a series of adventures.

Several years later, writer Bob Haney, obviously confused about who Wonder Girl really was, brought her into the Teen Titans. The glitch was resolved in the 1980s with the revelation that Wonder Girl was actually Donna Troy, an orphan whom Wonder Woman had rescued.

Finally, in 1968, the team of Kanigher, Andru, and Esposito left the book and, for a while, Kanigher was able to focus on his real interest—war comics.

Wonder Woman obtained a new creative team: writer Denny O'Neil, penciller Mike Sekowsky, and inker Dick Giordano.

"Wow! I-I'm gorgeous! I should have done this ages ago!"

—Wonder Woman, having ditched her iconic costume, *Wonder Woman* #178 (September–October 1968)

Inspired by the idea of Diana as a liberated, self-created heroine, the new team totally revamped the character. In a storyline than began in *Wonder Woman* #178, Steve Trevor was accused of criminal activity, even as Paradise Island was being transported to another dimension. Forced to choose between home and friend, Wonder Woman abandoned her Amazon powers and costume and remained on Earth to help Trevor. Bad decision! By *Wonder Woman* #180, Trevor was dead.

But being a non-powered woman in fashionable mod clothing didn't stop Diana. She studied with martial arts expert I-Ching and, usually dressed in a white jumpsuit, fought for peace around the world.

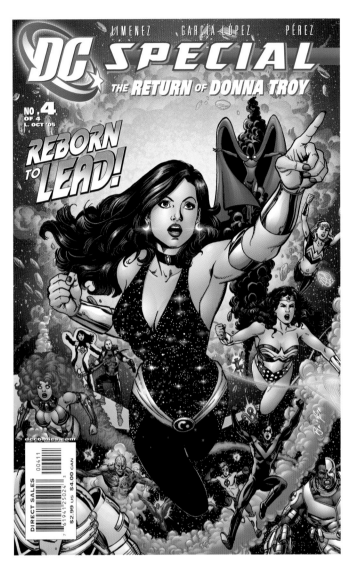

above
The Return of Donna Troy #4 — August 2005
Pencilled by Phil Jimenez, inked by George Pérez
In *The Return of Donna Troy* miniseries, Donna learns that she is one of the few individuals who can remember all of her pre- and post-Crisis incarnations—a state that will soon lead her to take on the mantle of Wonder Woman.

opposite
Teen Titans #23 — September–October 1969
Art by Nick Cardy
Donna Troy has had an active career as Wonder Girl of the Teen Titans.

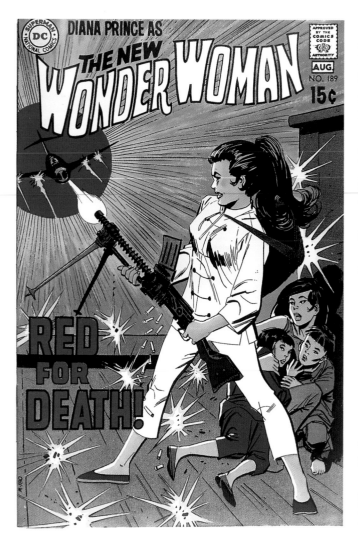

above

Wonder Woman (1st series) #189 — July–August 1970
Pencilled by Mike Sekowsky, inked by Dick Giordano
Disguised as a native Chinese (?!), Diana uses her machine gun to
create a diversion so that friends of her mentor I-Ching
can escape from Red China.

opposite

Wonder Woman (1st series) #178 — September–October 1968
Pencilled by Mike Sekowsky, inked by Dick Giordano
Forsaking her powers and exchanging her costume for mod fashion,
Diana Prince begins her controversial five-year run as a martial arts
wielding non-super heroine.

Several issues later, Sekowsky took over as *Wonder Woman's* writer/editor/artist. But, by *Wonder Woman* #200, O'Neil was back, this time as editor and sometimes writer. The self-made hero was a theme that worked well for O'Neil, who went on to become a major writer/editor of *Batman*, and Wonder Woman remained a non-powered heroine in mod clothing.

In July of 1972, the first issue of feminist Gloria Steinham's *Ms. Magazine* hit the newsstands. A towering figure of Wonder Woman in her original costume strode across the cover below a banner that read "Wonder Woman for President." Inside, an essay decried the depowering of Wonder Woman.

Bowing to feminist outrage, Wonder Woman's powers and iconic costume were restored in 1973. Kanigher was back writing *Wonder Woman*. And, once again, the heroine struggled to find an audience.

"Bullets-and-bracelets or bolts-and-bracelets... the outcome's still the same—you lose!"

—Wonder Woman, winning her Eighth Challenge against the
villain Dr. Felix Faust, *Wonder Woman* #218 (June-July 1975)

In the middle of 1974, editor Julius Schwartz reluctantly took over the reins of *Wonder Woman*, with orders to restore the heroine to popularity as he had with Superman and Batman.

Schwartz, who had a reputation for working with the best young writers and artists, proposed a plotline in which Wonder Woman tried to prove herself worthy to rejoin the Justice League. This story, written mostly by Marty Pasko, featured guest appearances by popular characters and effectively spurred sales.

Then, in 1975, the spectacular Lynda Carter, a former Miss World USA, became Wonder Woman.

"Wonder Woman... Wonder Woman... All the world is waiting for you..."

—from the *Wonder Woman* theme song,
with music by Charles Fox and lyrics by Norman Gimbel

First in a TV pilot and several specials, then in a regular TV show, Carter "owned" Diana, fixing a generation's perceptions of the Amazon super heroine. Carter, a dancer by training, introduced the graceful twirl, Diana Prince's method of transforming into Wonder Woman. Millions of young girls practiced the twirl, creating a generation who are more familiar with Lynda Carter's version of the character than any of the comic stories that inspired her.

In 1976, Jenette Kahn became publisher of DC Comics. Responding to the fact that comic books had begun to sell through specialty shops to an older audience, she began to refocus the company's efforts in that direction.

The next year, Schwartz gave up editing *Wonder Woman* and a series of different editorial and creative teams followed. Amid the tangle of conflicting plotlines, Steve Trevor was revived

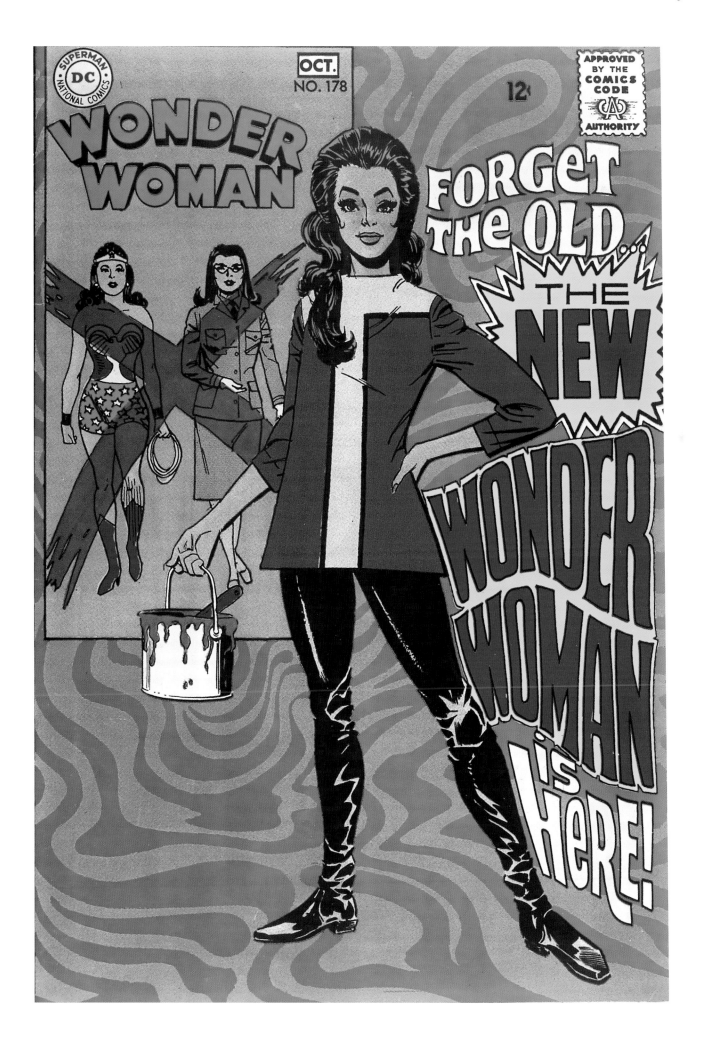

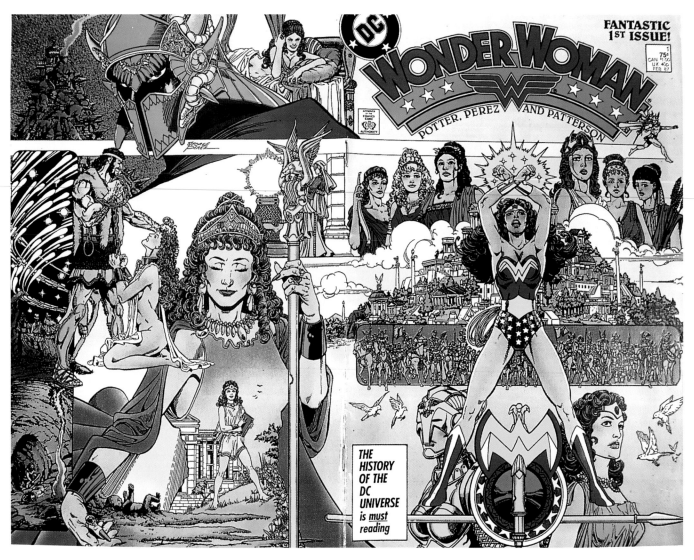

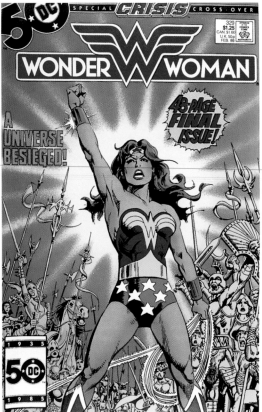

above

Wonder Woman (2nd series) #1 — February 1987
Art by George Pérez
This beautiful, intricately designed wraparound cover heralds Wonder
Woman's rebirth. It promises an epic saga rich in mythology, peopled
with gods, goddesses, and a cast of thousands—just the kind of
"reboot" Wonder Woman fans had been waiting for. George Pérez
remained on the book, in different capacities, for the next five years.

left

Wonder Woman (1st series) #329 — February 1986
Art by José Luis García-López
This final issue ends the first *Wonder Woman* series. Here Wonder
Woman rallies the Amazons against Hades' Army of the Dead,
as the Anti-Monitor takes his war against the multiverse to Olympus,
home of the gods. Diana and Steve Trevor finally marry—
before Diana and this version of reality are destroyed in the
Crisis on Infinite Earths miniseries. In fact, Diana was devolved into a
clay statue, from which she was soon reborn.

through the auspices of the goddess Aphrodite, then slain several issues later, as Wonder Woman cried, "Steve, no—not again!" In 1980, Steve Trevor was revived once more.

"Diana, only we know the Earths have changed."

—Earth-Prime's Wonder Woman to Earth-Three's Wonder Woman, *Crisis on Infinite Earths* #11 (February 1986)

By 1985, *Wonder Woman*, like many DC Comics titles, was floundering under the weight of nearly fifty years of conflicting continuity. Efforts to explain inconsistencies as happening on different parallel Earths had added to the confusion.

DC Comics' solution was radical: a miniseries called *Crisis on Infinite Earths*, written by Marv Wolfman and drawn by George Pérez, which sought to straighten out the continuity timeline by removing the tangled threads. Some characters died. Other characters changed. Some, by decree, had never existed.

Wonder Woman was devolved into a clay figure and returned to Paradise Island where she would soon be reborn. And, like several post-Crisis books, her series restarted with a brand-new #1 issue.

"The newspapers have already dubbed her Wonder Woman, and that appears to be the perfect name for her."

—WBST Newsbreak, *Wonder Woman (2nd series)* #4 (May 1987)

Hot off his *Crisis* triumph, George Pérez offered to draw the new *Wonder Woman* comic.

In February of 1987, *Wonder Woman (2nd series)* #1 hit the newsstand to enthusiastic fan reaction. Within a few issues, Pérez was the book's sole plotter and at times its scriptwriter as well. His careful inclusion of Greek mythology added depth and intensity to his tales of a reborn Wonder Woman. His Diana, a princess of Paradise Island, which he called Themyscira, was the recipient of godly gifts, among them strength, wisdom, and the power of flight.

He dropped Diana's secret identity and, amid her cosmic battles with gods and super-villains, focused on Wonder Woman's role as an ambassador of peace to Man's World.

Pérez's run finished in an epic mythological battle that tied up one of the most acclaimed depictions of the character. Pérez had been given the near impossible job of revising Wonder Woman from the ground up, and with the help of scripter Len Wein and others, he succeeded brilliantly.

After Pérez's departure, William Messner-Loebs wrote *Wonder Woman* with stories drawn by Mike Deodato. Deodato's controversial art, featuring Wonder Woman in provocative poses and sexy costume, had its fans. But, perhaps most popular of all, the powerful cover art of Brian Bolland drew enthusiastic attention to the comic. Their run ended with *Wonder Woman* #100 (July 1995).

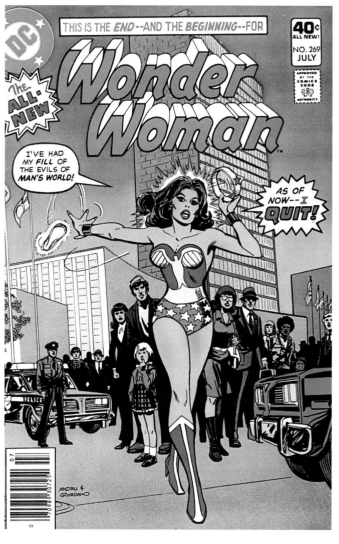

above

Wonder Woman (1st series) #269 — July 1980
Pencilled by Ross Andru, inked by Dick Giordano
Believing she can never make a positive change in "Man's World," Wonder Woman tosses aside her tiara and golden lasso. The "I quit!" cover in which a super hero symbolically abandons his or her role is an industry standard.

page 54

Wonder Woman (1st series) #229 — March 1977
Pencilled by José Luis García-López, inked by Vince Colletta
What—another missile?!? Tying into the early TV series, Wonder Woman time-traveled back to the 1940s. Here she is threatened by the Nazi villain, Red Panzer.

page 55

Wonder Woman (1st series) #205 — March–April 1973
Art by Nick Cardy
What is it with Wonder Woman and missiles, anyway?! This time she's bound to one and launched by the evil Dr. Domino.

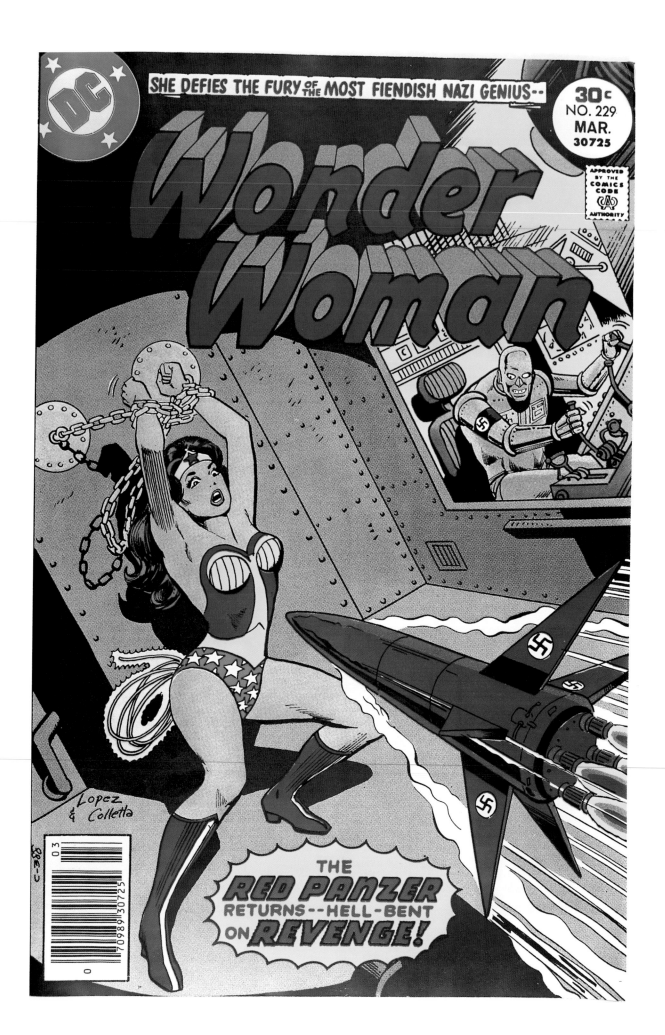

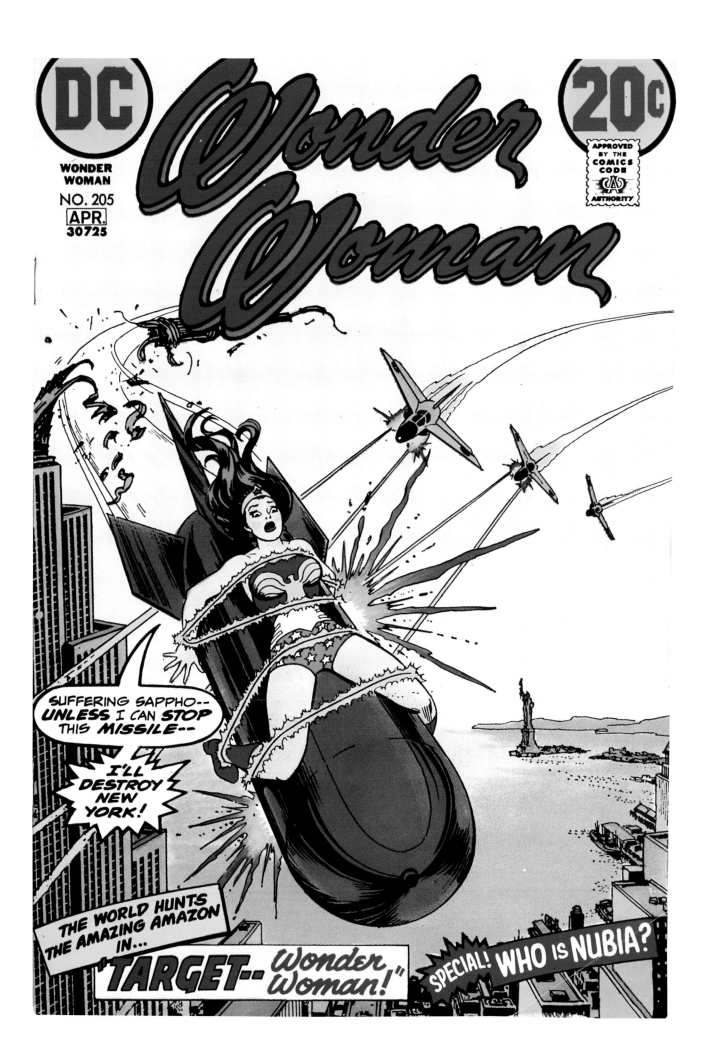

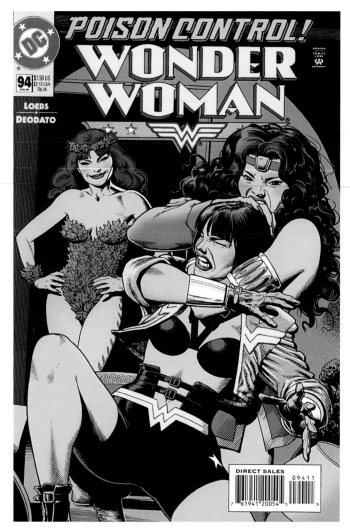

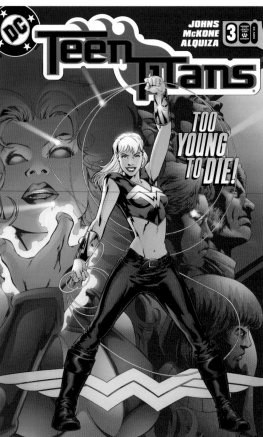

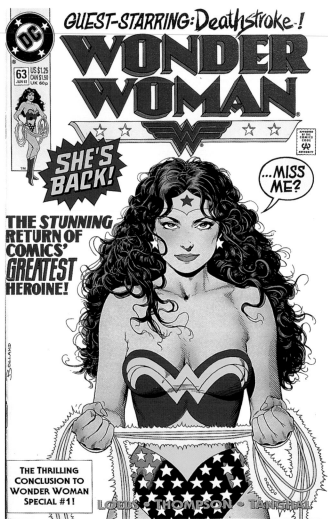

left

Wonder Woman (2nd series) #94 — February 1995
Art by Brian Bolland
For a short time, the Amazon Artemis replaced Diana as Wonder
Woman, leaving Diana free to face "Poison, Claws, and Death" in
another costume. Here she battles the assassin Cheshire as Poison
Ivy looks on.

above

Wonder Woman (2nd series) #63 — June 1992
Art by Brian Bolland
After a brief hiatus, Wonder Woman returns with a new
creative team. The powerful cover art of Brian Bolland graced
Wonder Woman covers #63–#100 and was an important factor in
the book's continuing success. Note the new logo: a striking design
that heralded a change for Wonder Woman.

left

Teen Titans #3 — November 2003
Pencilled by Mike McKone, inked by Marlo Alquiza
Cassie Sandsmark has replaced Donna Troy as the new Wonder Girl.
Cassie is a major member of the Teen Titans, as Donna Troy was
before her.

At the request of editor Paul Kupperberg, John Byrne took over *Wonder Woman* as writer/artist. During his three-year run, Byrne's Wonder Woman interacted super-heroically with the science-fiction-based New Gods and the mystical elements of the DC Universe.

The next two years featured Eric Luke as scripter and Yanick Paquette as penciller. In their most memorable contribution, the team used the Lansinar Morphing Disk, the device that creates Wonder Woman's invisible plane, to establish a huge environment known as the Wonderdome. It was during this run, with *Wonder Woman* #139, that Adam Hughes' spectacular series of covers began.

Hughes continued as the *Wonder Woman* cover artist through the run of Phil Jimenez, who took over as interior artist in January 2001. Soon Jimenez was writing as well as drawing the series. Throughout his two-year run (*Wonder Woman* #164–#188) Jimenez told stories that reminded many fans of the revered George Pérez era.

Wonder Woman #189–194, written by Walter Simonson and drawn by Gerry Ordway, referenced the powerless, jump-suited Wonder Woman of the O'Neil-Sekowsky era. In *Wonder Woman* #190, for the first time, Wonder Woman cut her hair, a bigger deal than anyone might have expected.

With issue #195, Greg Rucka took over as writer, with Don Johnson as penciller. Five issues later, with *Wonder Woman* #200 (March 2004), JG Jones began his run as the series' cover artist. The team explored dirty politics, modernized the Greek gods in a move applauded by many fans, destroyed the Amazon's homeland, Themyscira, and even temporarily blinded Wonder Woman. (She recovered, as did Themyscira.)

Wonder Woman killed a villain as part of the pivotal reality-shifting *Infinite Crisis* storyline. The woman who had fought for peace for over sixty years had deliberately taken a life. Shaken by her deed, Diana relinquished her tiara as *Wonder Woman* and, with *Wonder Woman* #226 (February 2006), volume two of the *Wonder Woman* series came to an end.

Wonder Woman (*3rd series*) #1 went on sale June 7, 2006. The unfolding Wonder Woman saga, by writer Allan Heinberg and artist Terry Dodson, promises to continue the drama and excitement Wonder Woman fans have come to expect of DC Comics' most enduring heroine.

It's nice to think that Marston would have been pleased to see who his creation has become. Modern-day Diana may not have an island of Amazons behind her; nor does she regularly find herself in bondage. Invented and reinvented during different times for different generations, she has nonetheless remained in essence the vibrant Wonder Woman of Marston's creation. And she has become America's iconic female super hero.

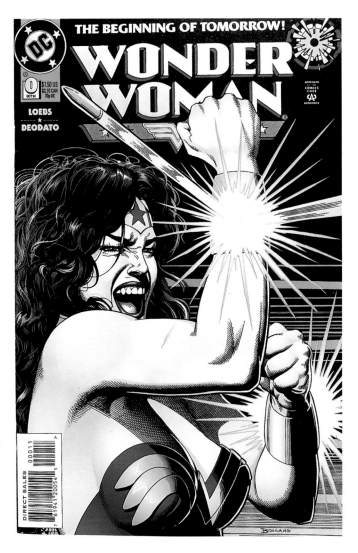

above

Wonder Woman (2nd series) #0 — October 1994
Art by Brian Bolland
Zero Hour (its icon is in the upper right hand corner of this cover) was a company-wide "Crisis In Time" that affected the continuity of a number of books. Here, Wonder Woman uses her bracelets to deflect bullets, preparing for yet another contest of prowess arranged by Queen Hippolyta on Paradise Island.

page 58

Wonder Woman (2nd series) #9 — October 1987
Art by George Pérez
The post-Crisis Cheetah was a human anthropologist, granted mystical powers of transformation. To this day, the Cheetah remains one of Wonder Woman's most enduring foes.

page 59

Wonder Woman (2nd series) #152 — January 2000
Art by Adam Hughes
In this arresting cover by artist Adam Hughes, Wonder Woman assumes a classic pose as she prepares for battle.

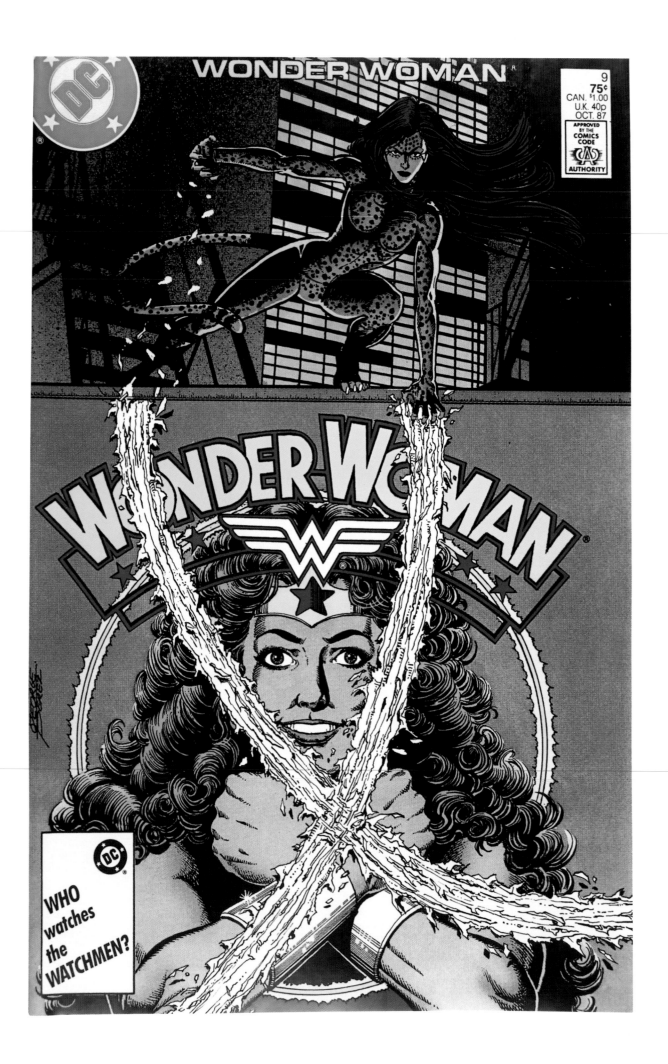

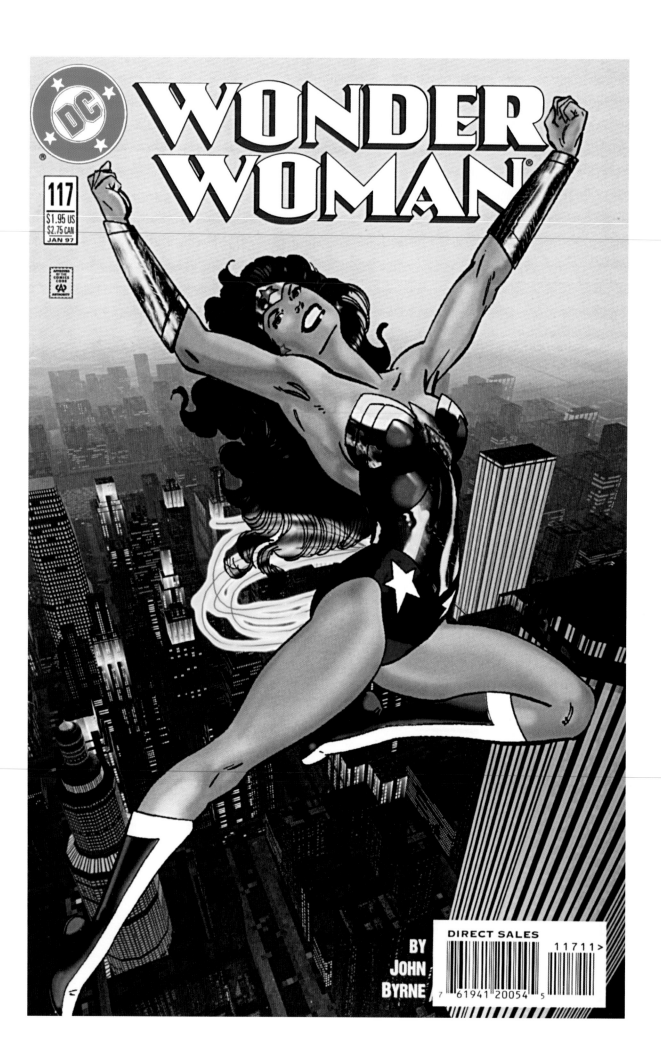

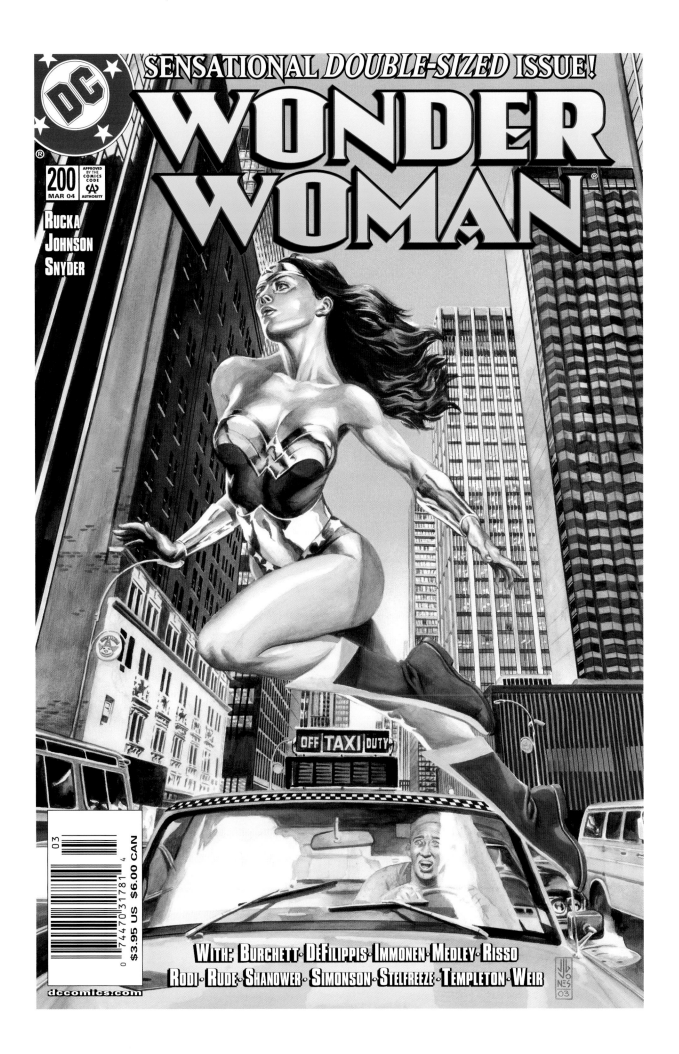

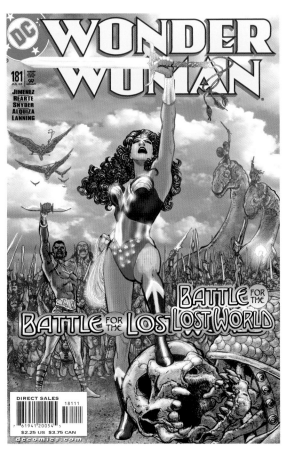

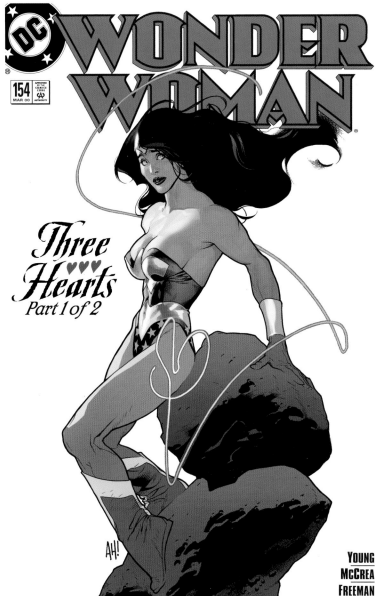

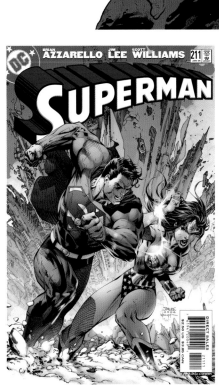

above

Wonder Woman (2nd series) #181 — July 2002
Art by Phil Jimenez
Writer/artist Phil Jimenez provides the triumphant cover to this issue.

above right

Wonder Woman (2nd series) #154 — March 2000
Art by Adam Hughes
Adam Hughes is the quintessential comic book covergirl pinup artist,
as his Wonder Woman here shows.

below right

Superman #211 — January 2005
Pencilled by Jim Lee, inked by Scott Williams
Artist Jim Lee demonstrates that Wonder Woman can hold her own
against Superman.

opposite

Wonder Woman (2nd series) #184 — October 2002
Art by Adam Hughes
Wonder Woman of today comes face to face with her earlier
incarnation, a symbolic cover in this cross-time tale featuring
dinosaurs and marauding Nazis.

page 61

Wonder Woman (2nd series) #117 — January 1997
Art by John Byrne
Writer/artist John Byrne's Wonder Woman soars above
ultramodern Gateway City.

page 62

Wonder Woman (2nd series) #200 — March 2004
Art by JG Jones
The Silver Swan attacks! Dr. Psycho foments unrest! The goddess
Hera, in a pique, hurls Themyscira into the sea! It's a heck of a way
for Wonder Woman to spend her 200th issue!

right
Wonder Woman (2nd series) #190 — May 2003
Art by Adam Hughes
A depowered Wonder Woman needs a quick disguise...and who
would recognize her with shorn locks and glasses?
Several issues later, when her powers return, Diana's hair magically
resumes its normal length.

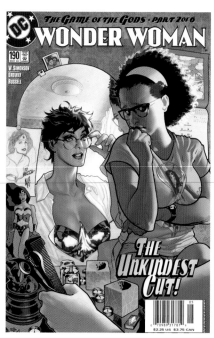

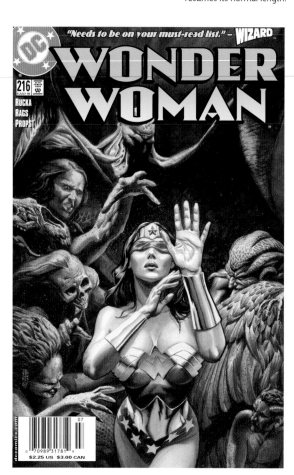

above
Wonder Woman (2nd series) #216 — May 2005
Art by JG Jones
To defeat the evil Medousa, Wonder Woman blinded herself and
remained sightless for many issues. Here she travels into Hades
where an army of the dead awaits her.

right
Wonder Woman (2nd series) #173 — October 2001
Art by Adam Hughes
Adam Hughes shows an armored Amazon, readied for battle,
as DC Comics' heroes face Imperiex, a cosmic force bent on
destroying the universe. As part of the "Our Worlds At War"
crossover, Wonder Woman's mother Queen Hippolyta died.

opposite
Wonder Woman: Spirit of Truth — November 2001
Art by Alex Ross
A beautiful Wonder Woman portrait by the fabulous Alex Ross.

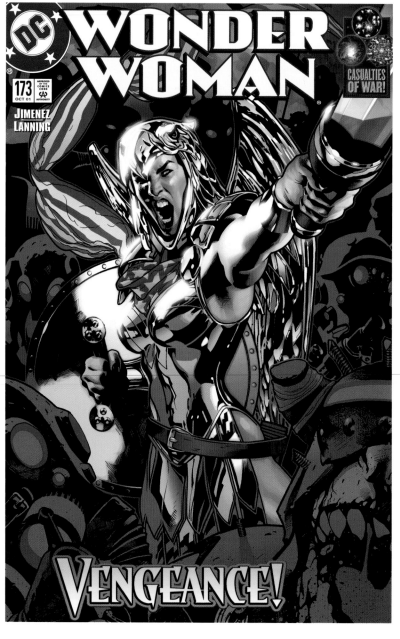

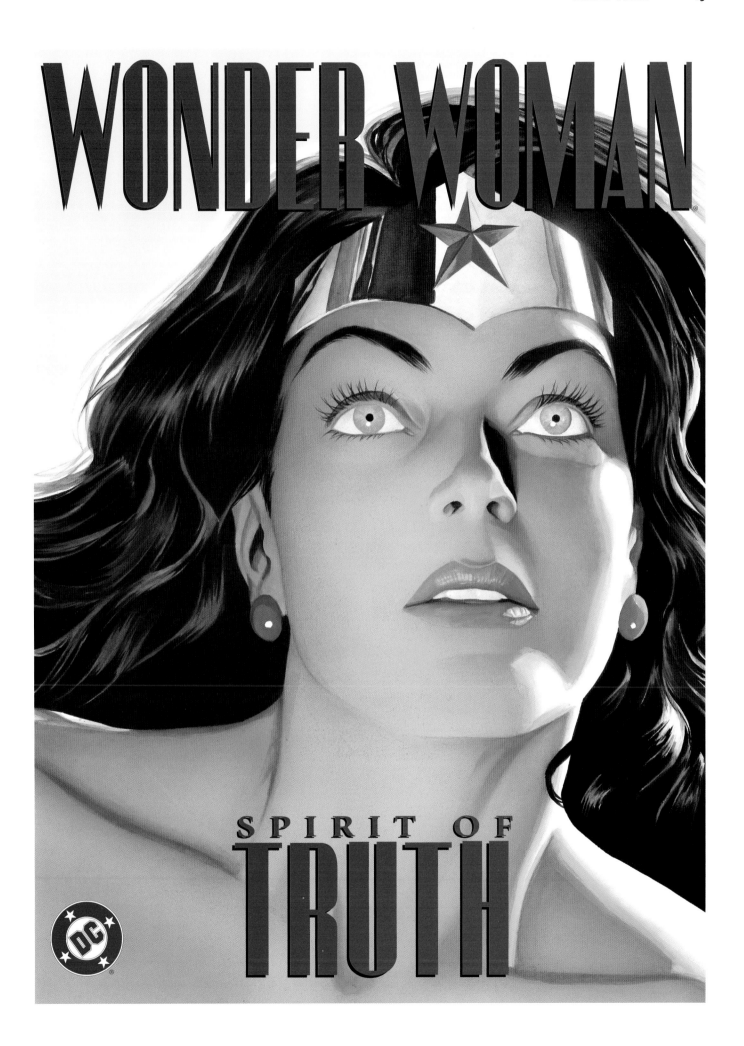

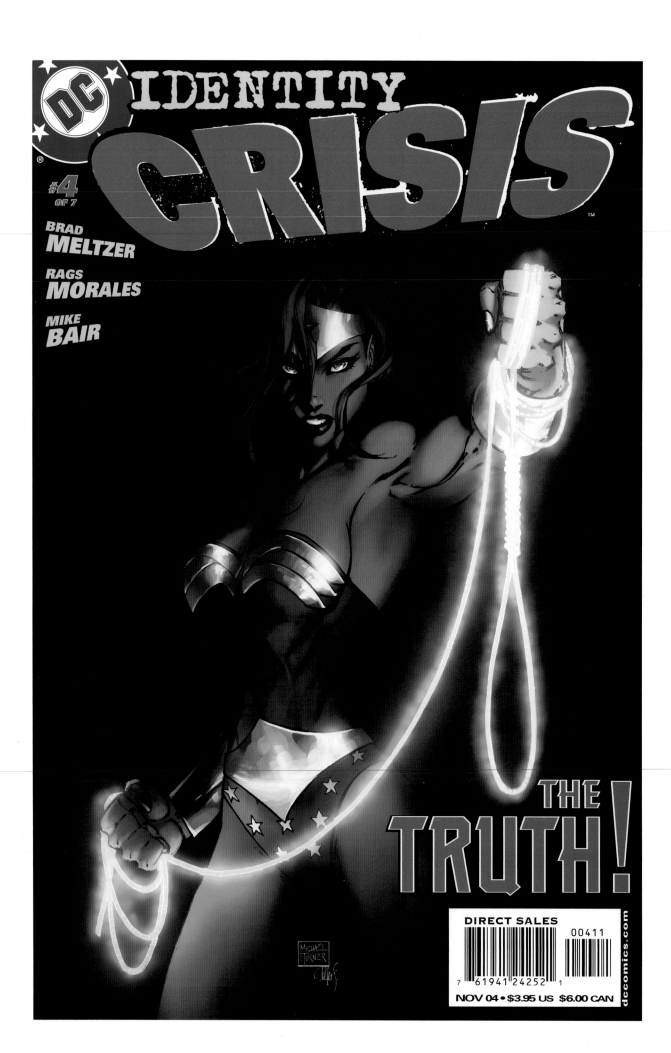

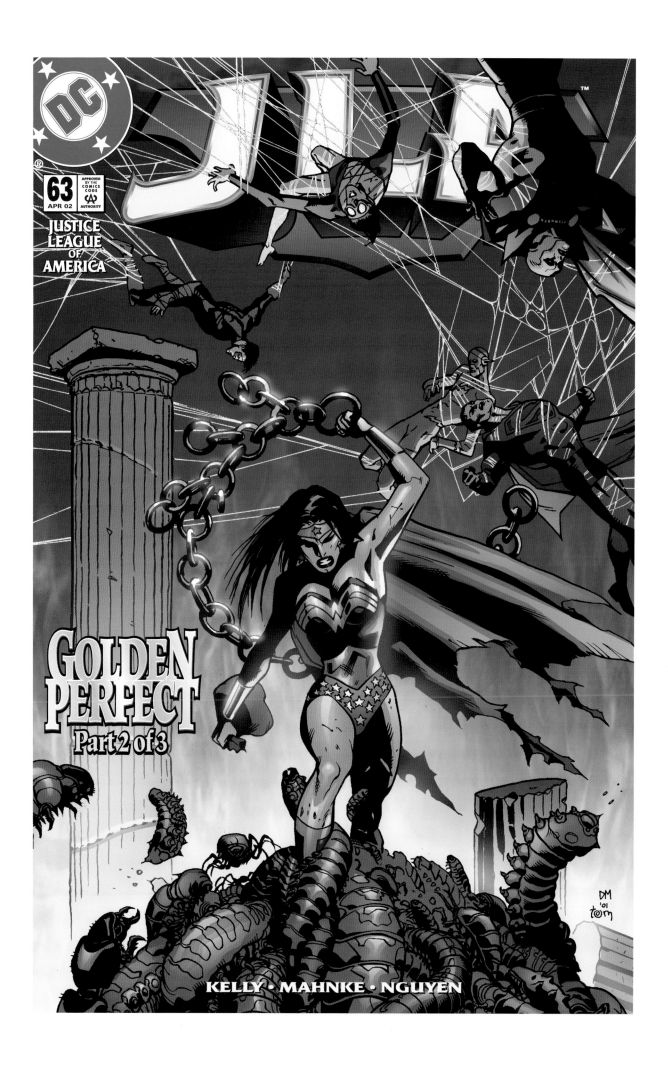

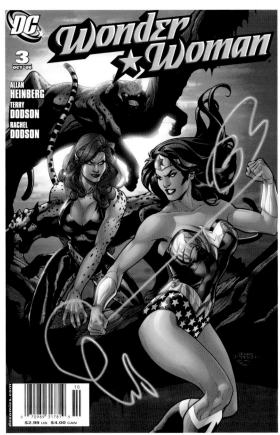

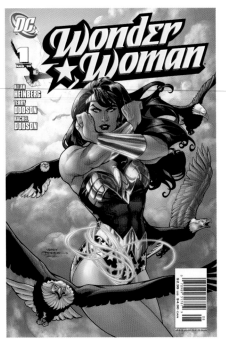

left

Wonder Woman (2nd series) #220 — August 2005
Art by JG Jones
In the events leading up to DC Comics' blockbuster *Infinite Crisis* miniseries, Wonder Woman shocked the world by killing the evil Maxwell Lord, who was controlling Superman. This cover is symbolic of the world's reaction.

below

Wonder Woman (3rd series) #3 — October 2006
Pencilled by Terry Dodson, inked by Rachel Dodson
The Cheetah is still on the scene, this time menacing the new Wonder Woman, Donna Troy.

left

Wonder Woman (3rd series) #1 — August 2006
Pencilled by Terry Dodson, inked by Rachel Dodson
The third *Wonder Woman* series began with a gorgeous cover by Terry Dodson, and a new Wonder Woman: Donna Troy.

page 66

Identity Crisis #4 — November 2004
Art by Michael Turner
Wonder Woman guest-starred in this epic miniseries of stolen identities.

page 67

JLA #63 — April 2002
Pencilled by Doug Mahnke, inked by Tom Doug Nguyen
Wonder Woman is a major player in the Justice League of America and is occasionally the only team member left standing after a bitter battle.

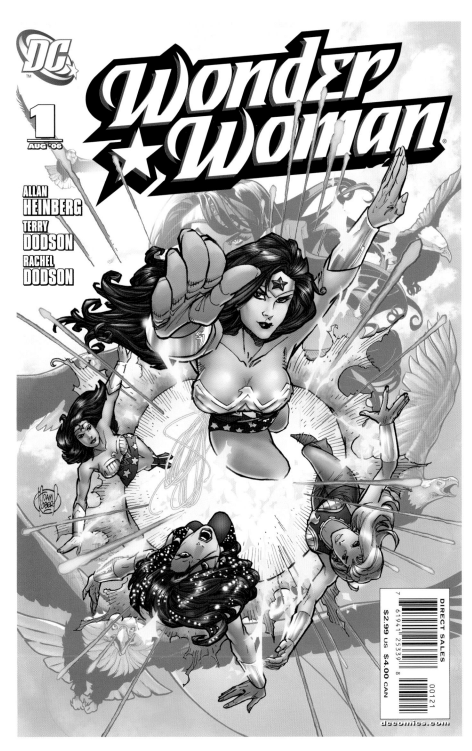

DIRECT SALES

$2.99 US $4.00 CAN

0 61941 25339 8

001121

dccomics.com

left

Wonder Woman (3rd series) #1
Adam Kubert variant — August 2006
Art by Adam Kubert
An alternate cover by fan favorite Adam Kubert,
as Donna Troy bursts onto the scene as the new
Wonder Woman. Alternate covers became popular
with comics collectors in the 1990s and are still
occasionally used today.

right

Wonder Woman (2nd series) #225 — January 2006
Art by JG Jones
As a result of *Infinite Crisis*, Wonder Woman's home Themyscira
disappeared from Man's World, ending her diplomatic mission of
peace and leaving her as the last Amazon. This brought an end to
the second *Wonder Woman* series.

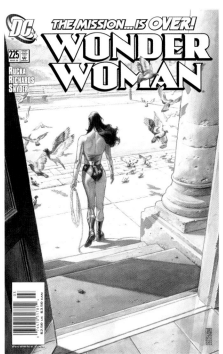

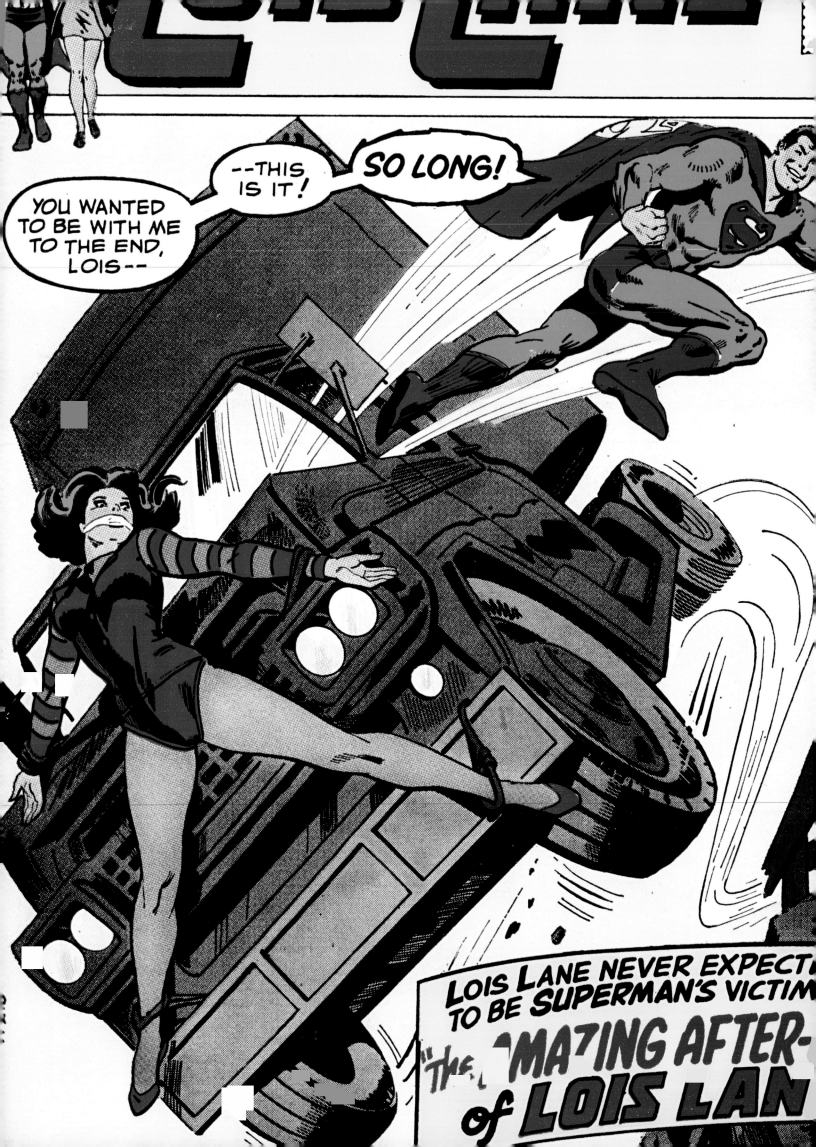

"Clark: Why is it you always avoid me at the office? Lois: Please Clark! I've been scribbling 'sob stories' all day long. Don't ask me to dish out another."

—Action Comics #1 (June 1938)

above

Superman #57 — March–April 1949
Pencilled by Wayne Boring, inked by Stan Kaye
Not a dream but a glimpse into a possible future, where Lois's descendant possesses Superman-like powers. Tales in which Lois acquires superpowers have amused readers for over sixty years.

opposite

Action Comics #29 — October 1940
Art by Wayne Boring
While following a story, Lois is kidnapped by insurance scamming thugs. Their getaway car—a cool late-1930s convertible—makes her rescue a snap for Superman.

Unlike most of DC Comics' covergirls, Lois Lane is not super-powered, at least not most of the time. But in her roles as a fearless reporter, Superman's girlfriend, and later his wife, she has become a super-powerful icon of the woman who has it all.

When Superman burst onto the comics scene in June 1938, Nazis were rampaging across Europe while America was in the grip of the Great Depression and poised on the brink of war.

Superman was the brainchild of a couple of guys in their early twenties, writer Jerry Siegel and artist Joe Shuster. Siegel and Shuster lived in Cleveland, Ohio, met in high school, became friends, and eventually became professionals working together in the fledgling comic book field, where they created several successful anthology characters.

For five years they tried unsuccessfully to sell Superman. Finally, they submitted their concept to M. C. Gaines.

Gaines, the man who first had the idea to reprint newspaper comic strips in pamphlet form, was then working for the McClure newspaper syndicate. He recommended Superman for a new anthology title National Periodical Publications was developing—*Action Comics*. National's publishers Harry Donnenfeld and Jack Liebowitz bought the property outright.

Action Comics #1, featuring Superman, went on sale in the summer of 1938 and sold out immediately.

The basics were there from the beginning: Superman, the superpowered alien hero who fought for "truth, justice, and the American way," and Lois Lane, a feisty female reporter who was attracted to Superman but disdained his alter ego, "mild-mannered reporter" Clark Kent. Schuster's design for Lois was based on a young model named Joanne Carter, whom Siegel eventually married.

Lane

**"But I tell you
I saw Superman last night!"**

—Lois Lane, *Action Comics* #1 (June 1938)

The success of Superman was galvanic; he immediately became a multimedia sensation.

By January 1939, Superman was featured in his own newspaper comic strip, with Gaines as editor. It was here that Superman's Kryptonian parents, Lora and Jor-L, were introduced.

In the summer of 1939, the eponymous comic *Superman* #1 hit the newsstands. It was filled with sixty-four pages of material—mostly carefully repackaged reprints—but every story featured Superman.

"Look, up in the sky! It's a bird! It's a plane! It's Superman!"

—Introduction to *The Adventures of Superman* radio show

The Adventures of Superman radio show began in 1940 and ran for the next eleven years. Perry White and Jimmy Olsen were both created for radio but almost immediately appeared in the comics as well.

By the end of 1940, the villainous Lex Luthor—who would go on to be Superman's perennial foe—was featured in *Action Comics* #23. And National Periodicals became known as DC Comics.

In 1941, the fabulous Fleischer *Superman* animated cartoon shorts were being shown on movie screens across the country. Soon Superman's image was everywhere: on socks, on toys, on cereal boxes. Superman was a phenomenon!

Though Lois Lane's primary plot purpose was to be one point in the Lois Lane-Clark Kent-Superman romantic triangle, she fulfilled this function as a strong-minded reporter excelling in a male-dominated field.

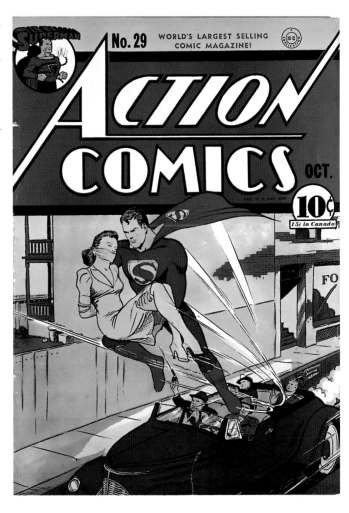

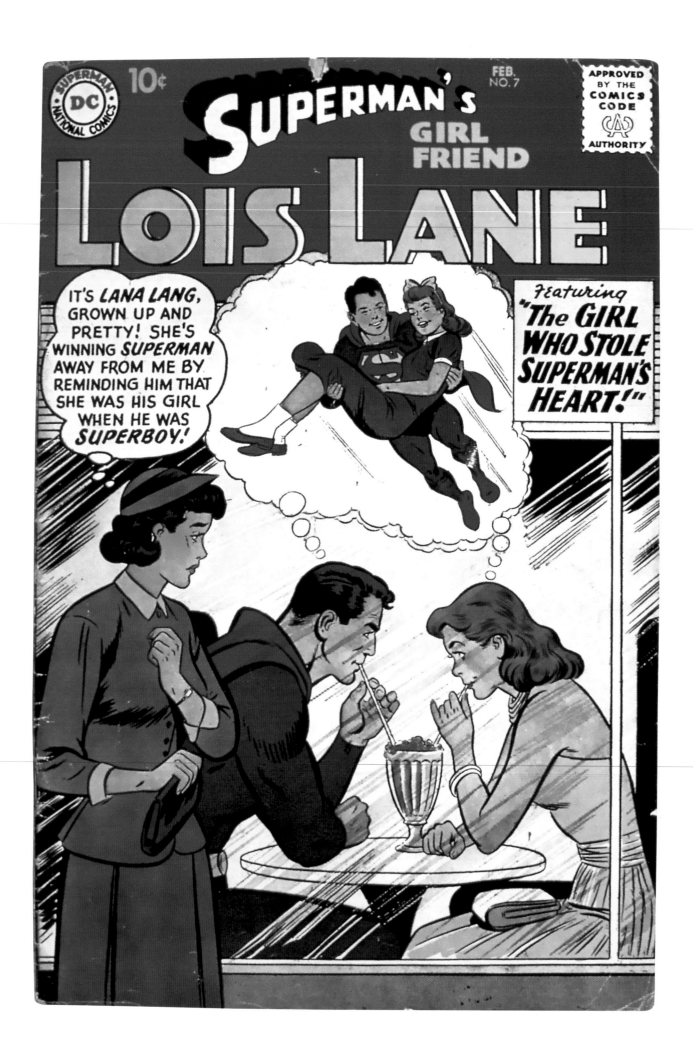

SUPERMAN NATIONAL COMICS · DC ·

GIANT

80 PAGES
25¢

APPROVED BY THE COMICS CODE AUTHORITY

Lois Lane

ANNUAL

Featuring **SUPERMAN'S** GIRL FRIEND IN HER GREATEST ADVENTURES!

LEOPARD GIRL LOIS

LOIS THE MERMAID

BIZARRO LOIS

BABY LOIS

POWER-GIRL LOIS

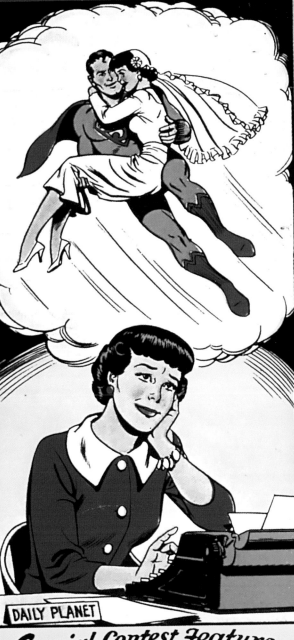

DAILY PLANET

LIEUTENANT LANE

Special Contest Feature...
PICK A NEW HAIR-STYLE FOR LOIS LANE!
PRIZES FOR BEST LETTERS... *SEE INSIDE!*

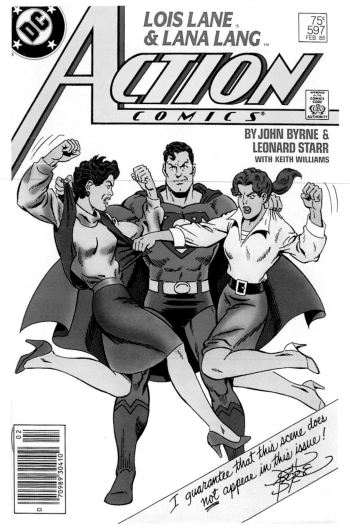

Sure, she preferred Superman to her professional rival, Clark Kent. Who wouldn't? Not only did Lois vie with Clark for those all-important Superman exclusives, Clark was also forced to act less than the hero around her in order to protect his secret identity.

> ### *"Now, if only I'm not discovered I'll be the only reporter in there. Gosh—a scoop—an exclusive!"*
>
> —Lois Lane, *Action Comics* #47 (April 1942)

Though Lois's role was subordinate in the melee of super-powered action, she had a nose for news and was stubborn, smart, and dedicated when it came to getting the story. And if occasionally she got in over her head and had to be rescued, well, that was Superman's job. He was the comic's hero, after all.

Still, in *Action Comics* #60 in 1943, Lois had a dream in which a blood transfusion gave her superpowers—the first appearance of a theme that has recurred over the next sixty years.

After World War II ended, super-hero comics began to lose sales (one quarter of the comics published during the war had gone to the GIs overseas). And DC Comics searched for ways to entice new readers. One idea was to appeal to younger fans by introducing kid versions of adult characters. Superboy first appeared in *More Fun Comics* #101 (January–February 1945). By issue #104 he was featured on the cover. In 1948, a story ran in *Adventure Comics* #128 in which a young Superboy meets a young Lois Lane. Finally, in 1949, Superboy received his own title.

Superman comics may have been in a temporary decline, but Superman continued to be hugely popular in other mediums.

> ### *"Superman . . . who, disguised as Clark Kent, mild-mannered reporter for a great metropolitan newspaper, fights a never ending battle for truth, justice, and the American way."*
>
> —From the opening of the classic *Adventures of Superman* television show

The late-1940s and early-1950s movie serials were followed by the hit *Adventures of Superman* television show, which premiered on September 19, 1952. Starring George Reeves as Superman, and with Phyllis Coates as Lois Lane for the first season (later portrayed by Noel Neill), the series gained immediate popularity. One hundred and four classic half-hour episodes were produced in a syndicated series that is still aired around the world today.

In 1950, Mort Weisinger was hired by DC Comics to oversee Superman's adventures, including giving input to the television show. Trying to bolster the comic's sagging sales, Weisinger focused on Superman's appeal to kids. One way of doing this, he believed, was to create more stories featuring young protagonists.

SUPERMAN'S GIRL FRIEND LOIS LANE

FEB.
NO. 15

10¢

SUPERMAN DC NATIONAL COMICS

APPROVED BY THE COMICS CODE AUTHORITY

This Super-Wedding is *REAL!*

The marriage is not a *HOAX!*
The bride and groom are not *ROBOTS!*
This romance is not a *DREAM* of LOIS LANE or SUPERMAN!

A *Great* 3-PART NOVEL!

"*The SUPER-FAMILY of STEEL!*"

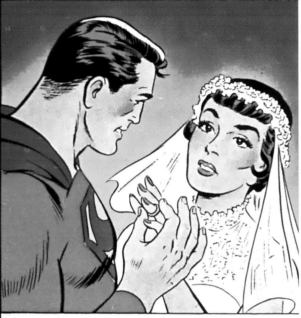

Part 1-- SUPER-HUSBAND *and* WIFE

Part 2-- The BRIDE GETS SUPER-POWERS

Part 3--SUPER-BABES *of the* SUPER-PARENTS

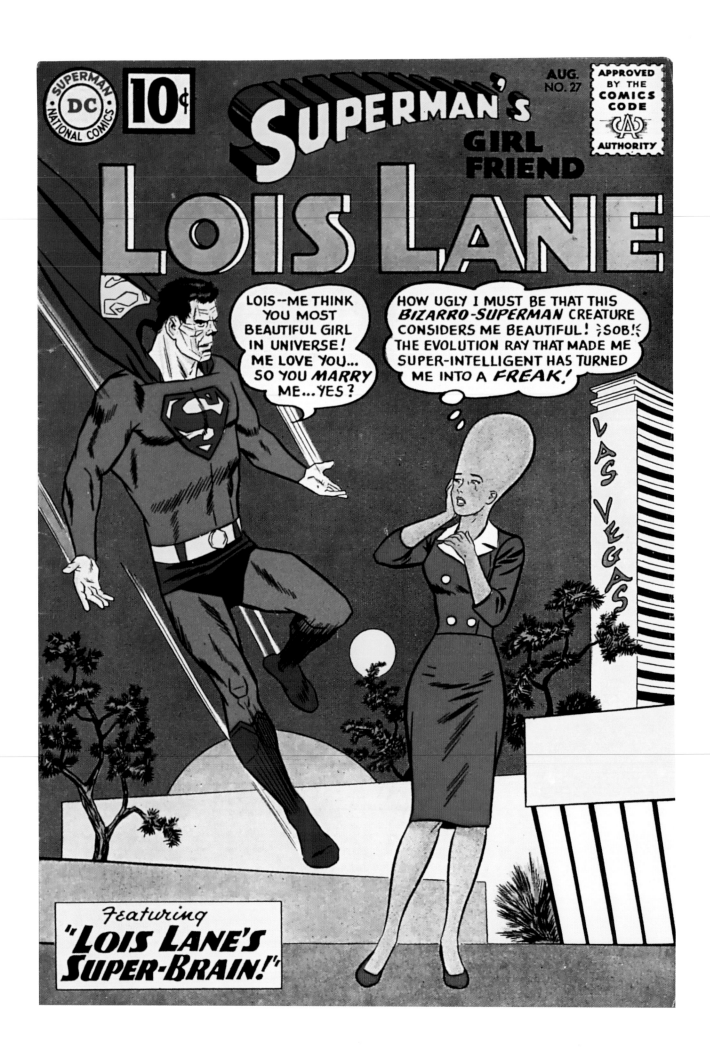

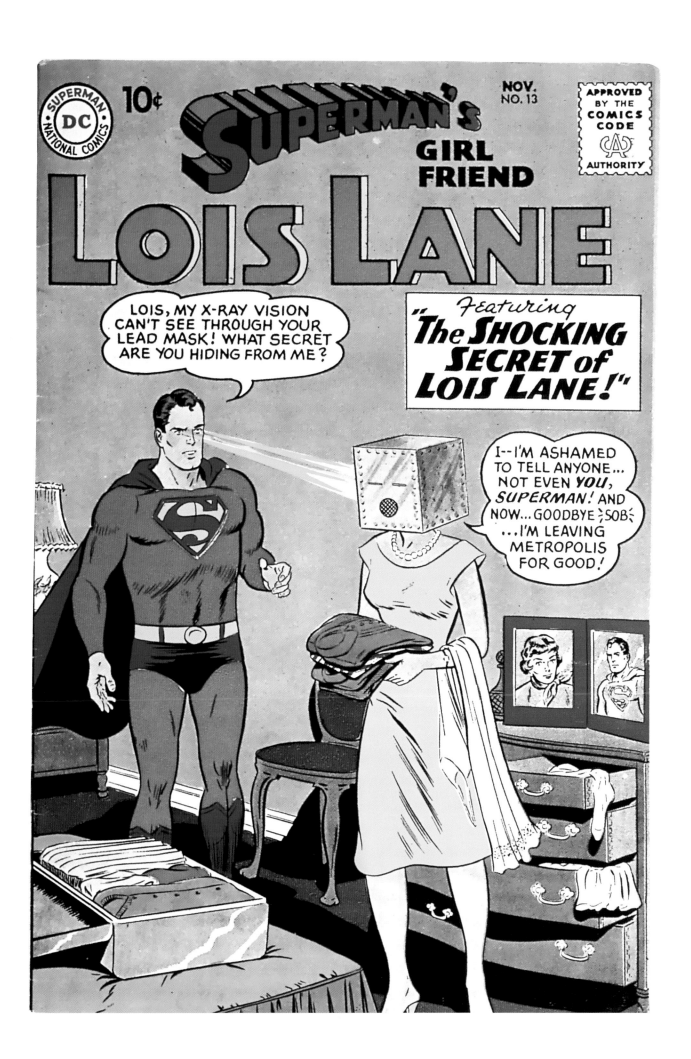

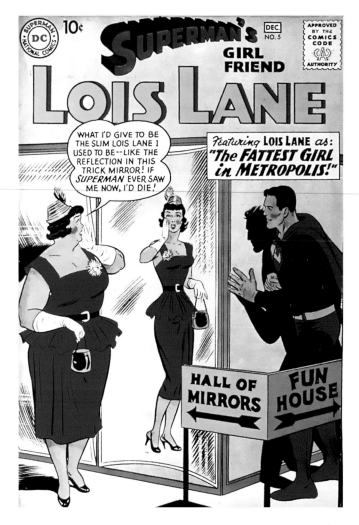

above
Superman's Girl Friend Lois Lane #5 — November–December 1958
Pencilled by Curt Swan, inked by Stan Kaye
While investigating a murder, Lois is hit by a size-altering ray. Little
does she know that Superman arranged the temporary disguise to
protect her from a killer.

opposite
Superman's Girl Friend Lois Lane #80 — January 1968
Pencilled by Curt Swan, inked by Neal Adams
Say it ain't so! A bit of the first page shows through a "hole" Lois has
ripped in the cover, as our exasperated covergirl splits up with
Superman and prepares to leave Metropolis forever!

page 78
Superman's Girl Friend Lois Lane #27 — August 1961
Pencilled by Curt Swan, inked by Stan Kaye
The "intelligence of hundreds of people" is accidentally inserted into
Lois's brain, causing this bizarre malformation. While Lois waits for
the effect to wear off she attracts the attention of Bizarro,
the Superman of a strange and backwards dimension.

page 79
Superman's Girl Friend Lois Lane #13 — November 1959
Pencilled by Curt Swan, inked by Stan Kaye
Yet another strange image created to catch readers' attention:
Lois with a lead-lined box encasing her head! When she finally
removes the box, she looks completely normal. She had been
hypnotized into believing she had the head of a cat.

In *Superboy* #10 (September–October 1950), Weisinger
introduced Lana Lang, Superman's childhood sweetheart, whose
presence would haunt "Superman's Girl Friend Lois Lane" over
the next forty years.

Influenced by the popularity of the television show's Jimmy
Olsen, Weisinger gave Superman's Pal Jimmy Olsen his own title
in the fall of 1954.

In March 1958, Lois Lane received her own title when *Superman's Girl Friend Lois Lane* #1 hit the newsstands.

"I . . . I wish I were more than a close friend . . . His wife! >sigh<

—Lois Lane, *Action Comics* #245 (October 1958)

Drawn by artist Kurt Schaffenberger and written by various
writers under the tight control of Mort Weisinger, *Lois Lane* was
designed to be a female-friendly subset to the Superman comics.
Lois Lane was a goofy pseudo-romance anthology filled with gim-
micks and "imaginary stories" which often focused on Lois's rivalry
with Superman's former girlfriends Lana Lang and the mermaid
Lori Lemaris. Lois's obsession had shifted from getting the story
to getting her man. There were some "action" stories, and occa-
sionally Lois would develop superpowers or be bizarrely altered
in some way. But the comic's dominant theme was romance and
Lois's dreams of marriage to Superman.

Later in the series, influenced by late-60s-era Women's Lib-
eration and America's awakening social consciousness, Weisinger
tried to create a more current Lois Lane.

"I've the assignment of my life! To get the inside story of Metropolis's Little Africa! I should get the Pulitzer Prize for telling it like it is!"

—Lois, *Superman's Girl Friend Lois Lane* #106 (November 1970)

To signal this change, Lois literally ripped the "Girl Friend"
from the logo of *Superman's Girl Friend Lois Lane* #80, giving
readers notice of a bold new direction for the heroine, including a
new job as a nurse and a new astronaut boyfriend.

The new and modern concept didn't stick, at least not com-
pletely. By *Superman's Girl Friend Lois Lane* #86, Lois was back to
her old habits, fantasizing about marrying Superman.

When Mort Weisinger quit in 1970, his old friend Julius
Schwartz acquired control of the main Superman books, which he
edited through 1985. Editor E. Nelson Bridwell took the subsidiary
titles, including *Lois Lane*. During this period the strange yet well-
meaning story "I Am Curious—Black!" (*Lois Lane* #106, November
1970) by Robert Kanigher and Werner Roth transformed Lois into
a black woman so that she could get the real scoop in Metropolis's
"Little Africa." The same team was responsible for a "bulls-eye" cov-
er (a motif of sorts in super-heroine comics) in a story concerning
the disappearance of Lois's sister in South America.

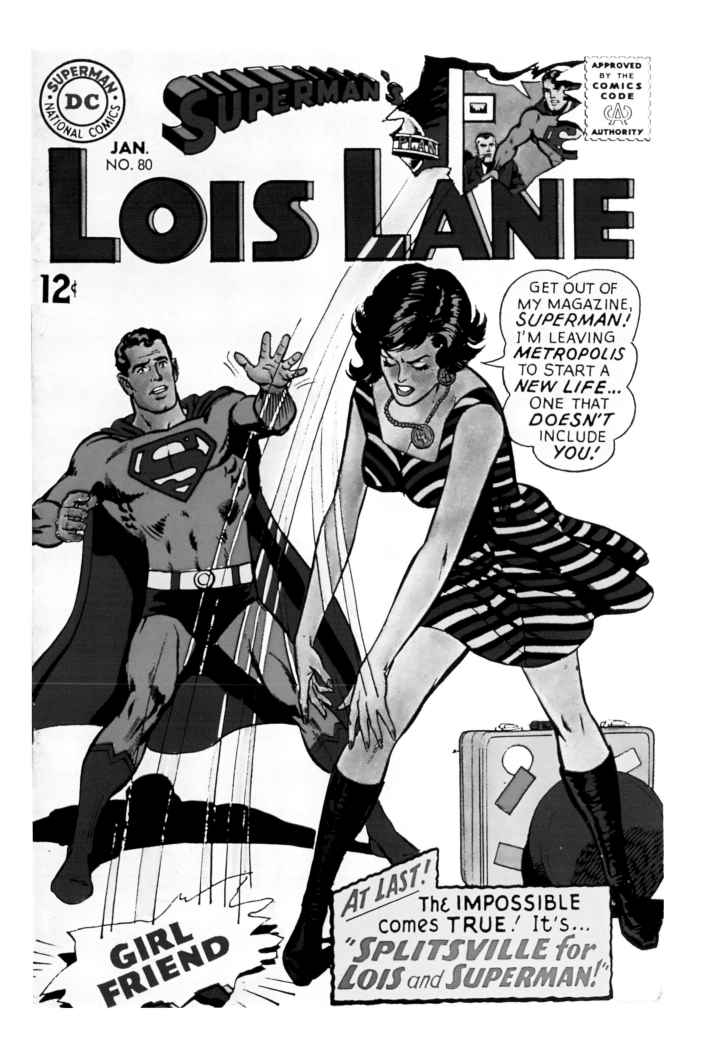

SUPERMAN's GIRL FRIEND
Lois Lane

DC SUPERMAN'S GIRL FRIEND LOIS LANE

NOV. NO. 106 15¢

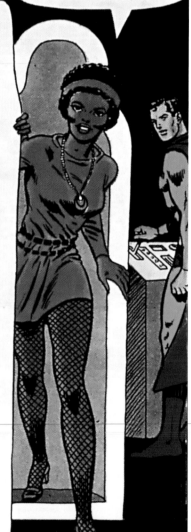

"I AM CURIOUS (BLACK)!"

PLUS ANOTHER EXPLOSIVE ADVENTURE of Rose and the THORN!

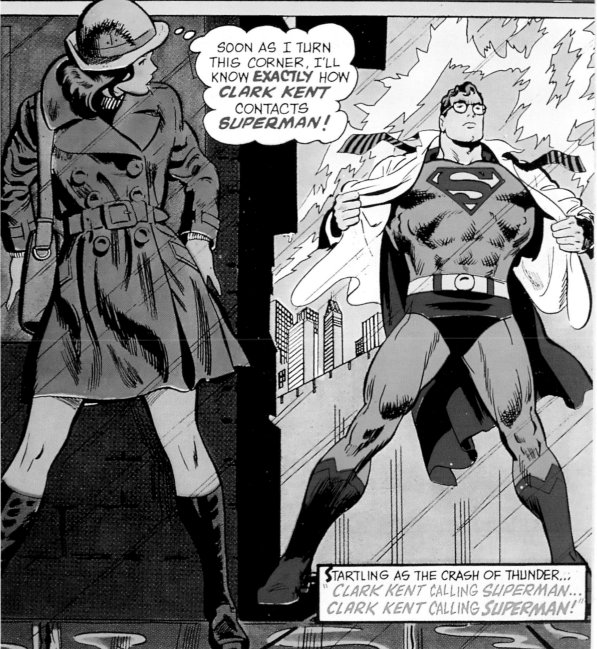

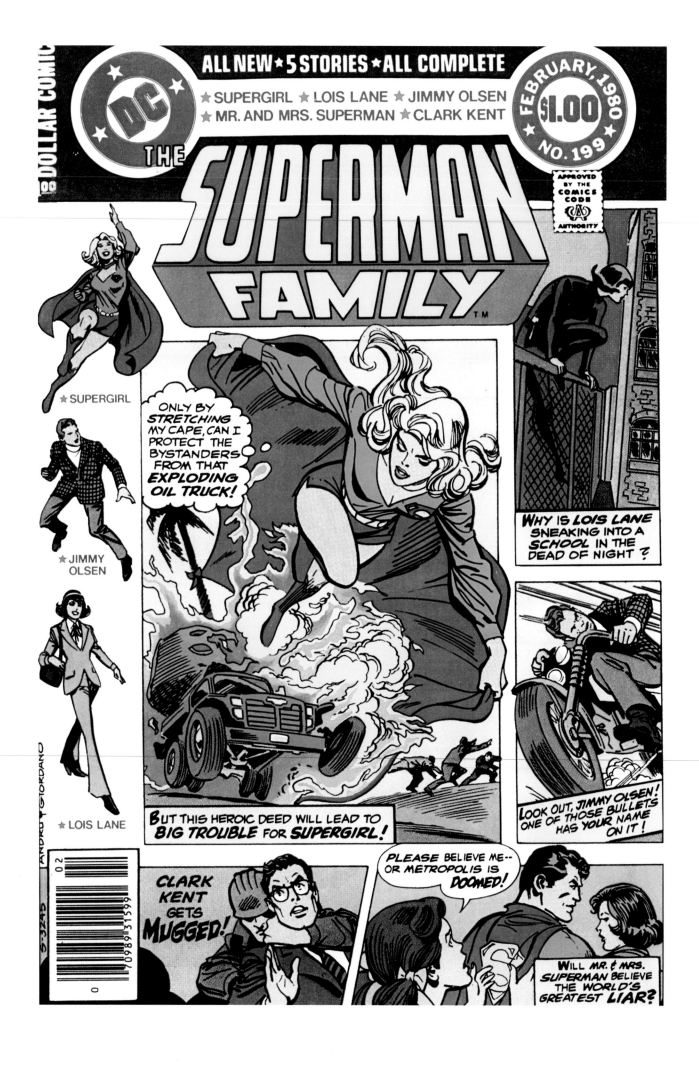

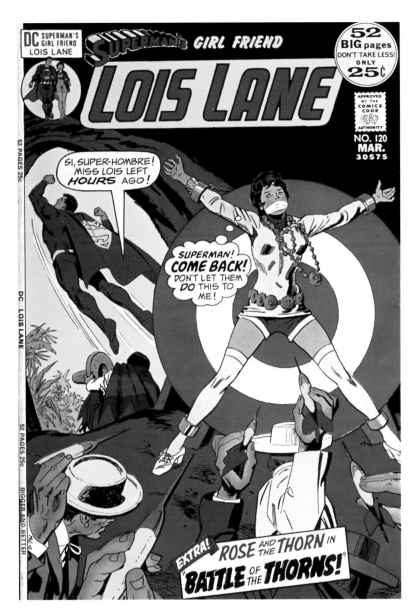

page 82

***Superman's Girl Friend Lois Lane* #106** — November 1970
Pencilled by Curt Swan, inked by Murphy Anderson
Superman uses the Kryptonian Transformoflux to turn Lois into an African American woman so she can get the real story on Metropolis's "Little Africa." This well-intentioned stab at social relevance ends with Lois donating blood to save the story's black protagonist, thus planting the seeds of interracial trust. But as always, the important questions is, "Superman… would you marry me? Even if I'm black?"

page 83

***Action Comics* #446** — April 1975
Art by Bob Oksner
In this story, Communist spies try to learn how Clark Kent summons Superman, but Lois beats them to the punch!

below

***Superman's Girl Friend Lois Lane* #135** — November 1973
Art by Bob Oksner
During the Silver Age, yet another startling cover theme emerged, one that was sure to catch the audience's attention: Lois dying or dead at the hands of Superman.

above

***Superman's Girl Friend Lois Lane* #120** — March 1972
Art by Bob Oksner
With the spotlight off romance, and social issues a minefield, the editors tried to interest the audience in a Lois Lane who was a repeated victim of Superman's inattention. The story inside, however, plays out a little differently, as Lois makes a deal with a manipulative villain, and it is Superman who saves both Lois and the day.

opposite

***Superman Family* #199** — January–February 1980
Pencilled by Ross Andru, inked by Dick Giordano
After the *Lois Lane* series ended, Lois continued her solo adventures in the *Superman Family* anthology comics, though Supergirl usually was the featured star.

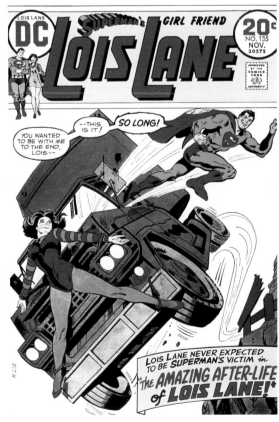

Odd creative choices like these were just one sign that *Superman's Girl Friend Lois Lane* was doomed. In 1974, after 137 issues, Lois's adventures were merged into the newly created *Superman Family* comic, which she shared with Supergirl and Jimmy Olsen.

Still, Lois continued to appear regularly in *Superman* and *Action Comics*.

Then in 1978, the first Superman movie was released, starring Christopher Reeve as Superman and Margot Kidder as Lois. The treatment of Lois was classic—a top reporter, she disdained the nebbish Clark Kent and was besotted with the miraculous Superman. She loved him. He loved her. The romance was magic.

Following in quick succession were *Superman II*, released in 1980, and the less successful *Superman III* (1983) and *Superman IV* (1987).

Spurred partly by the films' popularity, management began to position DC Comics to take advantage of the emerging fan-oriented marketplace.

We won't be apart, Lois. I promise you that. But I have to do this. It's as simple as that.

—Earth-Three's Superman, *Crisis on Infinite Earths* #10 (January 1986)

In 1985 through 1986, DC Comics published a landmark miniseries that changed the way the company viewed story continuity. For years, DC Comics had dealt with storyline inconsistencies by saying they happened on alternate Earths: Earth-One, Earth-Two, and so on.

Crisis on Infinite Earths wiped out all "parallel Earths" and initiated the relaunch of many DC Comics titles. Lois's goofy Silver Age "Girl Friend" adventures disappeared from the Superman continuity as if they had never existed.

The Man of Steel miniseries rebooted Superman under the auspices of writer/artist John Byrne and editor Mike Carlin. Byrne's Lois was, in spirit, not far from the feisty, intelligent Siegel and Shuster character, though Byrne saw a more assured Clark Kent as the book's "real" protagonist and Superman as his alter ego.

Lois was attracted to this stronger Clark, though she was equally attracted to Superman. This shift in character dynamics led to Lois and Clark's engagement in 1990 and Clark's revelation to her that he was, in fact, Superman.

It also influenced the lovers' portrayal in the romantic new hour-long television series *Lois & Clark: The New Adventures of Superman*, starring Dean Cain as Clark and Teri Hatcher as Lois.

In the comics, Lois was a strong presence throughout the popular 1992–1993 "Death of Superman" and "Return of Superman" storylines, reporting the story as Superman fought Doomsday and was killed, mourning his death, and eventually rejoicing in his recovery.

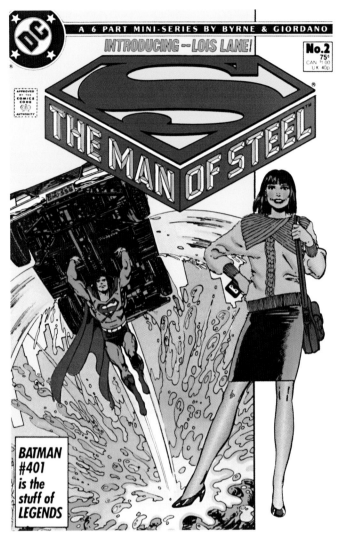

above

The Man of Steel #2 — October 1986
Art by John Byrne
John Byrne's post-Crisis *Man of Steel* reintroduced the Superman cast to the DC Universe, and relaunched the Lois Lane-Superman-Clark Kent romantic triangle.

opposite

Superman: The Wedding Album — December 1996
Art by John Byrne
Finally! Not a hoax! Not a dream! Not an imaginary story! The real wedding of Lois Lane to Clark Kent and, of course, his alter ego Superman.

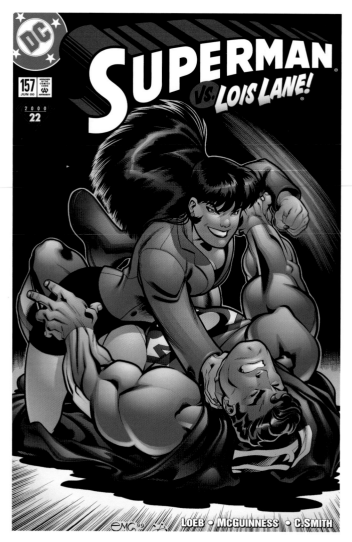

above
Superman #157 — June 2000
Pencilled by Ed McGuinness, inked by Cam Smith
It looks like Lois! It acts like Lois! It even breaks up with Clark like
Lois might conceivably do. But—surprise!—it's really the villainous,
powers-stealing Parasite, masquerading as our heroine so
he can foil Superman.

In 1996, the comic book marriage of Lois and Clark coincided with their marriage in the *Lois & Clark* television series.

This wedded Lois Lane, still an intrepid reporter, continues to share the life and adventures of Superman.

In her dual roles as wife and reporter, Lois has faced super-villains, demons, vampires, and aliens. She was impersonated by the deadly Parasite and was granted godlike powers as the Goddess of Integrity. She vacationed in the Bottle City of Kandor and time-traveled through the Phantom Zone to pre-destruction Krypton. She swung into action to investigate the sale of the *Daily Planet* to an unknown purchaser. And she narrowly avoided death when, on assignment in the Middle East, a sniper's bullet struck her.

> ### "I, Lois, take you, Clark, to be my husband . . . "
> —*Superman: The Wedding Album* (December 1996)

But these new, more complex stories haven't completely erased the nostalgia Superman's creators feel for the simpler tales of Superman's Silver Age. In an affectionate nod to the past, during their time on Krypton, Superman and Lois acquired a super-dog called Krypto. In a later story, they dealt with a rampaging Super-baby, though he proved to be a super-villain in disguise. And, in the retro pastiche *All-Star Superman* #3, Superman's girlfriend Lois Lane became a Kryptonian superwoman once again.

Finally, under the guidance of Executive Editor Dan DiDio, the *Infinite Crisis* storyline brought together the Supermen and Loises from alternate timelines in an epic tale that, along with the new *52* limited series, promised to once again remake the DC Universe—a move that coincided nicely with the 2006 movie, *Superman Returns*.

For a certainty, these events are just the beginning of the further amazing adventures of Lois Lane—and her partner, Superman.

right

Action Comics #662 — February 1991
Pencilled by Kerry Gammill, inked by Brett Breeding
Clark Kent proposed to Lois and she accepted. But he couldn't let
her marry him without revealing his most closely guarded secret.

below

Adventures of Superman #619 — October 2003
Art by Kevin Nowlan
Though Lois and Clark/Superman remain a team, in this issue
they operate in separate spheres: she as an investigative reporter
in Washington, he as a super hero facing one international
crisis after another.

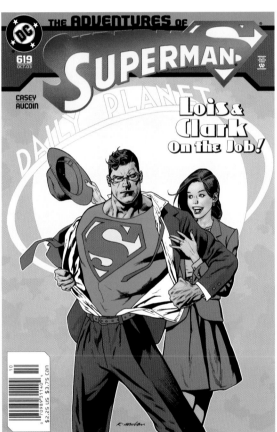

right

Superman (2nd series) #11 — November 1987
Art by John Byrne
Byrne reintroduced Mr. Mxyzptlk, a magical imp from the fifth
dimension with an unpronounceable name, who romanced Lois in
the guise of Ben De Roy and caused a great deal of trouble for
Superman. This cover showcases Byrne's fashionable, confident Lois.

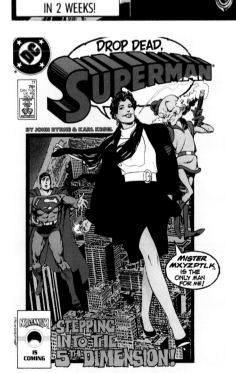

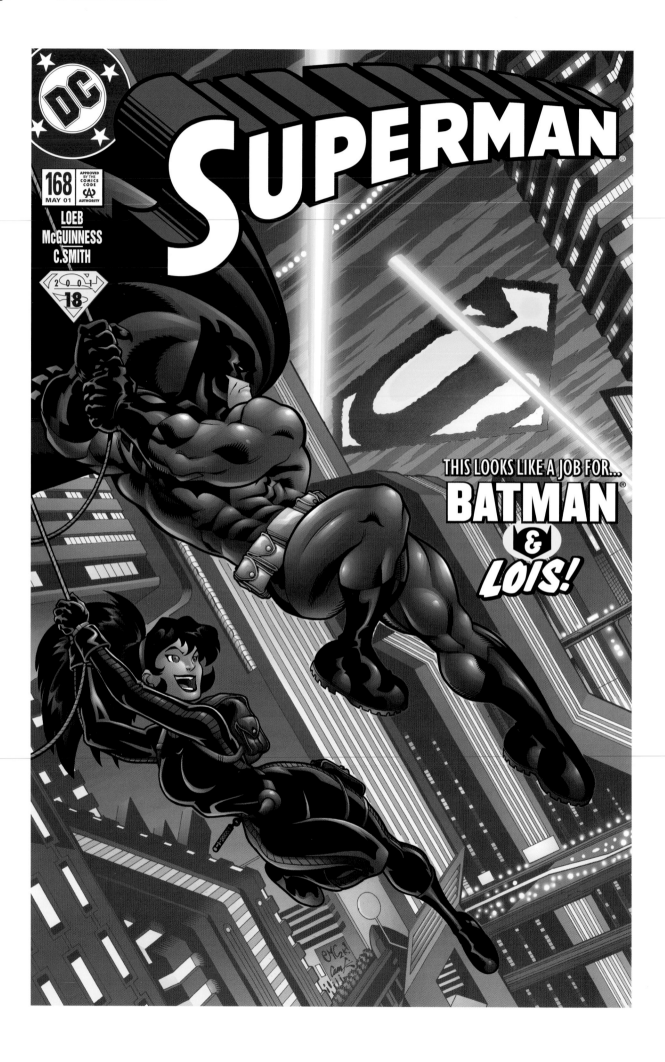

opposite
Superman #168 — May 2001
Pencilled by Ed McGuinness, inked by Cam Smith
Lois Lane joins Batman to retrieve a Kryptonite ring retained by
Lex Luthor—a weapon that could destroy Superman. This
modern, proactive Lois strives to safeguard her man, just as he
has always tried to protect her.

right
All-Star Superman #3 — May 2006
Art by Frank Quitely
In this series, writer Grant Morrison plays with Silver Age
concepts to create a timeless Superman story. Here we revisit the
theme of a superpowered Lois Lane.

below
Adventures of Superman #632 — November 2004
Art by Gene Ha
Lois, working as a war correspondent in the fictional country of
Sumac, is felled by a sniper's bullet as she tries to rescue an
injured soldier. Too late to stop her injury, Superman leaves a
major battle in Metropolis to rush to her side.

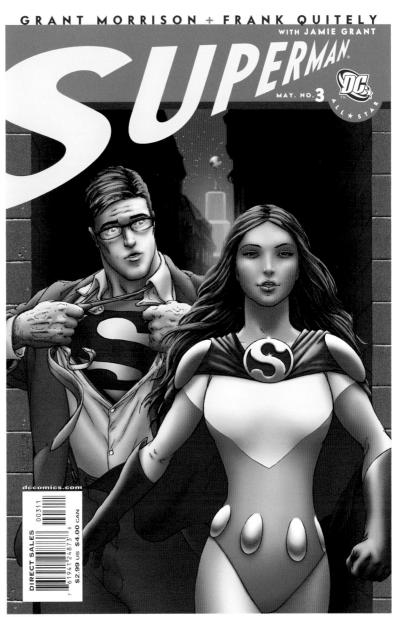

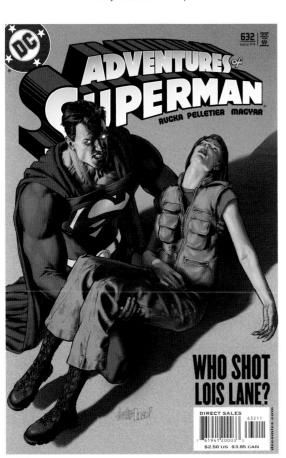

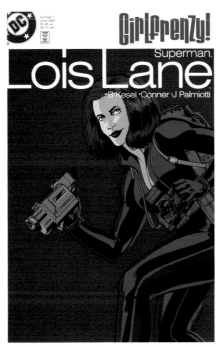

right
Superman: Lois Lane #1 — June 1998
Pencilled by Leonard Kirk, inked by Karl Story
This comic special focuses on Lois Lane, intrepid reporter,
who appears armed and ready for any kind of investigative
journalism that might be required.

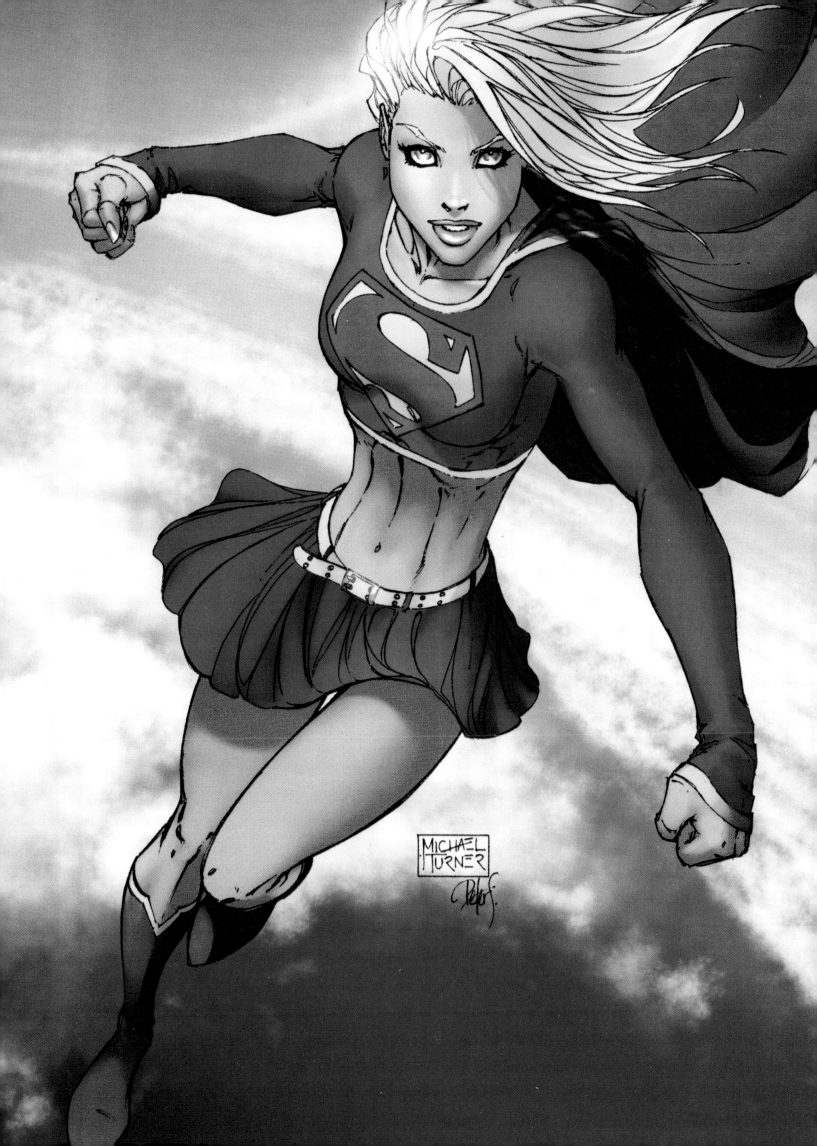

"Who am I?"

—Kara Zor-El, the newest Supergirl, *Supergirl (4th series)* #1
(October 2005)

above

Superman Adventures #21 — July 1998
Art by Bruce Timm
On *Superman: The Animated Series,* Supergirl came from Argo,
a sister world of Krypton that was destroyed in the same cataclysm.

opposite

Action Comics #252 — May 1959
Pencilled by Curt Swan, inked by Al Plastino
An eight-page story introduced Superman's cousin, Kara Zor-El,
the first Supergirl—but not the last!

Four major comic book characters have borne the name Supergirl: two have had the Kryptonian name Kara Zor-El and one is a melding of two other characters. To make the situation even more perplexing, several have had Linda Danvers as their alter egos. (A fifth major character, Power Girl, has similar powers and a parallel origin but—thank heaven!—a different name.)

Then, of course, there's the movie *Supergirl,* not to mention Supergirl from television's *Superman: The Animated Series.*

This confusing situation—to non-comic aficionados, anyway—came about through the typically messy interaction of real life and fiction.

From Superman's debut in 1938, comics featuring the Man of Steel sold like hotcakes. Superman's story was repackaged in other media and licensed incessantly. The Man of Steel was an entertainment and financial powerhouse.

But after World War II, sales of the *Superman* titles dropped off, though the radio and movie serials were still going strong.

Attempting to increase the comics' appeal to Superman's perceived kid audience, DC Comics began to recount the adventures of the teenaged Superman, called Superboy. The character proved to be so popular that, in 1949, he was given his own eponymous title.

Mort Weisinger, then editor of the Superman titles, felt the best way to keep the attention of a kid audience was to frequently introduce new, often fantastical variations on the Superman concept, similar to Superboy.

In *Superboy* #8 (May–June 1950), readers met the toddler Clark as Superbaby. In 1955, Krypto the Super-Dog arrived on Earth. Over the next few years, Superman and Superboy battled villainous Kryptonian super-apes. Then, in 1958, the Bottle City of

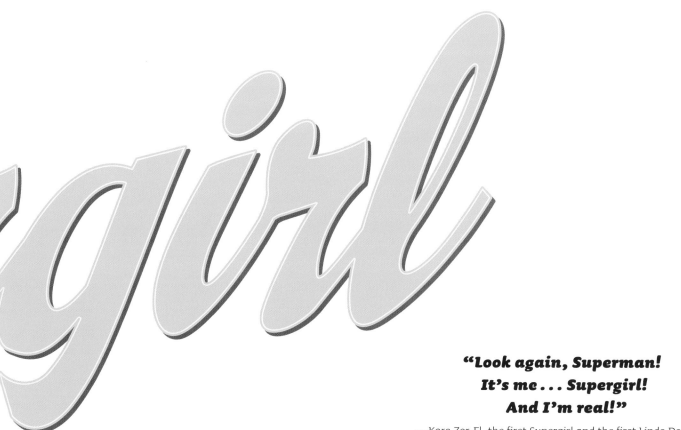

Kandor, a living Kryptonian city miniaturized by an evil scientist and preserved in a bottle, made its debut.

Finally, in 1959, in a bid to attract more girl readers, Weisinger introduced the first Supergirl.

Weisinger had been looking for a way to hold reader interest in the Superman comics, but in **Supergirl** (originally written by Otto Binder and drawn by Al Plastino) he hit upon a phenomenon who soon acquired a fan-base in her own right.

Kara Zor-El burst from a crashed rocket ship in *Action Comics* #252. She came from Argo City, a small chunk of the planet Krypton, which had been blown into space when Superman's home world exploded. Years later, when the citizens of Argo City began to die from exposure to poisonous green kryptonite, her scientist parents sent her to Earth in a rocket, hoping her first cousin Superman would look out for her.

Upon exposure to Earth's yellow sun, she manifested Superman-like superpowers.

Kara developed the secret identity Linda Lee, an orphan living at Midvale Orphanage. She was eventually adopted and took her new parents' last name, Danvers. When she wasn't acting as Superman's teenage sidekick, she hid her blonde hair beneath a brown wig to protect her secret identity.

In 1959, the same year that Beppo the Super-Monkey first appeared, Supergirl acquired her superpowered pet cat, Streaky.

Soon, she was traveling into the future to join the Legion of Super-Heroes, a thirtieth-century club of superpowered teenagers. In 1962, Comet, a flying super-horse, arrived.

In her free time not spent on superpowered adventures with Superman, Kara/Linda/Supergirl graduated from high school and entered college. Supergirl may have fought evil wherever she

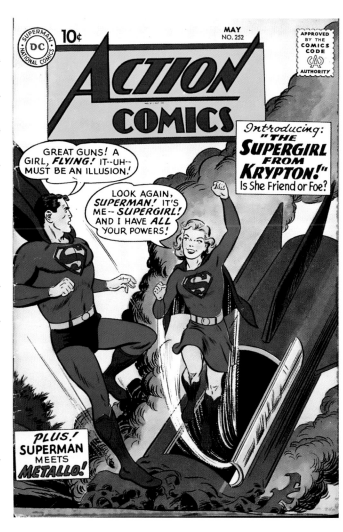

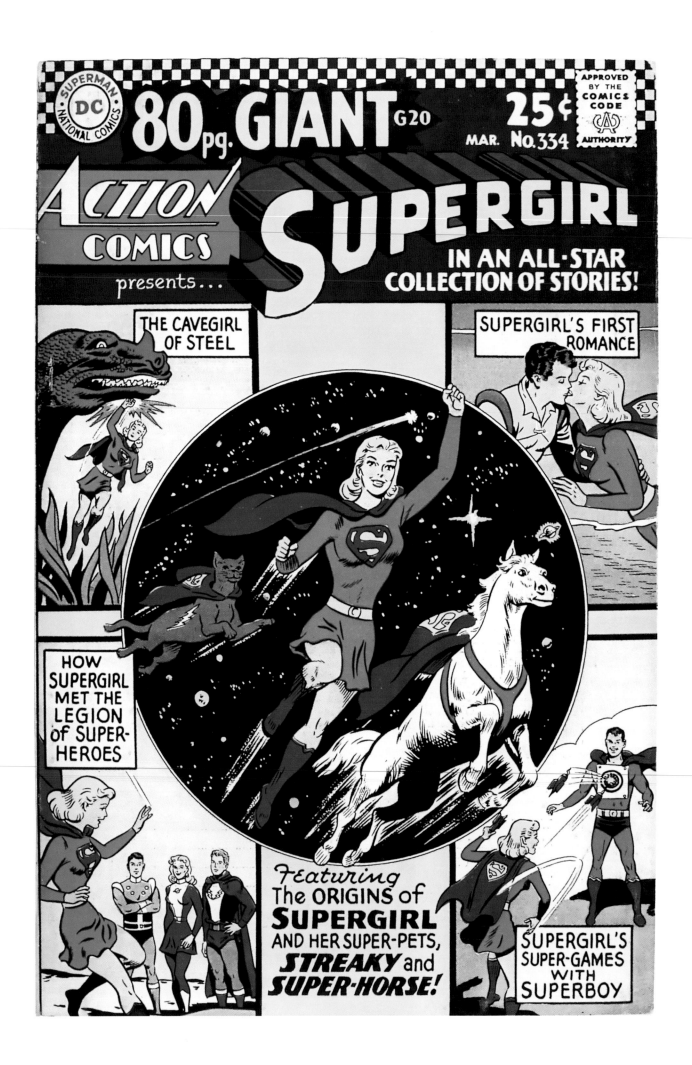

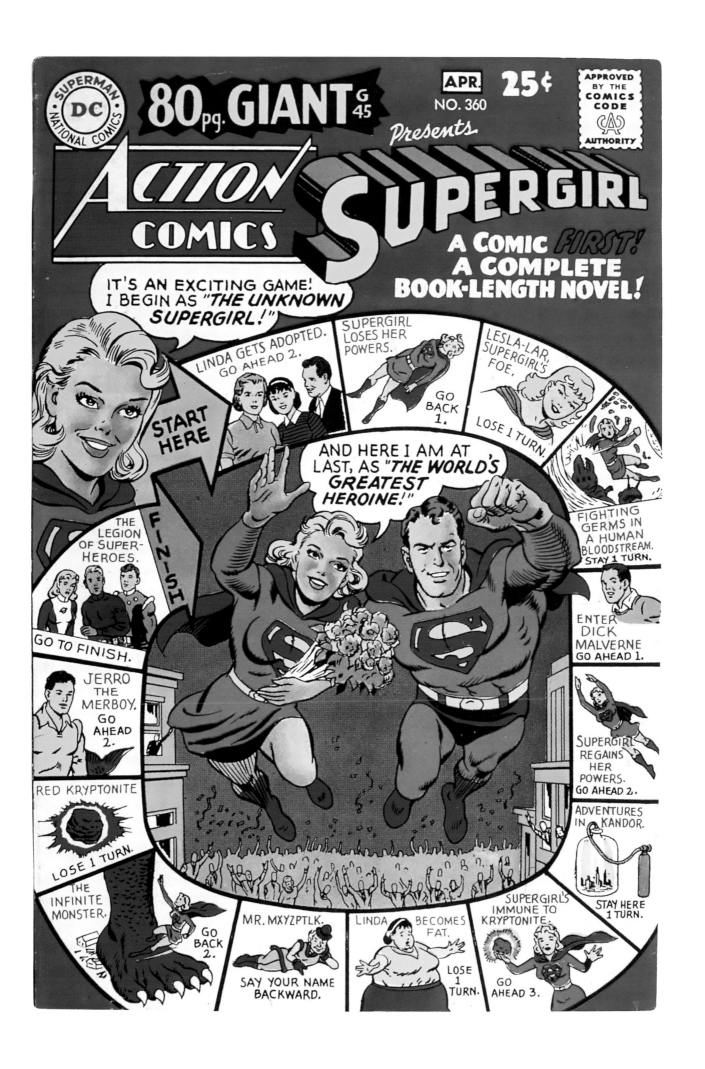

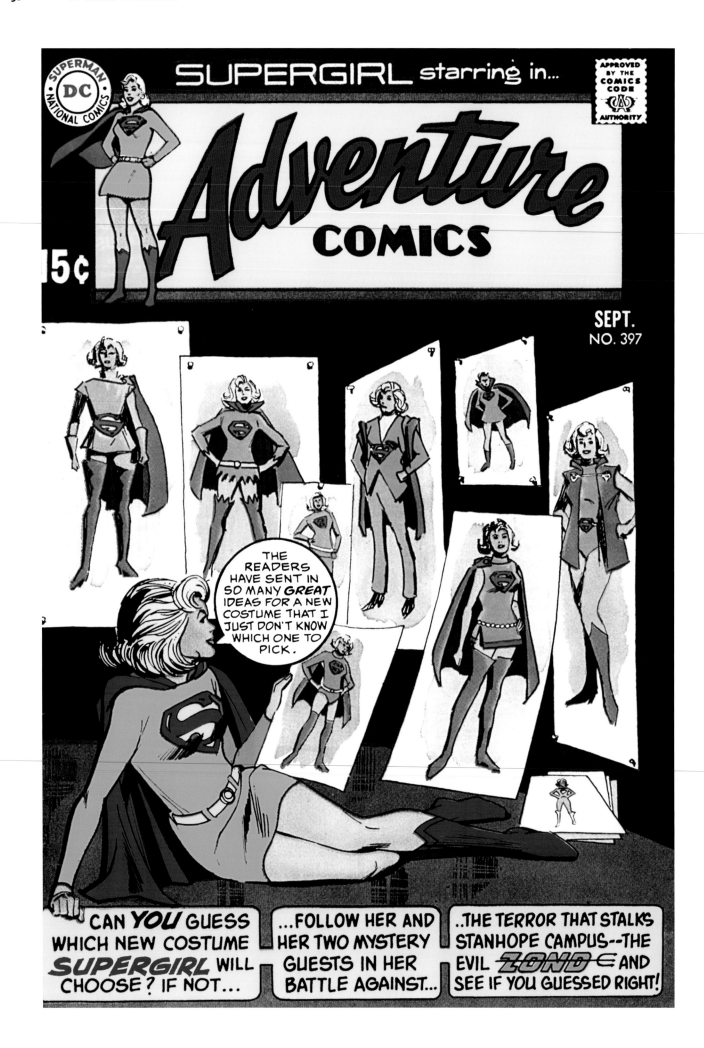

found it, but her stories were as much about romance and fashion as adventure.

In 1970, editor Mort Weisinger retired. Soon Supergirl was in the capable hands of editor Julius Schwartz. And in November of 1972, Supergirl transferred to Vandyre University in San Francisco and finally got her own monthly title. Unfortunately, it lasted only ten issues. In 1973, *Supergirl* was absorbed, like *Superman's Girl Friend Lois Lane* and *Superman's Pal Jimmy Olsen*, into the new *Superman Family* anthology comic.

In 1982, prompted by Hollywood's interest in producing a *Supergirl* movie, DC Comics launched a second Supergirl series, *The Daring New Adventures of Supergirl*. But the *Supergirl* movie was not a critical or commercial success.

Triggered in part by the movie's failure and by plans for an upcoming miniseries that would redefine Superman as the sole survivor of the planet Krypton, DC Comics cancelled the second *Supergirl* series at the end of 1984. And then Supergirl died.

"Y-you're crying . . . please don't. You taught me to be brave . . . and I was . . ."

—Supergirl, *Crisis on Infinite Earths* #7, (October 1985)

From the early 1960s, DC Comics had developed the multiverse, a system of parallel Earths on which alternate versions of many DC Comics characters existed.

In 1985, the twelve-part *Crisis on Infinite Earths* miniseries by Marv Wolfman and George Pérez appeared. In it, the evil Anti-Monitor began to destroy all the parallel Earths, one by one.

In *Crisis* #7, Supergirl was killed, heroically sacrificing herself to save Superman and protect the multiverse.

By the time *Crisis* ended, only Earth-Prime remained. Supergirl had been wiped from the memories of the remaining DC Comics characters as if she had never existed.

But she couldn't be wiped from the minds of the fans who adored her and demanded she be brought back—again and again—until they got it right.

In 1986, John Byrne's eagerly anticipated six-issue *The Man of Steel* limited series retold Superman's story as it would have unfolded had the alternate Earths never existed—which, for continuity purposes, they hadn't. He reintroduced the Superman cast to a modern audience and the Superman stories continued into three, then four, then five different Superman titles.

I . . . am . . . the Matrix. In this form . . . I am called . . . Supergirl!

—Matrix, The Protoplasmic Supergirl, *Action Comics* #674 (February 1992)

In 1988's *Superman (2nd series)* #16, a benevolent Lex Luthor from a pocket universe created the Matrix, a proto-matter shapeshifter with telekinetic powers, who he hoped would save his world from an invasion of evil Kryptonians. Luthor called his Matrix "Supergirl" and sent her to Earth-Prime to get Superman's help.

above

Supergirl (1st series) #3 — February 1973
Art by Bob Oksner
In this classic romance/adventure dilemma, Supergirl saves a man's life and foils a couple of bad guys, but loses her date to the big party. That is so not fair!

opposite

Adventure Comics #397 — September 1970
Pencilled by Mike Sekowsky, inked by Dick Giordano
When Supergirl's costume is shredded in battle, she gets a new one at Diana Prince/Wonder Woman's boutique.

page 96

Action Comics #334 — March 1966
Pencilled by Curt Swan, inked by Sheldon Moldoff
During this period, Super-Pets abounded. Superboy had Beppo the Super-Monkey. Supergirl had Streaky the Super-Cat and Comet the Super-Horse. And Superman had Krypto the Super-Dog, the only Super-Pet to survive in modern continuity.

page 97

Action Comics #360 — March 1968
Pencilled by Curt Swan, inked by George Klein
Supergirl's early perils and adventures are highlighted on this "game board" cover. With all she's been through, she deserves those flowers!

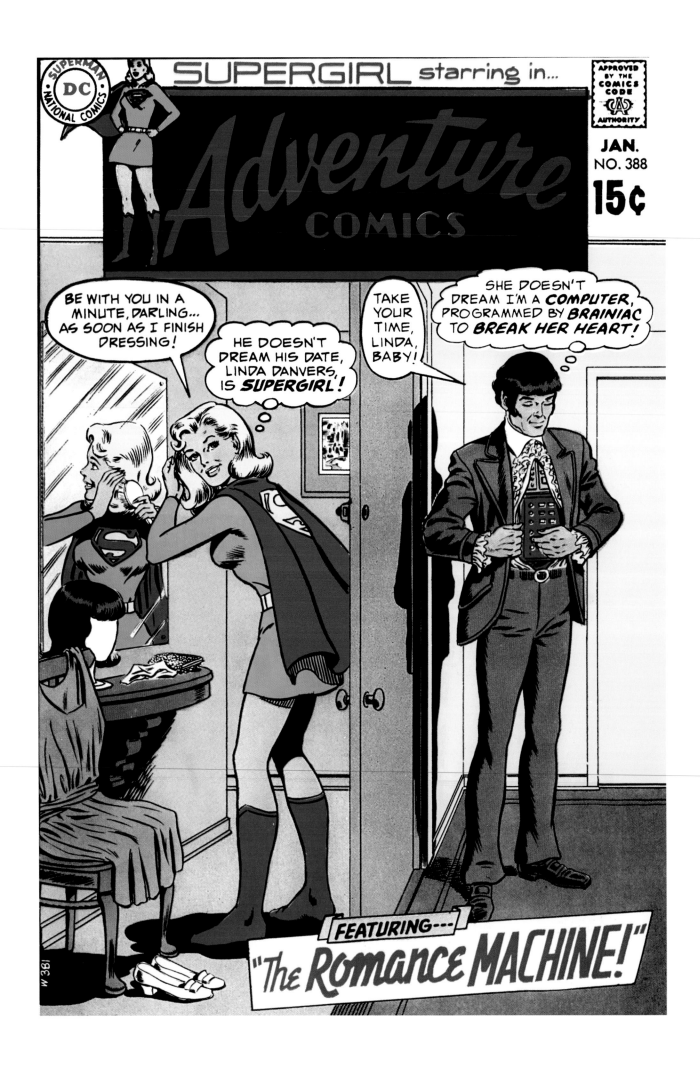

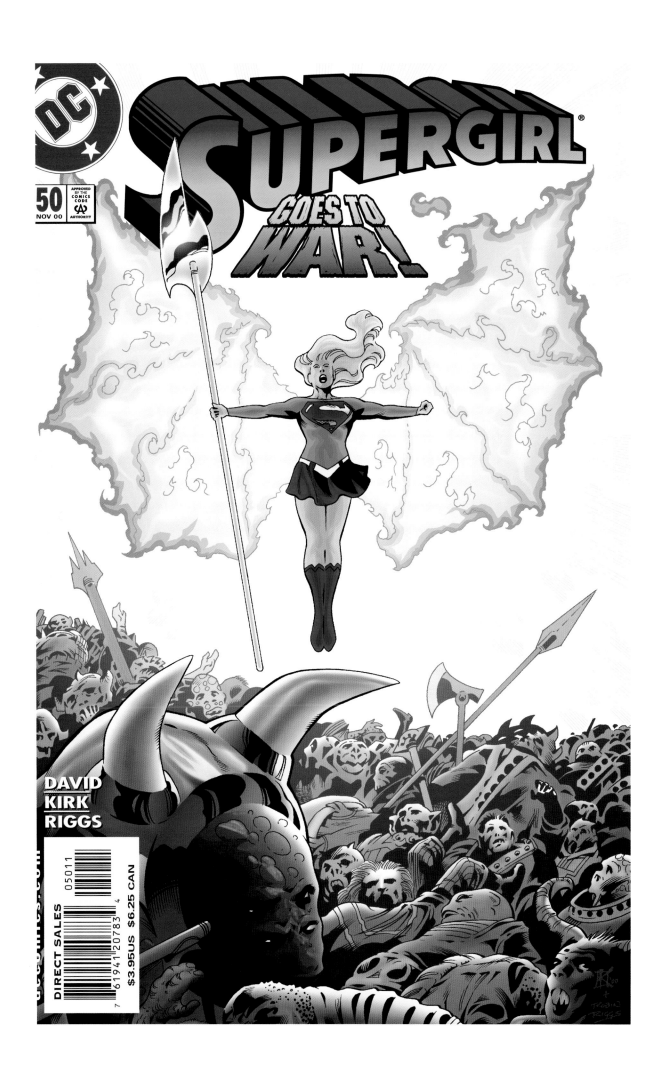

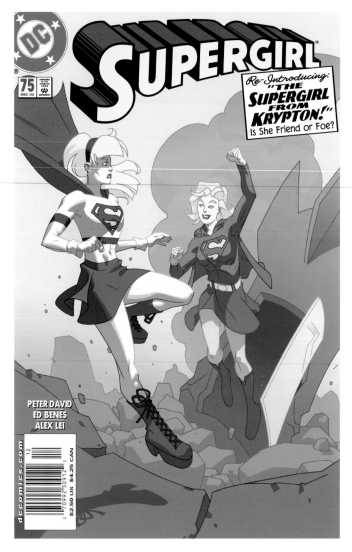

above

Supergirl (3rd series) #75 — December 2002
Art by Rob Haynes
Here's another cover where Supergirl meets a different incarnation of
herself. Due to a time anomaly, Linda Danvers/Supergirl meets
Superman's cousin Kara, the original pre-Crisis Supergirl.

opposite

Supergirl (3rd series) #1 — September 1996
Pencilled by Gary Frank, inked by Cam Smith
Human girl Linda Danvers melds with Matrix and magic and
becomes a demon-fighting Earthborn Angel in Peter David's unique
take on the Supergirl myth.

page 100

Adventure Comics #388 — January 1970
Pencilled by Curt Swan, inked by Murphy Anderson
The "He/She doesn't know..." cover is another comic book staple,
used here as a romance cover with a science-fiction twist.

page 101

Supergirl (3rd series) #50 — November 2000
Pencilled by Leonard Kirk, inked by Robin Riggs
Linda Danvers/Supergirl, as the Earthborn Angel of Fire, battles
demon hordes in the realm between Heaven and Earth.

On Earth, the Matrix morphed into a guise much like
the original Supergirl's. But, despite Superman's aid, her pocket
universe was destroyed. Realizing that Earth-Prime's Lex Luthor
was a villain, she declined to work for him, choosing instead to join
the group of teenage super heroes known as the Teen Titans.

Then, in September of 1996, in a story written by Peter
David and drawn by Gary Frank, a new Supergirl appeared.

"We are as one . . . my morphing body, somehow joined with that of Linda Danvers."

—Linda Danvers, Earth-Born Angel,
Supergirl (3rd series) #1 (September 1996)

Each new creative team put its own spin on Supergirl. While
the Matrix/Supergirl was a creature of science fiction, David's
Supergirl was a child of the supernatural.

In this continuity, troubled teenager Linda Danvers had run
afoul of a demon. This fiend was in the middle of sacrificing Linda to
the monstrous Lord Chakat when Matrix/Supergirl arrived.

Too late to save the teenager, Matrix reached out to her as
she died and merged with her, body and soul. Matrix/ Supergirl
and Linda Danvers combined to form a single entity. And the new
Supergirl—also know as the Earth-Born Angel of Fire—was created.

While there was once again a Supergirl with the secret iden-
tity of Linda Danvers, mixing the Matrix's powers and science-
fiction origin with the supernatural storyline of Linda Danvers led
to some new variations in the Supergirl continuity. She fought
demons, lost her powers, and in the end the Matrix and Linda
Danvers were separated, leaving Linda as a more ordinary human
version of Supergirl.

"But it was supposed to be all . . . all fun! And helping people! I . . . I . . . want to live. I don't want to go and die."

—The original Supergirl to Supergirl/Matrix,
Supergirl (3rd series) #78 (March 2003)

Then, due to a dimensional distortion, Linda Danvers/Su-
pergirl met Kara, the original Kryptonian Supergirl. Realizing Kara
was doomed to die (and in fact had already died in *Crisis*) Linda
tried to take her place in the battle against the Anti-Monitor. But
in the end, events progressed as they were foreordained and,
once again, Kara died.

Linda returned to our Earth, where she gave up being Su-
pergirl. Finally, she disappeared from reality as had the previous
Linda Danvers, this time as part of the events in the unfolding
Infinite Crisis saga.

In 2004, in the *Superman/Batman* series, a second Kara Zor-
El arrived on Earth. And, like the original Kara, she was Superman's
cousin. As a teenager on Argo City, she was placed in suspended
animation and sent to Earth in a rocket. But her mission was to
look out for the infant Kal-El as a sort of super-babysitter.

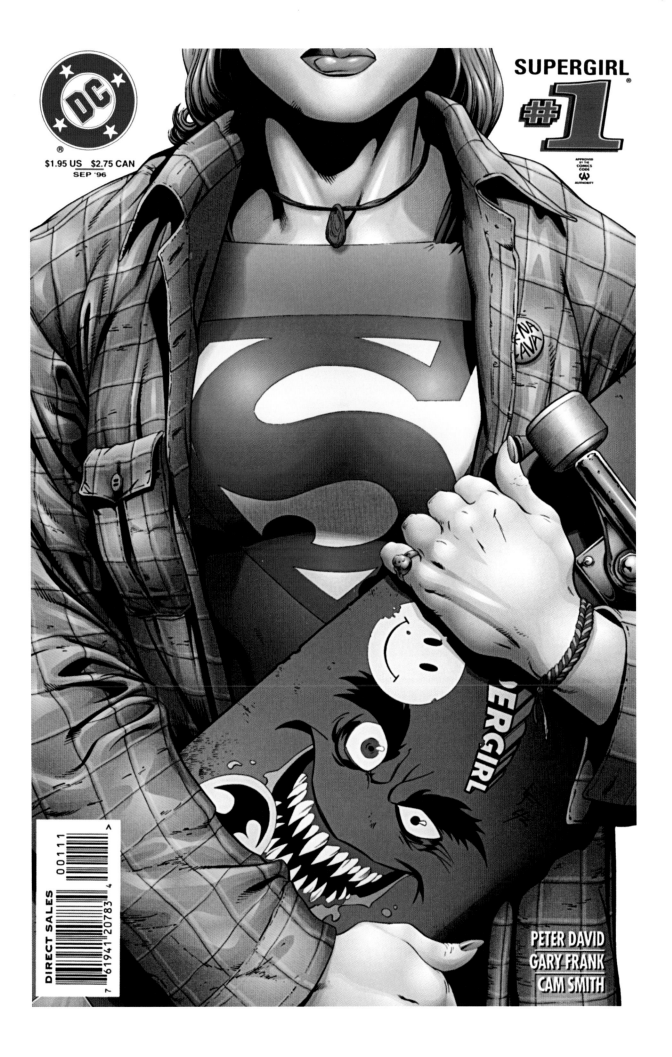

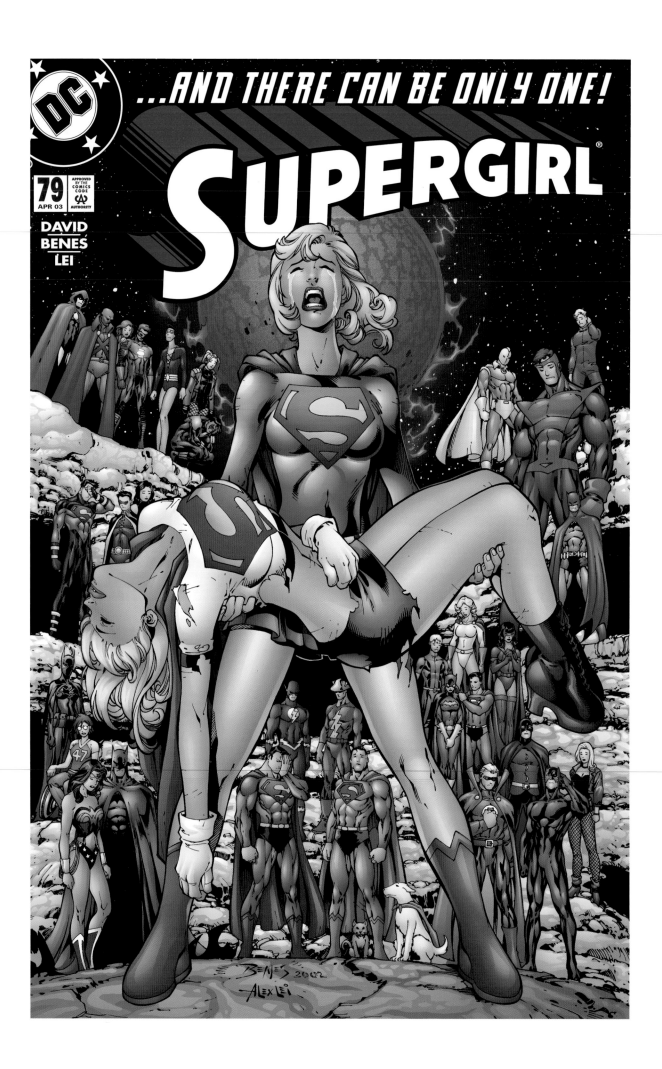

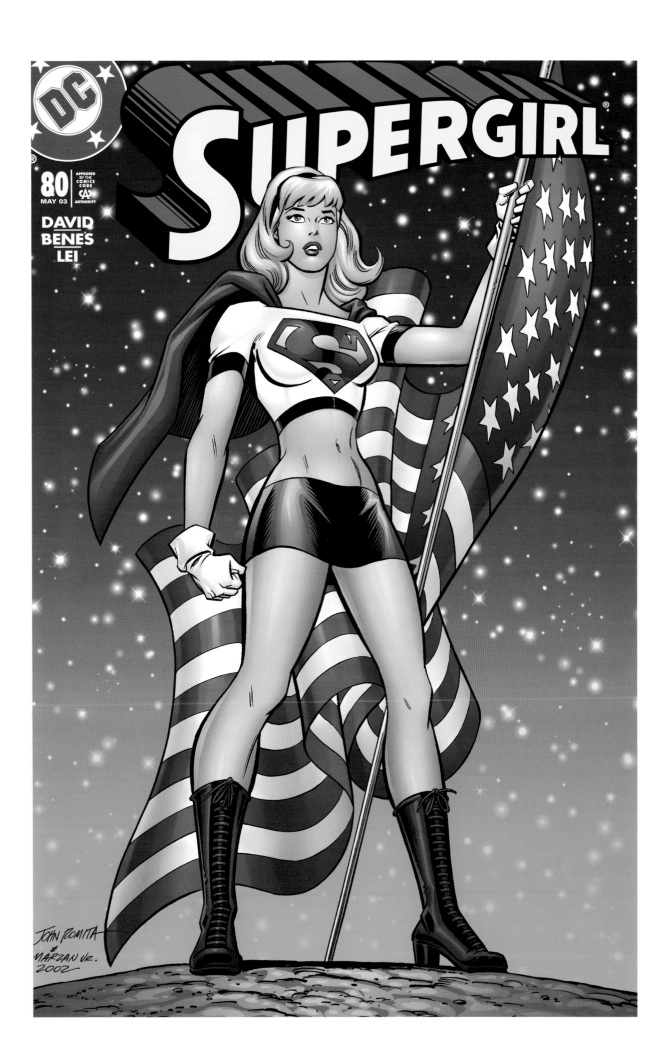

Unfortunately, her ship had an accident and, by the time she awoke on Earth, Kal-El was not only an adult, he was also Superman, Earth's greatest hero.

An amusing modernization of the myth, it retains the true Supergirl spirit. And that's what Supergirl fans want most of all.

There have been other claimants to the Supergirl title—if not in name, at least in spirit.

"What is my future? Or more important . . . where is my past?"

—Power Girl, *JSA Classified* #1 (July 2005)

In 1976, Power Girl was introduced in *All-Star Comics* #58. She, too, was Superman's Kryptonian cousin, but she came from an alternate Earth.

When, in 1985, DC Comics' system of parallel Earths was destroyed, most of the characters who lived on them winked out of existence. But some few who should have disappeared mysteriously remained. Power Girl was one of these.

Left weakened and with amnesiac confusion, she fought her way toward an almost unfathomable truth—that she is, indeed, Superman's cousin and one of the few survivors of a destroyed universe.

"I do remember! I'm not alone!"

—Power Girl, *Infinite Crisis* #2 (January 2006)

Others among the young, female, and superpowered have also been called supergirls, if only with a small "s." *Action Comics* featured three of these Supergirls: Traci Thirteen, a teenage sorceress; Natasha Irons, a girl in an armored shell; and Cir-El, another Supergirl-refugee from a timeline that no longer exists.

The first Supergirl was originally introduced to entertain a young audience with a female version of Superman. Though some of Supergirl's incarnations have endured bizarre plotlines and dubious fashion choices, all have had beauty, courage, intelligence, and power. Each was a heroic young woman, worthy of the mantle of Superman.

Icon for each new generation, time and again Supergirl has returned like a phoenix from her own ashes, stronger, brighter, and ready to protect the weak and fight evil wherever it appears.

"This vessel carries my daughter, Kara Zor-El, from the now dead planet Krypton. Treat her as you would your own child for you will see the treasure she will be for your world."

—Inscription on the vessel that took Kara Zor-El to earth, *Superman/Batman* #9 (June 2004)

above

Superman/Batman #12 — October 2004
Art by Michael Turner
The power-mad arch-villain Darkseid kidnaps and ensorcels Kara Zor-El, but she is rescued by her cousin Superman. During a subsequent battle with Darkseid, she fakes her death and disappears to Paradise Island.

opposite

Superman/Batman #24 — January 2006
Pencilled by Ed McGuinness, inked by Dexter Vines
Superman/Batman is an epic series that routinely features numerous guest stars and alternate universe stories. Featured on this cover is just one of the many versions of Supergirl appearing in this issue. (This one calls herself Superwoman.) Also shown here are an alternate version of Batwoman and a different Superboy, called Superlad.

page 104

Supergirl (3rd series) #79 — February 2003
Pencilled by Ed Benes, inked by Alex Lei
Here Linda Danvers mourns the death of the original Supergirl in a cover that repeats the motif of the famous cover for *Crisis on Infinite Earths* #7, which showed Supergirl dead in the arms of a grieving Superman.

page 105

Supergirl (3rd series) #80 — May 2003
Pencilled by John Romita, inked by Jose Marzan Jr.
This final cover of the second *Supergirl* series is similar in design to the cover of *Supergirl (2nd series)* #13.

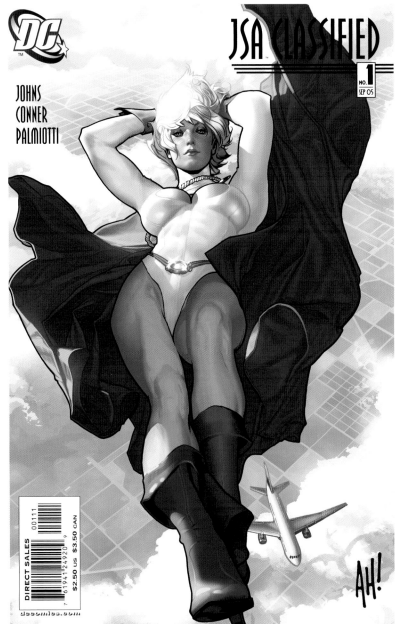

opposite

JSA: Classified #4 — December 2005
Pencilled by Amanda Conner, inked by Jimmy Palmiotti
Amanda Conner's amusing cover emphasizes
Power Girl's pugnacious attitude as well as her revealing costume.
She'll need that toughness for the story inside, when the Psycho
Pirate reveals the truth about her origin.

right

JSA: Classified #1 — July 2005
Art by Adam Hughes
Power Girl has always been one of the strongest super heroines in
the DC Comics universe, with a revealing costume that's belied by
her strong, stubborn personality. Here, beautifully rendered by Adam
Hughes, she literally floats on air.

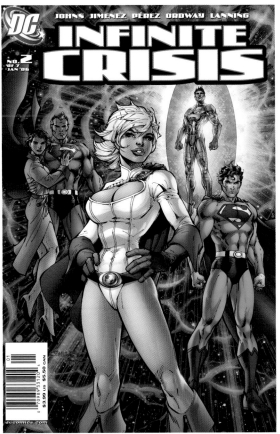

left

Infinite Crisis #2, Jim Lee Variant — January 2006
Pencilled by Jim Lee, inked by Sandra Hope
Power Girl is shown here in the comic that finally explained her
identity—she was Superman's cousin in a timeline that got erased,
leaving her with no memory of her past. She, then, is an alternate
version of Supergirl, and the two have since become friends and
occasional teammates.

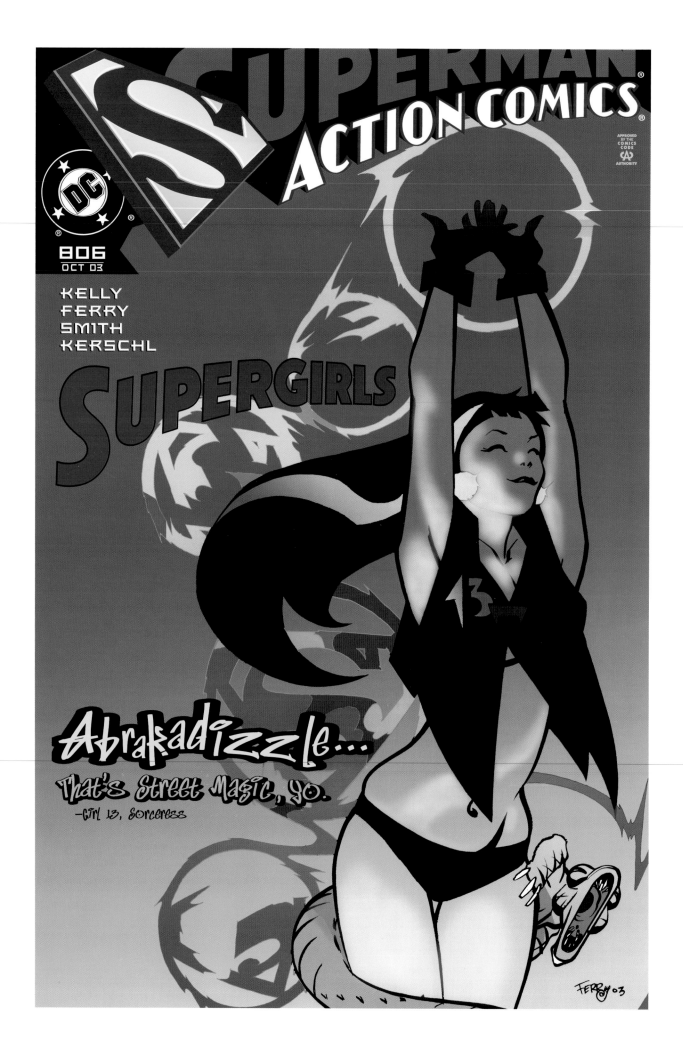

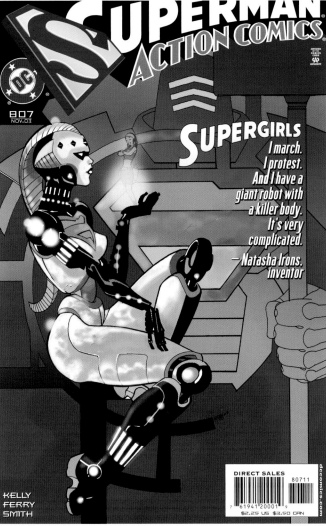

opposite
Action Comics #806 — October 2003
Art by Pascual Ferry
In this "Supergirls" story arc, written by Joe Kelly and charmingly
drawn by Pascual Ferry, Traci Thirteen, teenage sorceress, aiding an
injured Superman . . .

above
Action Comics #807 — November 2003
Art by Pascual Ferry
. . . is confronted by the armored Natasha Irons, niece of the
technological genius Steel, who is following in her super-heroing
uncle's footsteps. Natasha at first mistakes Traci for the assailant,
then bonds with her . . .

above right
Action Comics #808 — December 2003
Art by Pascual Ferry
. . . and, joined by Cir-El, an artificially created Supergirl from
a timeline that no longer exists, the three supergirls save Superman
and confound the enemy.

right
Superman/Batman #13 — October 2004
Art by Michael Turner
On Paradise Island, Kara Zor-El makes the momentous decision
to face the world as Supergirl in yet another new take on the
Maid of Steel's costume.

**"Batman, look! That girl's captured two
thieves! Why—she's a Batwoman!"**

—Robin, *Detective Comics* #233 (July 1956)

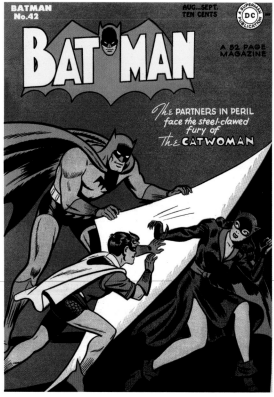

above

Batman #42 — August–September 1947
Pencilled by Jack Burnley, inked by Charles Paris
Catwoman was one of Batman's most popular foes from the
beginning. Here, in her modest 1940s costume, she peeks coyly
around the edge of the cover.

The Batman continuity is rife with strong female protagonists and antagonists—heroines like Batwoman, Batgirl, and Renee Montoya; antiheroines like Catwoman; and antagonists like Poison Ivy and Harley Quinn. At one time or another, most of these strong, passionate women have desired Batman. At other times, they've hated him. And Batman's reaction to them has been equally contradictory. But love Batman or despise him, these Gotham girls don't do anything by halves, though they exist in a universe nuanced by shades of grey. Not surprising, really, considering their origins and the no man's land in which they operate.

When Superman appeared in *Action Comics* #1, he became an instant sensation. *Detective Comics* editor Vin Sullivan immediately began looking for a similar character to lead off his title and mentioned this in passing to young artist Bob Kane.

Kane went home, sketched up some ideas, and kibitzed with writer Bill Finger.

As Kane and Finger tell it, their creation was inspired by a variety of elements. Kane knew he wanted his character to wear a form-fitting costume like Superman's. In 1939, bats were a staple of pulp and mystery fiction, and artist and writer agreed that scalloped wings and pointed ears would add a sinister visual element to their hero's costume. *The Phantom*, a popular newspaper strip by Lee Falk and Ray Moore, contributed a mask with blanked-out eyes and the costume's muted coloration, as opposed to the red Kane had originally envisioned. Batman, "a creature of the night," was born.

The pair decided Batman would be a master detective, like Sherlock Holmes. Like the Shadow, he would enact justice. Like Zorro, a masked, swashbuckling hero who was secretly an aristocrat, Batman would have wealthy Bruce Wayne as his alter ego.

"**Criminals are a superstitious and cowardly lot,
so my disguise must be able to strike terror into their hearts.
I must be a creature of the night, black, terrible . . .**"

Batman, *Detective Comics* #27 (May 1939)

And Batman would differ from Superman in a very fundamental way. He would have no superpowers. Only his wits and athleticism would help him carry out his crime-fighting mission.

Most often the villains he fought would be physically bizarre, obsessed maniacs, inspired by the outrageous criminals in Chester Gould's *Dick Tracy*. The Joker, the Penguin, and Two-Face were just a few of these early villains. Arkham Asylum, Gotham City's hospital for the criminally insane, is crammed full of Batman's foes with good reason!

Kane sold the concept to Sullivan and, in May of 1939, *Detective Comics* #27, featuring the "Amazing and Unique Adventures of The Batman," appeared on the newsstands.

Originally, Kane illustrated all the Batman features, while Bill Finger scripted most of the stories. *Detective Comics* #29 introduced Batman's utility belt, filled with crime-fighting implements. *Detective Comics* #31 gave Batman his flying Bat-Gyro and his boomerang-like Batarangs. *Detective Comics* #33 revealed Batman's origin in the story of a young boy whose parents were killed in a robbery before his eyes and who vowed retribution to evildoers. Then *Detective Comics* #38 introduced Robin, the Boy Wonder, Batman's kid sidekick.

Batman was such a hit that publisher Harry Donenfeld chose to change the name of the comic's parent company from National Periodicals to Detective Comics, Inc. And Batman received his own eponymous title.

Batman #1, which appeared in the spring of 1940, introduced two of Batman's most memorable foes: The mad, bad Joker, with his maniacal grin, and the Cat, who several issues later became Catwoman, a morally ambiguous figure who has become one of Batman's most sympathetic adversaries.

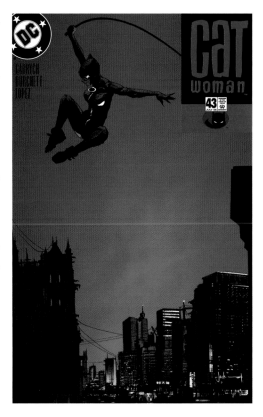

above

Catwoman (2nd series) #43 — July 2005
Art by Jock
What a difference six decades make! This gorgeous, dynamic cover features a Catwoman who is clearly a heroine. Leaping over the rooftops, she uses whip and claw to protect residents of the Gotham neighborhood known as the East End.

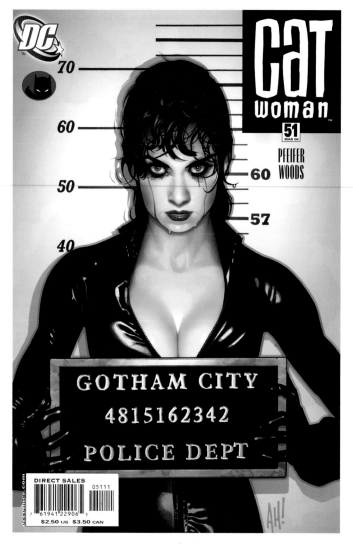

above

Catwoman (2nd series) #51 — March 2006
Art by Adam Hughes
Catwoman's first arrest may have come in *Batman* #15,
but it wasn't her last. Here Adam Hughes has rendered the cat-
suited heroine as both sexy and defiant.

opposite

Catwoman: When in Rome #1 — November 2004
Art by Tim Sale
In this stylish noir miniseries by Jeph Loeb and Tim Sale,
Selina Kyle sets out for Rome to discover if Mafia boss Carmine
Falcone is really her father.

"Well, what's the matter? Haven't you ever seen a pretty girl before?"

—The Cat, *Batman* #1 (Spring 1940)

In her first appearance in *Batman* #1, Selina Kyle was a beautiful and bold jewel thief who didn't wear a costume. And while she couldn't resist the lure of other people's riches, she also wouldn't kill. In fact, in *Batman* #2 she traded her ill-gotten treasure to the Joker to save Robin's life. By *Batman* #3, The Cat had become Cat-Woman, a costumed "bad girl" wearing a furry, full-face cat mask.

By the mid-1940s, she had abandoned the cat-mask for her Golden Age purple costume with its cat-eared cowl and green cape, in obvious mimicry of Batman's classic cape and bat-eared cowl. But the whip she carried was definitely not a "good girl's" accessory, a visual clue that she was a character who walked on the dark side. Though the details of Catwoman's costume have altered over the years, her ears, claws, and whip have remained constant.

From the beginning, there had been mutual attraction between Catwoman and Batman. Batman had thwarted her, sure, but hadn't taken her into custody—yet. Then, in *Batman* #15, Catwoman fell in love with Batman. Hoping to lure her from a life of crime, he courted her, became engaged to her—and then admitted the whole thing was a sham. Feeling betrayed, Catwoman resumed her life of crime. And finally, Batman arrested her.

Catwoman's origin is shrouded in mystery. Over the years, she is said to have been an amnesiac ex-flight attendant (Golden Age *Batman* #62); an abused wife who, in leaving her husband, was forced to steal back her own jewels and enjoyed the experience so much she became a cat burglar (Silver Age *The Brave and the Bold* #197); a prostitute and dominatrix (Post-Crisis *Batman: Year One*); or the long-lost illegitimate daughter of a Mafia boss.

Julie Newmar played Catwoman enchantingly in twelve episodes of the campy *Batman* TV show, which ran from 1966–1968. Eartha Kitt, a completely different Catwoman, took over the role in three later shows to much acclaim.

Over the years Catwoman has both fought Batman and aided him as the whim took her. That she continues to love him is unquestioned. But she's a woman who has always played by her own rules—and continues to play a very dangerous game.

"That's my territory . . . In between right and wrong."

—Catwoman, *Catwoman* (2nd series) #1 (January 2002)

The post World War II sales slump had Batman group editor Jack Schiff scrambling to find a solution. Schiff tried the usual bizarre ploys to grab reader attention, including tales of attacking aliens. More successful were the stories that added to Batman's cast of bizarre villains: tales of The Riddler, The Mad Hatter, Tiger Shark, and Killer Moth. Some introduced new paraphernalia—a new Batmobile, a new Batplane—even a flying Batcave. But the Batman books continued to flounder.

In 1954, psychiatrist Dr. Fredric Wertham's anti-comic books polemic *Seduction of the Innocent* nearly destroyed the Batman franchise. In *Seduction*, Wertham informed parents that their kids would copy the crimes they saw committed in the Batman comics. Even more damning, he "revealed" a homosexual relationship between Batman and Robin. (The fact that Bruce Wayne had a butler and flower-filled vases in his mansion was proof enough!) And Wertham warned parents that readers of the comics would likely follow in Batman's depraved footsteps.

His appearance before the Senate Subcommittee on Juvenile Delinquency nearly hammered the nails in Batman's coffin.

Despite the Comics Code label that began to appear on the Silver Age Batman titles, the Batman franchise spent the next decade reassuring its audience that Batman stood for positive family values.

To shore up this effort, Superman joined forces with Batman in *World's Finest Comics,* a team-up that lasted for the next thirty-two years. Batman acquired a dog, Ace the Bat-Hound. And in July of 1956, Batwoman joined the cast of Batman in *Detective Comics* #233.

"Don't worry, Batman and Robin— I'll save you!"

—Batwoman, *Detective Comics* #233 (July 1956)

Kathy Kane was a former circus acrobat who swung onto the comic book pages to rescue Batman and Robin from a towering killer robot, in a story by Edmond Hamilton and Sheldon Moldoff. Using an inheritance to fulfill her obsessive desire to emulate Batman, she had constructed a red-and-yellow costume loosely based on Batman's, but instead of a utility belt, she carried a little red utility purse. Her "weapons" included tear-gas-filled lipstick and a compact packed with sneezing powder. (You can't make this stuff up, folks!)

Batwoman made guest appearances in the Batman books from 1956 to 1964.

Soon other characters joined the "Batman Family." In May of 1959, Bat-Mite, a magical imp from another dimension with a Batman fixation and copycat costume, appeared in *Detective Comics* #267.

"Oh, Robin—then it's all right for me to kiss you now!"

Bat-Girl, *Batman* #144 (December 1961)

Then, in 1961, Bat-Girl joined the Batman cast.

Bat-Girl (with a hyphen) was Betty Kane, the teenage niece of Batwoman Kathy Kane. She wore a short red dress and mask and a green cape—an outfit based on Robin's costume, because she had a crush on him. She was created to be Robin's romantic interest and to add to the reassuringly heterosexual atmosphere the Batman books were striving for.

above

Batman: Legends of the Dark Knight #43 — March 1993
Art by P. Craig Russell
Lush art by P. Craig Russell portrays Poison Ivy as an appealing though creepily off-kilter villain.

opposite

Batman: Dark Victory #11 — October 2000
Art by Tim Sale
In the *Batman: Dark Victory* miniseries, the villain Two-Face and the Gotham mob are at war and policemen are dying. Here we see Tim Sale's creepy take on Poison Ivy, who has joined the mad Two-Face as one of his henchmen.

page 120

Batman: Gotham Knights #8 — October 2000
Art by Brian Bolland
Attraction and repulsion, romance, and danger tinge the sexually charged relationship between Catwoman and Batman, underscored in this edgy, unsettling cover by Brian Bolland.

page 121

Batman #122 — March 1959
Pencilled by Curt Swan, inked by Stan Kaye
While Batman and Kathy Kane are out on a date, the sleeping Dick Grayson dreams of being displaced.

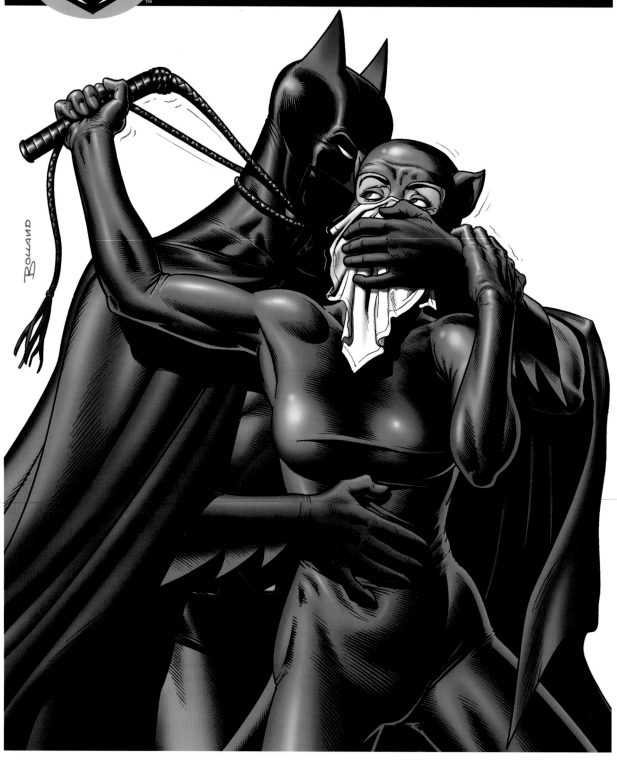

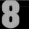

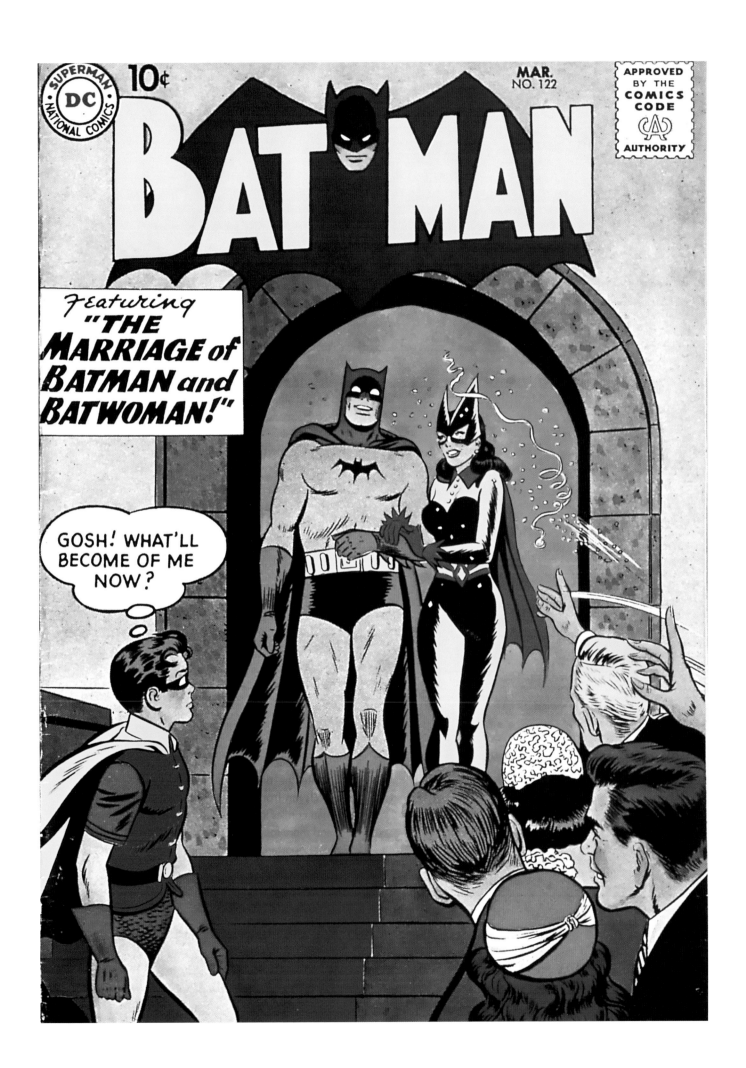

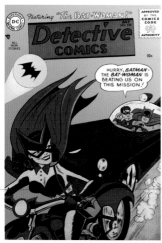

above top

Batman: Harley and Ivy #2 — July 2004
Art by Bruce Timm
The femme fatales Poison Ivy and Harley Quinn dodge the villains
Slash and Burn in this Bruce Timm cover—a team-up inspired by
Batman: The Animated Series.

above

Detective Comics #233 — July 1956
Art by Sheldon Moldoff
Kathy Kane was an ex-circus performer, not a fashion designer.
(As if you couldn't tell!) Poor Robin seemed to live in constant dread
that she would outperform him and Batman.

Bat-Girl made several guest appearances until she was finally dropped from the Batman titles when Julius Schwartz took over as editor in 1964.

During the late 1950s and early 1960s, the Batman stories had gotten sillier and sillier. Batman was transformed into a Bat-baby, an energy-creature, a phantom, a giant, a merman, a genie, a space alien—even the Superman of an extraterrestrial world. Anything to get the kids to pick up an issue of the comic!

"Alfred, you know all this just isn't going to work anymore— not the way it used to be!"

—Bruce Wayne, *Batman* #217 (December 1969)

Julius Schwartz was given control of the Bat-titles with orders to restore the characters to prominence, as he had the Golden Age Flash and Green Lantern.

Schwartz dropped the strange transformations and space aliens that had afflicted Batman and refocused the title on its core characters: Batman and Robin and their interactions with their bizarre cast of villains.

In 1966, Robert Kanigher and Sheldon Muldoff created the second of Batman's most beloved femme fatales: Poison Ivy.

"You'll let me go, won't you, lover?"

—Poison Ivy, *Harley and Ivy* #1 (June 2004)

First appearing in *Batman* #181, Poison Ivy was a botanist who had been poisoned by deadly herbs. This gave her the ability to secrete plant toxins—often through her lips, giving her a particularly deadly kiss—as well as immunity to those toxins. She could also psychically manipulate plants. Unfortunately, she chose to use her powers to pursue a life of crime.

Poison Ivy, with her striking figure, clothes of leaves, bright red hair, and pale, often greenish skin, is a seductress whose allure mixes overtones of sex and death.

Like most women in the Batman mythos, she has been in love with Batman, though she has also been attracted to a variety of villains—and even to plants!

Despite the distraction of the campy *Batman* television show, which ran from 1966–1968 and occasionally influenced the Batman comics in oddly goofy ways, Batman became darker, grittier, and more focused under Schwartz.

Most importantly, Schwartz brought in fresh talent, among them artists Carmine Infantino and Gil Kane. The team of Steve Englehart, Marshall Rogers, and Terry Austin created some Batman classic stories. Denny O'Neil and Neal Adams made major contributions to the Batman legend, among them the enduring Batman antagonist Rā's al Ghūl, chief villain in the 2005 movie, *Batman Returns,* and his beautiful daughter Talia.

In 1967, writer Gardner Fox and artist Carmine Infantino introduced the new (un-hyphenated) Batgirl in *Detective Comics* #359.

right

Batman: Shadow of the Bat Annual #5 — September 1997
Art by Glen Orbik
A fun cover that references Batman's pulp and noir influences finds
Poison Ivy creating plant-zombies and seducing a hard-boiled
detective with the unlikely name of Joe Potato.

below

Batman #495 — June 1993
Art by Kelley Jones
Kelley Jones, who illustrated Batman for a long run, was known for
his expressionistic, creepy depiction of the Dark Knight and his
Rogues Gallery. Note the extremely long ears on the bat cowl,
and Poison Ivy's defiant stance over the Batman.

right

Batman: Gotham Knights #15 — May 2001
Art by Brian Bolland
On the cover, Robin is in grave danger from the seductive and
deadly Poison Ivy. Inside the comic, however, Robin holds his own,
threatening to set fire to the grass to make Ivy listen to reason.

opposite
Detective Comics #359 — January 1967
Pencilled by Carmine Infantino, inked by Murphy Anderson
Barbara Gordon's first appearance as Batgirl.

right
Detective Comics #752 — January 2001
Art by Dave Johnson
During the "No Man's Land" storyline, the authorities threaten to
destroy the park in which Poison Ivy is hiding with abandoned
children she has adopted. Ivy finally surrenders in order to protect
both the children and her beloved park. The gas masks give Ivy and
children an almost alien aspect.

below
Detective Comics #422 — April 1972
Pencilled by Neal Adams, inked by Dick Giordano
A classic "secret identity revealed" cover. Here Batgirl is beautifully
drawn by the talented Neal Adams, whose influence on the Batman
universe is still felt today.

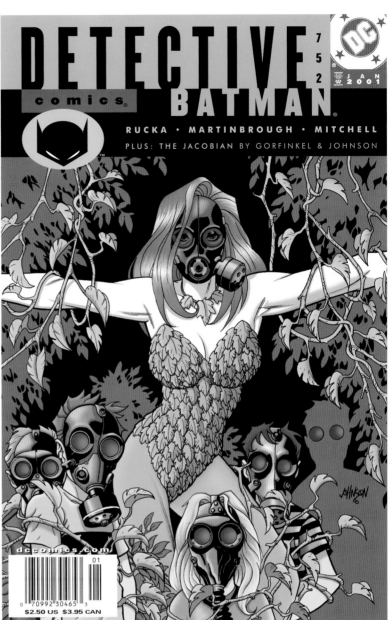

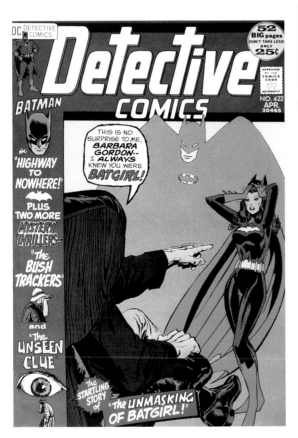

right
Detective Comics #371 — January 1968
Pencilled by Gil Kane, inked by Murphy Anderson
Okay, this cover is both silly and sexist—a nod, perhaps, to the
campy *Batman* TV show, then in its third season.

page 126
Detective Comics #369 — November 1967
Pencilled by Gil Kane, inked by Murphy Anderson
In this symbolic cover, a female dressed in a bat-suit once again
threatens to come between Batman and Robin.

page 127
Batman #197 — December 1967
Pencilled by Carmine Infantino, inked by Mike Esposito
Batgirl heroically protects the fallen hero against the machinations of
Catwoman, seductive and dangerous in a new, skin-tight green costume.

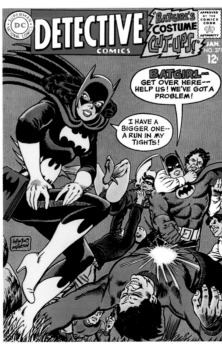

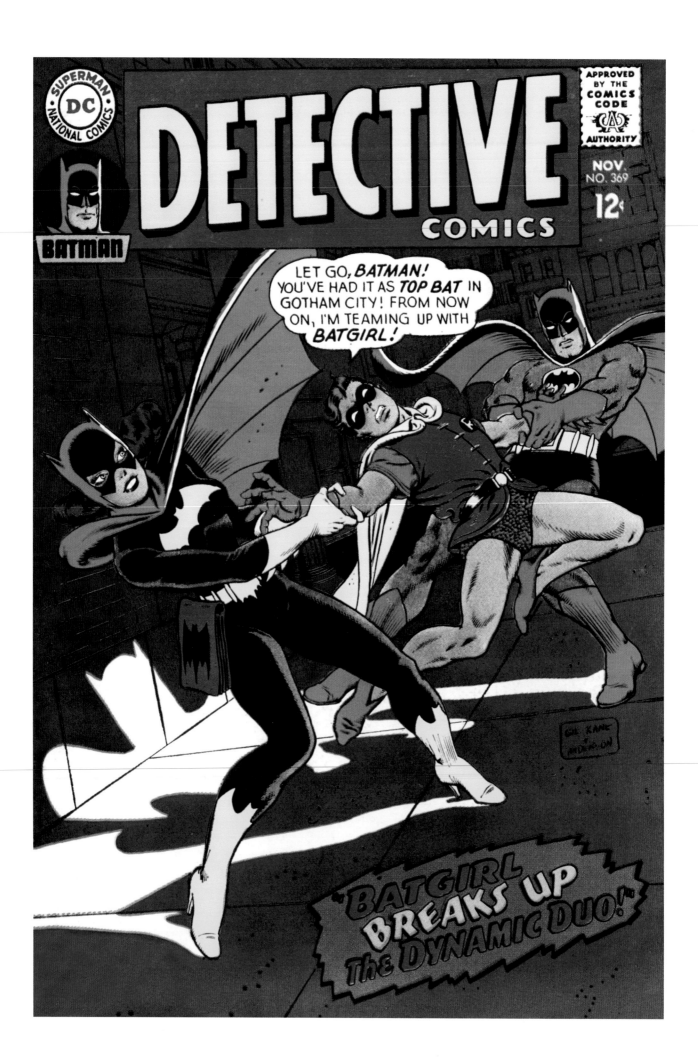

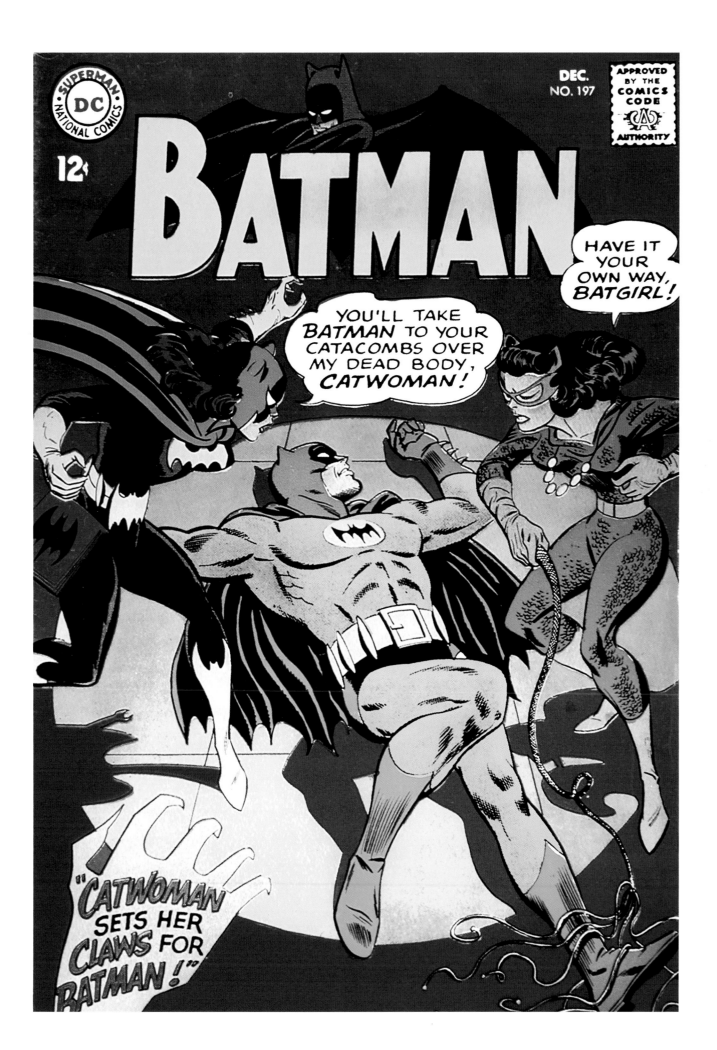

above
Batman: Dark Victory #5 — April 2000
Art by Tim Sale
Catwoman, a featured player in the Jeph Loeb/Tim Sale *Dark Victory* miniseries, appears both creepy and alluring as she prepares for a trip to Rome to investigate her parentage, a tale told four years later in *Catwoman: When in Rome*.

opposite
Batman Family #9 — January–February 1977
Pencilled by Ernie Chan, inked by Vince Colletta
The exploits of Batman spin-off characters were collected in the anthology *Batman Family*. Here Batgirl fights it out with the female offspring of one of Batman's deadliest foes.

page 130
Batman: Batgirl: Girlfrenzy — June 1998
Pencilled by Leonard Kirk, inked by Karl Story
Barbara Gordon—the original Batgirl—in a flashback to her early adventures.

page 131
Batman: The Dark Knight Returns #3 — 1986
Art by Frank Miller
Frank Miller's vision of a future Batman revitalized the character. Thirteen-year-old Carrie Kelly, the first female Robin, managed to save the day several times and was a favorite among readers.

"Who is this new Batgirl who seems to have taken over my crime-fighting territory?"

—Batman, *Detective Comics* #359 (January 1967)

Barbara Gordon was the daughter of Gotham City Police Commissioner James Gordon. Dressed for a costume ball as a female Batman and calling herself Batgirl, she foiled the attempted kidnapping of Bruce Wayne by the Killer Moth. And, though the villain escaped from the party, "Babs" was instrumental in his later capture.

Crime fighting was in her blood, and joining Batman and Robin in their endeavors seemed like a good idea, though she kept her super-heroine identity secret from her father.

Yvonne Craig played Batgirl during the *Batman* television show's final season and her appearance as part of *Batman*'s regular cast added to the show's popularity.

"Never mind about Batman! You have enough on your hands handling Batgirl!"

—Batgirl, *Detective Comics* #369 (November 1967)

In addition to Schwartz, the Batman comics had a series of talented editors who worked with the best of the young talent: Archie Goodwin, who also wrote the award-winning "Manhunter" back-up series for artist Walter Simonson; Paul Levitz, who created a story bible in order to present a consistent world throughout the Batman titles and who eventually became the President and Publisher of DC Comics; artist Dick Giordano, who was quickly promoted to Executive Editor; and writer Len Wein.

In an effort to encourage the development of the graphic novel format and position DC Comics for the next millennium, Publisher Jenette Kahn and Giordano convinced artist-writer Frank Miller and inker Klaus Janson to produce the gritty, futuristic 1986 miniseries *Batman: The Dark Knight Returns*. The story, featuring a borderline-psychotic Batman and a young female Robin, was an unmitigated critical and sales success.

That same year, writer Dennis O'Neil took over as the Batman editor. And the *Crisis on Infinite Earth* miniseries swept the DC Universe.

Batman: Year One, written by Miller and drawn by David Mazzucchelli, retold the story of Batman's origin and first year in Gotham and rebooted the Batman Universe. First released in *Batman* #404–#407 (1987), it was soon compiled in a graphic novel format. The story reintroduced Selina Kyle as a dominatrix-prostitute, inspired by Batman to put on the Catwoman costume and become a cat burglar. Her younger friend, Holly Robinson, has since taken up the Catwoman mantle.

Number 1
June 1998
$1.95 us
$2.75 can

GirLfreNZy!

BATMAN

Batgirl

W/Puckett P Balent Burchett

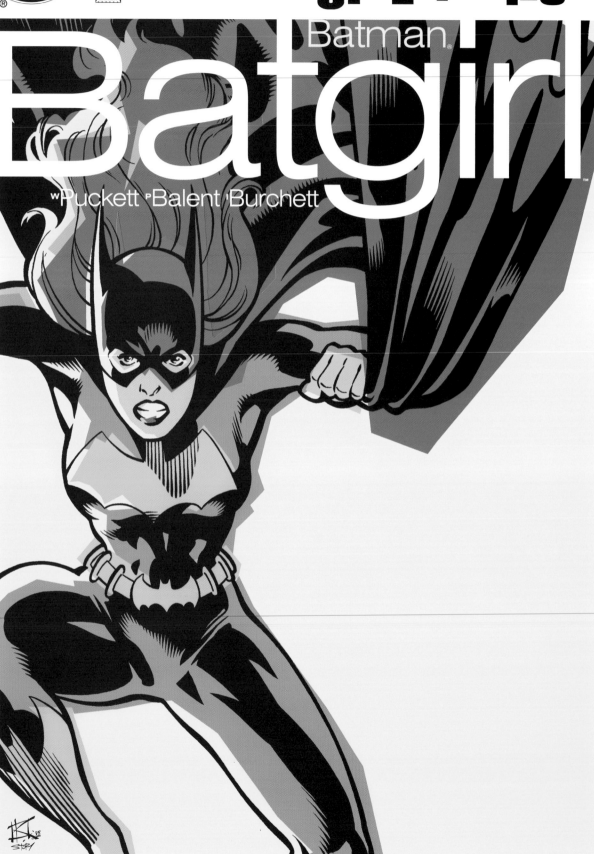

BATMAN

HUNT THE DARK KNIGHT

BY
FRANK MILLER
WITH
KLAUS JANSON
AND
LYNN VARLEY

BOOK THREE • $2.95
$4.50 IN CANADA

FM/LV

Batman comics and graphic novels proliferated, buoyed by the success of the Batman movie franchise: the Burton *Batman* film (1989); *Batman Returns* (1992); *Batman Forever* (1995); and *Batman & Robin* (1997). Halle Berry played Catwoman in the 2004 *Catwoman* movie, and 2005 saw the opening of *Batman Begins*.

Unlike a number of other characters, Barbara Gordon survived the 1985 miniseries *Crisis on Infinite Earths*, only to be shot by the Joker and paralyzed in the 1988 graphic novel, *The Killing Joke*, by Alan Moore and Brian Bolland.

This ended Barbara Gordon's career as Batgirl, though from her wheelchair, she continues her crime-fighting vocation as the all-knowing computer-wiz Oracle, director of the female super-heroine team Birds of Prey. "Babs" remains one of DC Comics' most prominent disabled characters, and certainly its most prominent disabled woman.

In 1992, the "Knightfall" saga (written principally by Chuck Dixon, Doug Moench, and Alan Grant) chronicled the destruction of Batman by the vicious Bane; the rise of the antihero, Azrael; and finally, in 1994, the return of Batman.

In 1993, amid this controlled chaos and inspired by the success of the second Batman movie, *Batman Returns*, in which Catwoman—played by Michelle Pfeiffer in a memorable skin-tight black leather catsuit—had a prominent role, Catwoman got her first eponymous series, which lasted nearly eight years.

"It's all going so purrfectly."

—Catwoman, *Catwoman (1st series)* #15 (November 1994)

The stories about its morally ambiguous heroine ranged from Selina's difficult past as a kid thief through present day tales of international jewel heists. She evaded marriage to a European prince and enjoyed a short stint as a CEO—a job acquired through blackmail, of course. She aided Batman when Gotham was a "No Man's Land," then apparently was killed by Deathstroke the Terminator, ending the series with *Catwoman* #94.

But she is Catwoman—and as such she has nine lives.

For a while she was featured in a back-up story in *Detective Comics*, in which detective Slam Bradley searched for her.

This led to a popular second *Catwoman* series by writer Ed Brubaker and artist Darwyn Cooke, released in 2001.

These tales focused on the dichotomy of Catwoman, who championed Gotham's poor and downtrodden East Enders even as she gleefully stole from the rich. Detective Bradley and Selina's younger friend, ex-drug addict Holly Robinson, kept Selina informed of East End problems and provided ample back-up.

After a romantic relationship in which Batman revealed his identity to a more-or-less reformed Selina, she learned that her change of heart had been in part the result of mental manipulation. Enraged and confused, for the first time she killed an antagonist.

This act—as much as her impending motherhood—led Selina to retire, passing the whip and claws to her red-haired friend, Holly, who has now become the new Catwoman.

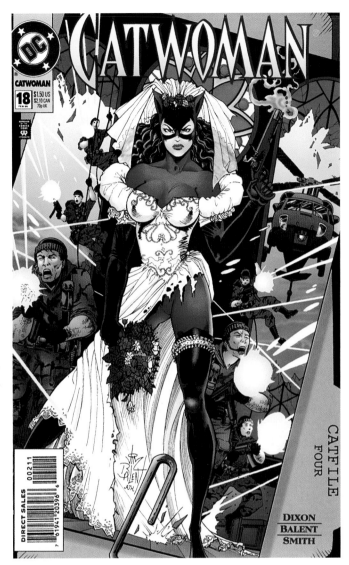

above

Catwoman (1st series) #18 — February 1995
Art by Jim Balent
Catwoman got her own series in the 1990s in which she inhabited the grey area between good and evil. This evocative, symbolic cover makes it clear that gun-toting Selina Kyle is playing her own game and is not anybody's blushing bride.

opposite

Batman: Gotham Knights #6 — August 2000
Art by Brian Bolland
Brian Bolland focuses on the dramatic moment when the Joker shot and paralyzed Barbara Gordon, ending her career as Batgirl.

page 134

Gotham Girls #5 — February 2003
Art by Shane Glines
As many fans' favorite Batgirl, Barbara Gordon stars in a number of stories focusing on her early career. Here is artist Shane Glines' lively take on one.

page 135

Catwoman (1st series) #66 — March 1999
Art by Jim Balent
Catwoman in Paris—this cover says it with wit and style! Selina's plot to steal stolen loot from a caucus of thieves has inspired her secret smile.

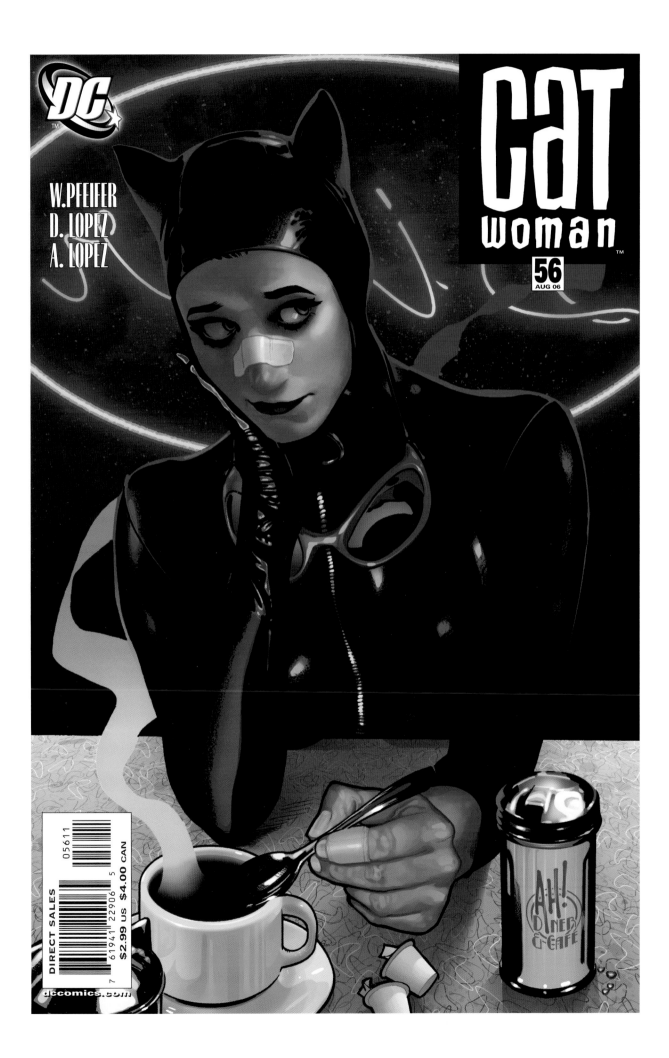

1992 was a big year for the Batman franchise. Not only did they have a hit movie and a hit comic storyline, they also had a hit animated series.

Batman: The Animated Series took the animation world by storm. Its dark, serious tone and first-rate design won it fans among regular viewers and comics professionals alike.

> ## "In her own way, Alfred, Harley Quinn's as crazy as the Joker. Her playful exterior hides an obsessive and dangerous mind."
>
> —Batman, *Batman Adventures: Mad Love* (February 1994)

The character Harley Quinn, created by writer and story editor Paul Dini and artist Bruce Timm as part of the TV show, proved hugely popular.

Harley's real name was Harleen Quinzel. She was an Arkham Asylum psychiatrist who fell head-over-heels in love with her patient, the Joker. She donned a harlequin costume and followed him blindly as his faithful sidekick and sometimes girlfriend, Harley Quinn.

No matter how monstrously the Joker behaved, Harley saw him through rose-colored glasses. Her devotion to him was absolute. She was convinced that, if only she could help the Joker do in his nemesis, Batman, her lover would finally focus his attention on her.

O'Neil liked the character so much that he asked Dini and Timm to produce a Harley Quinn graphic novel. The result was the delightful *Mad Love*, published in 1994. Harley was later officially added to DC Comics continuity in a one-shot introducing her character.

From there, a number of comics followed, with Harley interpreted in many different ways. But always, she maintains that essential zaniness that makes her the special lunatic that she is.

> ## "A Batarang was recovered at the scene. It's at the lab now."
>
> —Renee Montoya, *Gotham Central* #33 (September 2005)

Harley Quinn wasn't the only character introduced in *Batman: The Animated Series* who became so popular she was brought into the comics.

Renee Montoya, created by Paul Dini, was a Gotham City police officer, soon promoted to detective.

Her segue into Batman comics continuity won her a promotion to Homicide Detective, then Lieutenant.

In 1999, the Batman books began a year-long story arc called "No Man's Land." Gotham City was destroyed by an earthquake and overrun by the mad criminals who escaped from Arkham Asylum. As an ungovernable ruin, Gotham was declared a No Man's Land by the United States government and cut off from aid.

above

Harley Quinn #1 — December 2000
Pencilled by Terry Dodson, inked by Rachel Dodson
The madly engaging Harley Quinn got her own monthly comic in 2000. This issue focused on her romantic delusions concerning her "puddin"—the Joker.

opposite

Batman #609 — January 2003
Pencilled by Jim Lee, inked by Scott Williams
Batman is caught between Poison Ivy's pheromones and Catwoman's seductive wiles.

page 136

Catwoman (2nd series) #48 — December 2005
Art by Adam Hughes
Adam Hughes contributed this sexy cover of a Catwoman who has gone undercover to take down a cadre of villains threatening Gotham's East End.

page 137

Catwoman (2nd series) #56 — August 2006
Art by Adam Hughes
After the epic miniseries *Infinite Crisis*, Selina Kyle's friend Holly became the new, uncertain Catwoman.

page 140

Catwoman (2nd series) #1 — January 2002
Art by Darwyn Cooke
Darwyn Cooke gave Catwoman a sharp new costume in this restart of the *Catwoman* series.

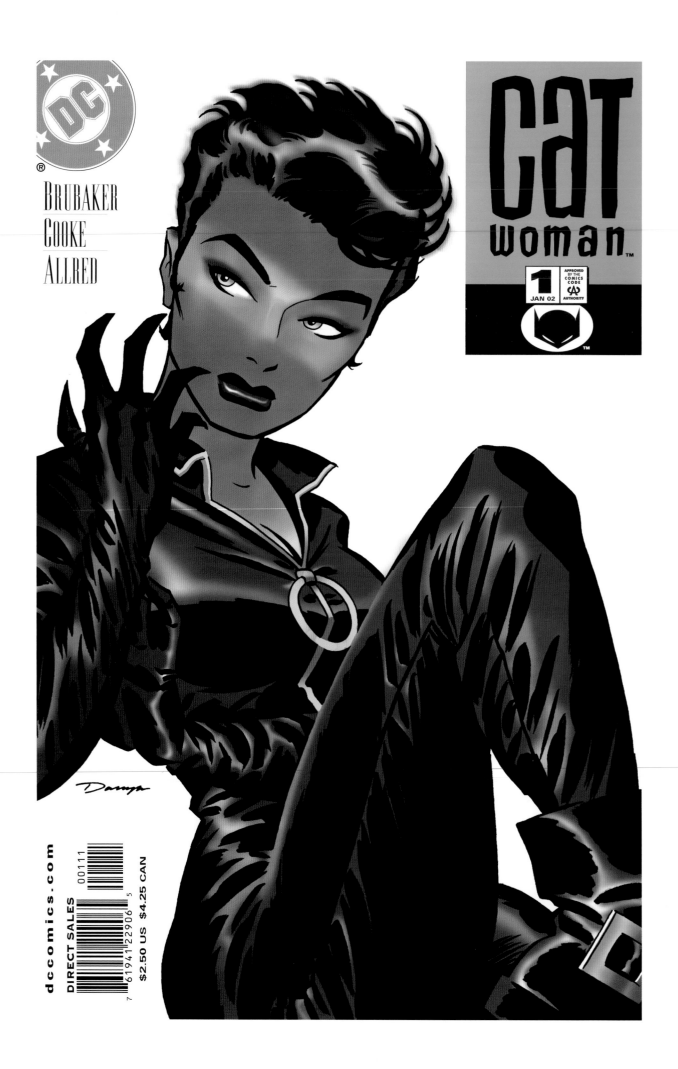

page 141
Catwoman (2nd series) #2 — February 2002
Art by Darwyn Cooke
On this second cover, Darwyn Cook shows Selina from an unusual angle. She's also in full costume, including goggles.

opposite
Batman: Harley Quinn — October 1999
Art by Alex Ross
Migrating officially into the comics, Harley starred with the Joker in this one-shot with a beautiful cover by Alex Ross that visually defined their relationship.

left
Batgirl Adventures #1 — February 1998
Art by Bruce Timm
Batman: The Animated Series featured a cheerful take on the classic Barbara Gordon version of Batgirl. Here she blithely leaps into adventure, unaware of the danger behind her from Harley Quinn and Poison Ivy.

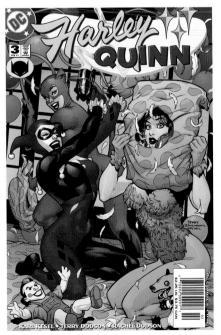

above
Batman Adventures: Mad Love #1 — February 1994
Art by Bruce Timm
Harley Quinn was introduced as a sidekick and love interest to the Joker as part of *Batman: The Animated Series* and became by far its most popular original character. Here, in her first comic book appearance, Harley was still defined by her animated design.

left
Harley Quinn #3 — February 2001
Pencilled by Terry Dodson, inked by Rachel Dodson
With her girlfriend Poison Ivy's support, Harley is determined to abandon the Joker as a romantic interest and strike out on her own. The *Harley Quinn* series ran for thirty-eight issues, ending when Harley returned to Arkham Asylum.

GOTHAMGIRLS.COM
DIRECT SALES

above

Gotham Girls #4 — January 2003
Art by Shane Glines
In this series highlighting various women in the Batman universe,
police lieutenant Renee Montoya looks both stylish and tough.
Shane Glines provided striking covers for the *Gotham Girls* series
that strongly referenced the animated cartoon style.

During this period, Montoya, one of the most visibly homosexual and realistically portrayed women in comics, was heavily featured, and she later was a primary charater in the *Gotham Central* series.

After the murder of her partner, Montoya quit the force. Now a private investigator, she was featured in DC's miniseries, *52*, where she encountered a new Batwoman—who proved to be Montoya's old flame Katherine Kane.

"From now on, you can call me Robin."

—Stephanie Brown, *Robin* #126 (July 2004)

Soon Batman had a temporary new Robin, as well—a teenage girl who looked surprisingly like the young female Robin in *The Dark Knight Returns* series.

She was Stephanie Brown, daughter of the criminal Cluemaster. In an effort to prevent her father's return to crime, Stephanie put on a hooded costume and became the costumed heroine, the Spoiler.

When her friend Tim Drake quit as Robin, Batman allowed her to take Tim's place as the fourth Robin.

A conflict with Batman led her to inadvertently incite a gang war in Gotham, got her fired as Robin, and finally resulted in her death.

"Her strange training enables her to . . . read opponents. 'Body language' is a real language for her. Her only language."

—Batman describing Cassandra Cain, *Batgirl* #4 (July 2000)

The "No Man's Land" storyline produced yet another female heroine—Cassandra Cain, the newest Batgirl. The daughter of an assassin working for the criminal mastermind Rā's al Ghūl, Cassandra was trained in extreme martial arts from infancy to become Rā's perfect bodyguard.

To this end, she was prevented from learning expressive language so that she would use that area of her brain to "read" and predict the movements of her enemies.

Tricked into committing a murder when she was eight years old, the horrified child escaped from her father and lived on the streets for ten years, until she became one of Oracle's agents during the pivotal "No Man's Land" storyline.

In time, she saved Commissioner Gordon's life and, with the complete approval of Batman and Oracle, became the new Batgirl—the first Batgirl to get her own eponymously titled comic.

When a telepath rewired Cassandra's brain for language, she temporarily lost her ability to read movement. To re-learn this skill, she studied with the assassin Lady Shiva, whom she soon learned was her mother.

right

Detective Comics #747 — August 2000
Art by Dave Johnson
Two-Face, furious when Montoya rejected his advances, outed her as
a lesbian, wrecking her personal life and complicating her career.
Here Dave Johnson features Montoya prominently, transforming
flowers from Two-Face into bats, an example of the clever graphic
devices his covers are known for.

above

Gotham Central #39 — March 2006
Art by Sean Phillips
Renee Montoya reacts to her partner's murder. Note the necklace
indicating her gender preference.

right

Robin #82 — November 2000
Pencilled by Pete Woods, inked by Jesse Delperdang
Teenager Stephanie Brown took on the costumed identity of the
Spoiler and became a major female super hero in Gotham,
enjoying an off-and-on romance with Robin.

This interaction led to a life-or-death conflict, won by Cassandra, who then refused to take her mother's life. Rejecting her Batgirl persona, Cassandra left Gotham to wander the world alone.

Infinite Crisis and the *52* weekly series have already revealed the emergence of a new Batwoman and Catwoman. And it is fairly certain that, in due time, a new Batgirl will follow, to join Gotham's girls in the vibrant, ever-changing Batman community.

Heroines, antiheroines, and villains alike, they all share an element of darkness, questioning traditional ideas of heroism and happy endings, just as Batman does himself.

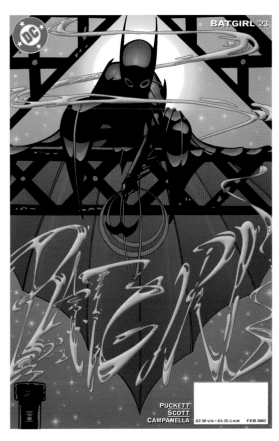

page 146
Batman Chronicles #16 — February 1999
Art by Jason Pearson
As part of the "No Man's Land" storyline, Renee Montoya developed a friendship with the scarred split-personality Two-Face, reaching out to his kinder Harvey Dent persona in an attempt to turn him to good.

page 147
Robin #127 — August 2004
Art by Damion Scott
Unfortunately, Stephanie didn't mesh well with Batman. After he fired her as Robin, further disastrous exploits led to her death. Still, as a female Robin, she recieved real-world media attention and paved the way for another female to possibly take on the character someday.

opposite
52 #11 — July 2006
Art by JG Jones
This is the first appearance in costume of the new Batwoman, whose lesbian status generated a lot of mainstream press in 2006. Her name—Katherine Kane—is an obvious tip of the hat to the old Silver Age Batwoman.

above right
Robin #126 — July 2004
Art by Damion Scott
When Tim Drake briefly abandoned his role as Robin, Stephanie became the first female Robin in normal DC Comics continuity.

right
Batgirl #23 — February 2002
Pencilled by Damion Scott, inked by Robert Campanella
This moody image is indicative of the dark tone of this Batgirl and her series. Note that Cassandra perches on a girder at the top of the cover, while the series title is spelled out below in wisps of smoke.

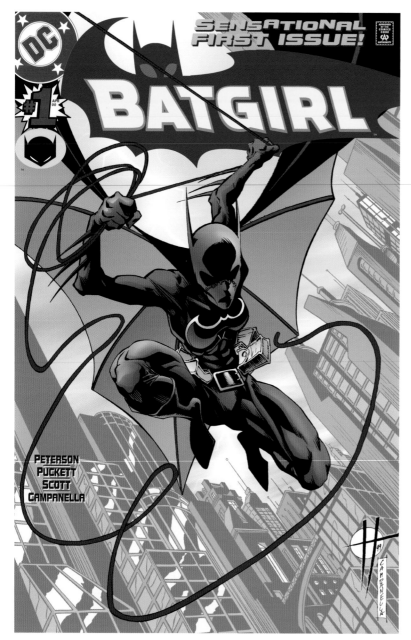

left

Batgirl #1 — April 2000
Pencilled by Damion Scott, inked by Robert Campanella
After the Joker crippled Barbara Gordon, there was no Batgirl for a long time; when a new Batgirl finally arrived on the scene, she was much darker than her predecessor. Cassandra Cain, the mute child of assassins, was rescued and trained as the new Batgirl by the former Batgirl, Barbara Gordon.

opposite

Batgirl #45 — December 2003
Art by James Jean
Cassandra tried to emulate her mentor Barbara Gordon—including putting on the old Batgirl costume, an impulse caught perfectly in this great James Jean cover. Cassandra soon realized that she's more comfortable just being herself.

below

Batgirl #57 — December 2004
Art by James Jean
The new Batgirl, tough on crime, KOs a scary-looking bad guy. James Jean juxtaposes cartoon visual symbols with matter-of-fact violence as the goon sees stars and chirping birds encircling his head.

left

Batman #613 — May 2003
Pencilled by Jim Lee, inked by Scott Williams
This clever image hints at story events in which Batman is, once again, caught between the opposing needs of two women in the Batman universe.

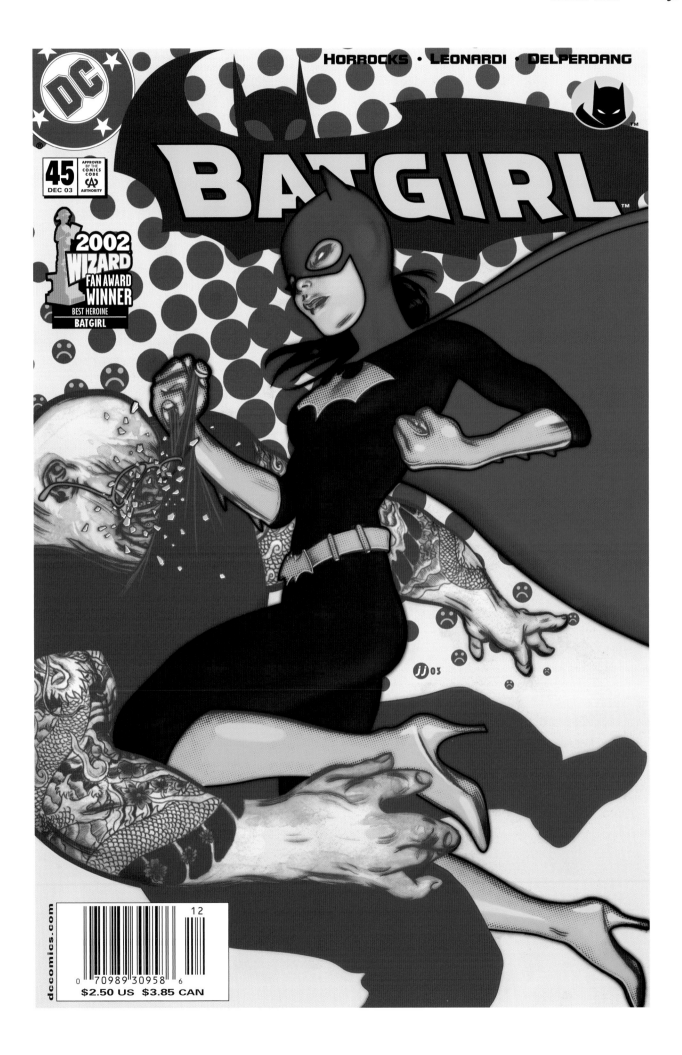

above

House of Secrets #92 — June–July 1971
Art by Bernie Wrightson
The eerie art of a young artist named Bernie Wrightson made Swamp
Thing, premiering in this issue, visually memorable and insured his
success as a character. Wrightson went on to produce comics, book
illustrations—including his fabulous version of *Frankenstein* and
collaborations with horror writer Stephen King—and conceptual
designs for television and films such as *Ghostbusters* and *Spider-Man*.
And the model for this cover? Your author, Louise Simonson.

Vertigo, an imprint of DC Comics aimed at a more mature readership, was founded in 1993. It features comics in other genres than super-hero stories, ranging from harsh reality to science fiction, from horror to war to fantasy. What ties most of its titles together is an occult twist.

Vertigo's stories are as literary as they are visual and, as such, are driven by the sometimes bizarre wants and needs of their protagonists and villains, many of whom are strong female characters. Perhaps because of this, Vertigo has a larger female readership than DC Comics' main line of super-hero comics.

Vertigo had its roots in DC Comics continuity long before its actual creation as a separate imprint.

After World War II ended, readers lost interest in super-hero comics. This prompted publishers to try other genres; westerns, fantasy, science fiction, romance, mystery, and horror comics abounded.

Most successful among the horror anthology titles were the series from EC Comics, whose tales of suburban terror and revenge, while enormously popular, were not always in the best of taste.

The notoriety of these horror comics drew the attention of the Senate Subcommittee on Juvenile Delinquency in 1953 and soon after led comics publishers to create the self-policing Comics Code Authority.

Though EC as a comics publishing entity soon folded, its titles are fondly remembered by readers who enjoyed their bizarre and memorable tales of horror, fantasy, and science fiction.

During the mid-1950s, DC Comics introduced the horror-themed anthology titles *House of Mystery* and *House of Secrets*, hosted by the bizarre characters Cain and Abel. These code-approved stories were horror-lite and, like many Silver Age stories, featured a lot of space aliens and the monstrous creations of mad scientists.

Beyond

In 1970, the restrictions of the Comics Code loosened, encouraging a resurgence of true horror and fantasy genres in comics.

"Why can't I shake the feeling that someone is watching me?"

—Linda Olsen Ridge, *House of Secrets* #92 (June–July 1971)

In 1971, a short story featuring the Swamp Thing appeared in *House of Secrets* #92. This tale of betrayal, monstrous transformation, and revenge, written by Len Wein with art by Bernie Wrightson, was a huge hit with comics fans.

In 1972, an eponymous *Swamp Thing* comic debuted and ran for four years. It retold Swamp Thing's origin and featured the transformed hero and his efforts to become human once again.

In 1979, Karen Berger began working at DC Comics as assistant to editor Paul Levitz. Berger preferred horror, mystery, and fantasy to super-hero stories and, within six months, was editing *House of Mystery*.

By 1980, DC Comics was open to different kinds of comics and formats. Berger, now editorial coordinator, initiated the series *Amethyst: Princess of Gemworld*. A fantasy comic aimed at female readers, it was an anomaly in many ways—and a precursor of Berger's titles to come.

Then, in 1982, the first *Swamp Thing* movie, written and directed by master of horror Wes Craven, appeared in theaters around the country. Inspired by the film's moderate success, DC Comics initiated *Saga of the Swamp Thing*, written by Marty Pasko, drawn by Tom Yeates, and edited by Swamp Thing co-creator Len Wein. With issue #16, Steve Bissette and John Totleben began their memorable run as *Swamp Thing* artists. In 1984's issue

above
Swamp Thing #34 — March 1985
Art by Stephen R. Bissette
Swamp Thing, at first a straight horror character, became more nuanced in the hands of writer Alan Moore. Swamp Thing developed a deep and touching relationship with Abby, shown here on the cover for the famous, award-winning issue where they made love in the most psychedelic way possible.

#20, Alan Moore joined the team as writer. Five issues later, Karen Berger came on board as editor.

"Alec, you are not a damn vegetable, for god's sake!"

—Abby to the Swamp Thing,
Saga of the Swamp Thing #22 (March 1984)

Under Berger and Moore, *Swamp Thing* became a true pre-Vertigo title. Swamp Thing was revealed to be a plant elemental who had mistakenly thought he'd once been human. Moore re-introduced Cain and Abel as characters and created John Constantine (soon to star in the *Hellblazer* series), along with many demons, vampires, werewolves, and ghosts.

On its surface, *Swamp Thing* was an occult horror comic, but its stories explored larger issues like the purpose of existence and the nature of good and evil. Because of its mature content, DC Comics decided to publish the title without the Comics Code seal of approval.

Berger continued to edit super-hero titles, including Paul Levitz and Keith Giffen's *Legion of Super-Heroes*, which featured superpowered teens in a science-fiction future. After DC Comics' 1985–1986 *Crisis on Infinite Earths* miniseries, Berger began to edit the very successful post-Crisis *Wonder Woman*.

Around the same time, DC Comics published another groundbreaking miniseries: *Watchmen*, by Alan Moore and Dave Gibbons, edited by Len Wein. This groundbreaking alternate history, set in a United States where super heroes were real, is the only graphic novel to win the coveted Hugo Award for excellence in science fiction.

"I think you take this vigilante stuff too seriously."

—Detective Joe Bourquin, *Watchmen* #1 (September 1986)

Berger enjoyed the edgy literary style and dark, provocative perspective of Britain's comic book creators and began to recruit them for the titles she edited.

"Searching within myself: A purple flame is burning, flickering with terror and despair."

—Black Orchid, *Black Orchid* (limited series) #2 (1989)

In 1988, British creators Neil Gaiman and Dave McKean re-introduced the Black Orchid, once a superpowered mistress of disguise who had first appeared as a regular DC super hero in the 1970s. The *Black Orchid* limited series revealed that Black Orchid was a hybrid plant-woman with two similar "siblings." The series linked her to Swamp Thing and Poison Ivy and, in the end, it violently murdered her, leaving her siblings to carry on.

Closely following this acclaimed series, Gaiman began to write *The Sandman,* starring Dream (a.k.a. Morpheus) and his siblings, collectively known as the Endless—different aspects of

above

Adventure Comics #428 — July 1973
Art by Bob Oksner
Although she had superpowers, Black Orchid originally preferred a role as a mistress of disguise. From 1973 through 1987, she appeared intermittently as a back-up character.

opposite

Swamp Thing #91 — January 1990
Art by John Totleben
Eventually, through partially mystical means which involved the intervention of the sorcerer John Constantine (Don't ask!), Abby had a baby girl whom she breastfeeds in this peaceful, lyrical cover.

from the pages of THE SANDMAN

Death

AT DEATH'S DOOR

JILL THOMPSON

NO. 1

VERTIGO

NEIL GAIMAN
CHRIS BACHALO
MARK BUCKINGHAM

DEATH

the high cost of living

above top
Death: At Death's Door — July 2003
Art by Jill Thompson
Death—one of Vertigo's most popular characters—gets a manga-
style treatment in this graphic novel.

above
Death: The High Cost of Living #2 — April 1993
Art by Dave McKean
Death, as envisioned by Neil Gaiman, is a friendly teenage Goth girl
who ushers people into the afterlife as nicely as possible.

opposite
Sandman Mystery Theatre #47 — February 1997
Art by Gavin Wilson and Richard Bruning
This cover—a reference to earlier pulp noir-romance genres—
demonstrates Vertigo's willingness to experiment.

reality made flesh. *The Sandman* ran for seventy-five issues, from 1988 to 1996. Each storyline featured a different artist. In time, a number of characters introduced in *Sandman* received their own separate series, miniseries, and graphic novels.

In 1988, another Brit, Jamie Delano, began the *Hellblazer* series, featuring the tortured, amoral sorcerer John Constantine, introduced by Moore in earlier Swamp Thing continuity. The popular *Hellblazer* comics inspired the 2005 movie *Constantine*.

Other British invasion writers included Scottish writer Grant Morrison on *Animal Man* and *Doom Patrol* and Irish writer Peter Milligan, who revamped *Shade, the Changing Man*.

In 1992, Berger suggested creating a new imprint for the more adult, occult-oriented titles she was now producing.

In January of 1993, the Vertigo imprint appeared with Berger as Group Editor. *Swamp Thing* was officially placed in the Vertigo line along with *Hellblazer, Animal Man, The Sandman, Shade: The Changing Man* and *Doom Patrol*—a title which faded from the DC Comics main line into Vertigo and then, as a result of the recent *Infinite Crisis* storyline, moved solidly back into the DC Universe.

Berger commissioned a number of miniseries and graphic novels, both new material and comics spinning off of previous Vertigo continuity.

> ### *"You are utterly the stupidest, most self-centered, appallingest excuse for an anthropomorphic personification on this or any other plane!"*
> —Death, to her brother Dream, *The Sandman* #8 (August 1989)

From the Sandman continuity, Dream's older sister, Death, starred in a 1993 miniseries. This was the first of many adventures starring the personification of Death as a wise-cracking Goth girl. Death was an enormously popular character whose iconoclastic portrayal moved, amused, and delighted her audience and led to appearances throughout the Vertigo Universe.

A number of miniseries and graphic novels featured Dream and Death's other siblings: Delirium, Desire, Despair, Destiny, and Destruction.

> ### *"Of course I know what happens when you die, Sexton. I do. I'm death."*
> —Death, *Death: The High Cost of Living* #1 (March 1993)

In the spin-off series *Lucifer,* the arrogant fallen angel, bored with ruling Hell, has retired to the piano bar "Lux" in Los Angeles. In stories written by Mike Carey, Lucifer indulges his Machiavellian whims as he deals with mortals and immortals alike.

Thessaly, a powerful millennia-old witch, once Dream's lover, also starred in several spin-off series.

And a new *Black Orchid* series, written by Dick Foreman with art by Jill Thompson, featured a darker plant-woman hybrid who controlled others through the use of pheromones. She too died, leaving a final hybrid "Suzy" to carry on alone.

BLACK
Orchid
BOOK ONE

BY NEIL GAIMAN & DAVE McKEAN

$3.50 USA $4.75 CAN

THE **SANDMAN** PRESENTS **BAST**

vertigocomics.com

VERTIGO

ISSUE **1**

CAITLÍN R. **KIERNAN**

mar 2003 **2·95** can **4·95**

JOE **BENNETT**

ETERNITY GAME: 1 of 3

SUGGESTED FOR MATURE READERS

page 160
Black Orchid #1 — 1988
Art by Dave McKean
Writer Neil Gaiman reimagined Black Orchid just before he began his memorable run on *The Sandman*. McKean's upscale, sexy cover tells readers this is a more adult take on the old super heroine.

page 161
Sandman Presents: Bast #1 — March 2003
Art by Dave McKean
Dave McKean is well known for his *Sandman* work, but he's also contributed beautiful covers to many different Vertigo and DC titles. McKean's haunting images are a combination of illustrations, photographs, and found objects, digitally manipulated for optimum impact. Here he give us Bast, a character from the Sandman mythos.

left
Lucifer #57 — February 2005
Art by Michael J. Kaluta
Michael Kaluta, known for his intricate, moody art, drew many of the covers for the last half of the *Lucifer* series. This disturbing image is of the character Lilith who, as part of her private war with Yahweh, sacrifices her own children in her search for vengeance. Lucifer himself dangles from her right earlobe.

above
Lucifer #25 — June 2002
Art by Christopher Moeller
Is this the end of Lucifer Morningstar? Don't bet on it, despite the fact that Death appears as part of the epic "Purgatorio" storyline in this complex Vertigo title.

left
The Little Endless Storybook — March 2005
Art by Jill Thompson
This is the story of Destruction's dog, Barnabus, and his search for Delirium. Here, Jill Thompson draws the anthropomorphic Endless as manga-style toddlers.

"Wow! I . . . I can't believe I just did that. It all seemed so easy."

—Caitlin Fairchild, *Gen13* #3 (April 1994)

1993 was a prime year to begin a new line of comics. Sales were hot, fueled by a rabid speculative market. DC Comics had just published the enormously successful "Death of Superman" storyline. And a group of fan-favorite artists had broken away from Marvel Comics to begin their own publishing venture: Image Comics.

WildStorm Comics, owned by Jim Lee, was included under the Image banner. Among other titles, it published the science-fiction-based *WildC.A.T.S.,* featuring a Covert Action Team of super heroes created to fight an alien war on Earth; and *Gen13,* an amusing and hugely popular title starring a team of superpow-ered teens, over half of whom were female. Soon, WildStorm too would become an imprint of DC Comics.

In 1994, Scottish writer Mark Millar took over *Swamp Thing* and, by the time the book was cancelled with #171, the Earth elemental had become a cosmically aware protector of the planet.

The first of several *Vamps* miniseries by Elaine Lee and William Simpson, featuring vampire-babes with biker attitude, also appeared that year.

And Grant Morrison created the anarchic, reality-bending series *The Invisibles.* In it, time-traveling humans with psychic and sorcerous powers battle other-dimensional alien invaders who have most of humanity in thrall.

"The way I hear it, there's two good places you can look for God: in church, or at the bottom of a bottle."

—Tulip, *Preacher* #1 (April 1995)

In 1995, Garth Ennis began his over-the-top *Preacher* series in which Jesse Custer, a minister in a small Texas town, is bonded with an angel/demon hybrid called Genesis and given the power to command obedience from anyone, perhaps including God himself. Pursued by a legion of enemies, and aided by his girl-friend Tulip O'Hare and the hard-drinking Irish vampire Cassidy, Custer embarks on a quest to find God, who has abandoned his throne in Heaven.

1995 also saw the publication of Grant Morrison and Phillip Bond's demented *Kill Your Boyfriend* graphic novel, a pop-teen romp on the violent side. Grant Morrison has gone on to write a number of acclaimed miniseries for the imprint.

In 1997, DC Comics introduced the Helix imprint, which focused on adult-oriented science fiction. A year later, Helix folded, and Warren Ellis and Derick Robertson's *Transmetropolitan,* featuring the antihero Spider Jerusalem, was moved to Vertigo.

"Nobody hates what I've become more than me."

—Corporal Mary Malone, *Bloody Mary: Lady Liberty* #3 (November 1997)

above

The Witching Hour #3 — 2000
Art by Chris Bachalo
A beautiful, centuries-old witch in Manhattan offers people she meets the opportunity to change their lives in this handsome miniseries. Chris Bachalo's beautiful art and graphic design creates an arresting cover image.

opposite
Thessaly: Witch For Hire #1 — April 2004
Art by Tara McPherson
This off-beat cover catches the spirit of this amusing comic
about a powerful but bookish witch and a ghost who signs her up
as a contract killer of monster gods without her prior
consent or knowledge.

right
Gen¹³ #1 paperdoll variant — March 1995
Pencilled by J. Scott Campbell, inked by Tom McWeeney
Gen¹³ was introduced in a highly successful miniseries. This "paper
doll" cover was just one of the thirteen variant covers for the first
issue of the regular series. This image features Fairchild, the
gorgeous, highly moral, and intelligent team leader who is totally
unaware of how sexy she is.

below
Gen¹³ #6 — November 1995
Pencilled by Jim Lee, inked by Scott Williams
This Jim Lee cover features the entire Gen¹³ team, with Fairchild
front and center. Her Barbie-doll build with large breasts, tiny waist,
improbably arched back and long, long legs clearly marked her as a
quintessential "Image babe."

BRANDON CHOI • J. SCOTT CAMPBELL • ALEX GARNER

right
Gen¹³ #12 — August 1996
Pencilled by J. Scott Campbell, inked by Alex Garner
Through use of gesture and detail, J. Scott Campbell's women
became not just gorgeous bodies but fun and sexy individuals. Not
surprisingly, his work on *Gen¹³* made him a comics superstar.

In 1997 through 1998, Vertigo published the prose novella *Stardust* by Neil Gaiman in serial form with beautiful illustrations by Charles Vess. *Stardust*, a lyrical fantasy quest and romance in the pre-Tolkien tradition, showcased Gaiman's storytelling range and versatility as well as Vess's beautiful artwork.

"Also in the attaché is a gun, and one-hundred rounds of ammunition. All untraceable, all yours. Do with it as you see fit."

—Agent Graves, *100 Bullets* #1 (August 1999)

100 Bullets, an award-winning ongoing series that practically defines edgy, first appeared in 1999. Written by Brian Azzarello with art by Eduardo Risso, it tells stories of 100 untraceable bullets offered by the mysterious Agent Phillip Graves and their effects on the sometimes intertwined lives of the people who use them, often to exact revenge.

In January 1998, DC Comics purchased the WildStorm line from Jim Lee. Effective January 1999, WildStorm became a separate DC Comics imprint that operates from the West Coast, with Lee remaining as editorial director.

WildStorm's titles were already popular and DC benefited from the additional exposure and a link to the burgeoning adult-oriented super-hero market.

" . . . I wish I had a cigarette."

—Jenny Sparks, *The Authority* #2 (June 1999)

The move worked for WildStorm as well, supplying funds to expand and allowing it to launch the graphically violent, adult-oriented *The Authority*, created by Warren Ellis and Bryan Hitch. *The Authority*'s light plots, panoramic panels, and focused violence mingle manga-style action and the American super-hero comics genre told with a cynical British twist, and drew a huge fan following.

WildStorm continued to publish its own special imprint: America's Best Comics, a line created expressly to allow writer Alan Moore to oversee his own comic book line.

This award-winning line has produced such diverse titles as the Moore/Kevin O'Neill *The League of Extraordinary Gentlemen*, a series filled with literary references which inspired the 2003 movie; the anthology title *Tomorrow Stories* and *Tom Strong*, co-created with artist Chris Sprouse. These retro tales feature a family of enhanced humans and the robot and talking gorilla who assist them. *Tom Strong's Terrific Tales*, an anthology title, features the Strong family along with the adventures of Jonni Future, a time-traveling heroine in the pulp tradition.

by Elaine Lee & William Simpson

DIRECT SALES

above

Vamps #5 — December 1994
Art by Brian Bolland
As the cover of a vampire/biker-chick comic, this arresting image offers just the right mixture of horror and allure.

opposite

The Invisibles #7 — August 1997
Art by Brian Bolland
This Brian Bolland cover, with its completely different kind of arresting image, pushes boundaries, as does Grant Morrison's reality-bending series.

page 168

Preacher #63 — July 2000
Art by Glenn Fabry
Preacher was approaching its climax when Glenn Farby created this cinematic and emotional illustration of Tulip O'Hare, whose romantic confusion motivated much of the series' drama.

page 169

Preacher #16 — August 1996
Art by Glenn Fabry
Tulip is going to need all her toughness—and that big gun—when dealing with the evil sadist Jesus de Sade.

opposite

Bloody Mary #4 — January 1997
Art by Carlos Ezquerra

In this Garth Ennis/Carlos Ezquerra science-fiction romp, Corporal "Bloody Mary" Malone goes undercover to retrieve a super-weapon that fascist Europeans plan to use to destroy America and its British allies.

right

100 Bullets #29 — December 2001
Art by Dave Johnson

Isabella "Dizzy" Cordova, seen here hanging tough south of the border, is a female star of *100 Bullets*. Cover artist Dave Johnson uses different techniques to separate story arcs—here placing a fully painted figure against a line-drawn background.

below

Stardust #3 —1998
Art by Charles Vess

Acclaimed fantasy illustrator Charles Vess here draws the mysterious, beautiful girl who is at the center of Neil Gaiman's fantasy novella, *Stardust*, along with some of the denizens of her fairy-tale realm.

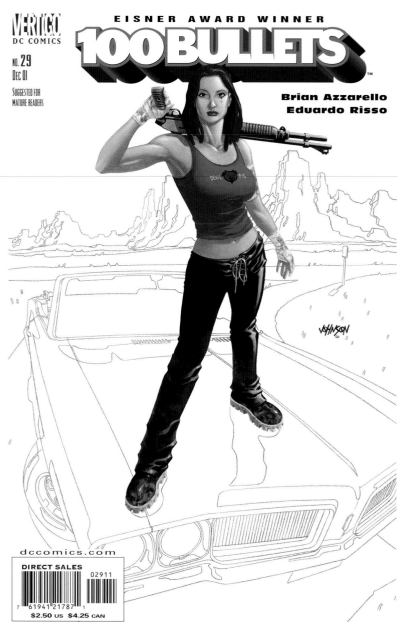

right

Cyberella #1 — September 1996
Pencilled by Howard Chaykin, inked by Don Cameron

Cyberella is a merged being—part human, part computer program—with the ability to read men's minds and reflect back at them whatever they believe her to be.

VERTIGO
DC COMICS

NO. 18
JAN 01

SUGGESTED FOR
MATURE READERS

100 BULLETS ™

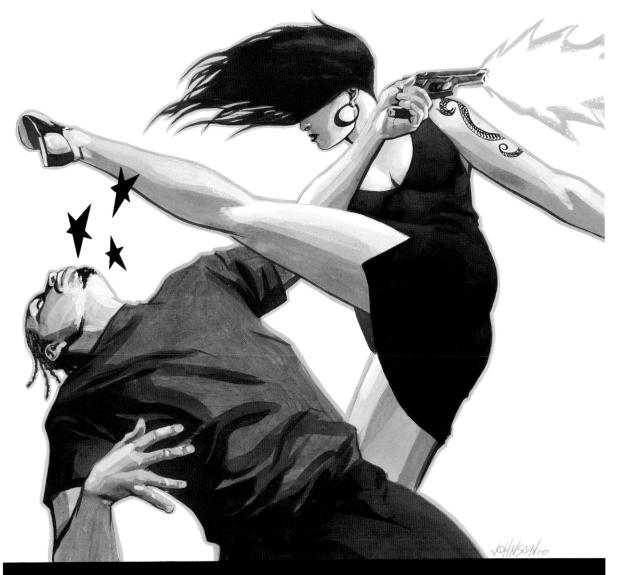

Brian Azzarello
Eduardo Risso

page 172
Kill Your Boyfriend #1 — June 1995
Art by Philip Bond
A bored British schoolgirl kills her boyfriend, and finds a gory but exciting new life in the process, thanks to writer Grant Morrison.

page 173
100 Bullets #18 — January 2001
Art by Dave Johnson
Here an Asian bodyguard for a very old gangster takes apart Louis "Loop" Hughes, a gangbanger who soon becomes a major player in the *100 Bullets* mythos.

left
Wildcats #4 — September 1999
Pencilled by Travis Charest, inked by Richard Friend
The heroine Zealot supposedly died during this mission. But this is a comic book—a place where every character has at least nine lives.

above
Wildcats #2 — May 1999
Art by Travis Charest
Wildcats, originally an Image series begun by Jim Lee, returned to the WildStorm line with a more experimental look by the extremely detailed artist Travis Charest, who here gives us beauty and horror in the single figure of Voodoo—a half-human heroine with alien Daemonite DNA.

left
Wildcats #28 — December 2001
Art by Sean Phillips
After a series of tumultuous adventures, the Wildcats series went on hiatus with a final cover featuring Voodoo, everybody's favorite half-human, half-alien.

Promethea, an experimental, symbolic miniseries created by Moore and J. H. Williams III with Mick Gray, explores Moore's ideas on magic and art and tells the story of the people—often artists—whom the Promethea persona imbues with powers when they call up her image.

"I'm friggin' Promethea, you idiot."

—Promethea, *Promethea* #1 (August 1999)

New Vertigo titles continue to garner sales and critical acclaim.

Bill Willingham created and wrote the popular *Fables*, featuring a new take on old fairy tale characters—human and otherwise—who hide out from their enemy, The Adversary, in New York City and on an upstate farm.

Another Vertigo series of particular interest is the critically acclaimed *Y: The Last Man,* written by Brian K. Vaughan—who had previously scripted a run of *Swamp Thing* focusing on the title character's daughter, Tefe—with most of the art by *Y* co-creator Pia Guerra.

Y: The Last Man stars Yorick, literally the last man alive in a world where all other males have suddenly and mysteriously died. A potentially exploitative concept, *Y* is actually a witty, action-packed examination of gender roles. In a world where only women remain, ultra-feminist groups, male impersonators, and those willing to help and hide the only man alive battle it out in a deeply developed political landscape that plays all preconcep-

"I don't know if I'm the only man on Earth . . . but I swear I'm not going to be the last."

—Yorick, *Y: The Last Man* #3 (November 2002)

tions of femininity against each other, in the form of an exciting adventure story.

The *Bite Club* miniseries, written by Howard Chaykin and David Tischman with art by David Hahn, is a hedonistic and violent romp through vampire-ridden Miami, where a vampire family runs the mob, its Don is staked with wooden bullets, and his son, a vampire-priest, slowly loses his struggle to escape the family business.

DC Comics created the Vertigo imprint to build on the momentum generated by its mature comics—beginning with Alan Moore's *Swamp Thing* and continuing through the "British Invasion" of the late 1980s and early 1990s.

Though Moore has never actually written for Vertigo—he quit DC Comics following a dispute with the company, before

"The Mundanes may look to their government to solve their problems, but in the Fable community, we expect you to be able to run your own lives."

—Snow White, *Fables* #1 (July 2002)

above

Tomorrow Stories #5 — February 2000
Art by Melinda Gebbie
One of the ABC line's major female heroines is the Cobweb, featured here in a retro cover designed to evoke the old pulp magazines.

opposite

Promethea #12 — February 2001
Pencilled by J. H. Williams III, inked by Mick Gray
This cover evokes the pop art of the 1960s with its hallucinatory
graphic design.

left

Tom Strong's Terrific Tales #2 — March 2002
Art by Arthur Adams
A featured heroine in this anthology title, Jonni Future inherits
her uncle's fish-shaped spaceship, universal translator helmet,
and ray gun and sets off into the far future to protect the
Grand Array from those who would do it harm.

above

The Many Worlds of Tesla Strong #1 — July 2003
Art by Arthur Adams
Tesla Strong, daughter of hero Tom Strong, is a sharp, funny, and
intelligent teenage heroine. In this one-shot she encounters
countless alternate versions of herself, many of them hinted at in
this terrific cover by Art Adams.

left

Tom Strong's Terrific Tales #6 — April 2003
Art by Arthur Adams
Pulp science-fiction heroine Jonni Future relaxes aboard ship with
her cheetah-man sidekick. Though much of Jonni's wardrobe is
shredded in battles, she nonetheless prevails against staggering odds.

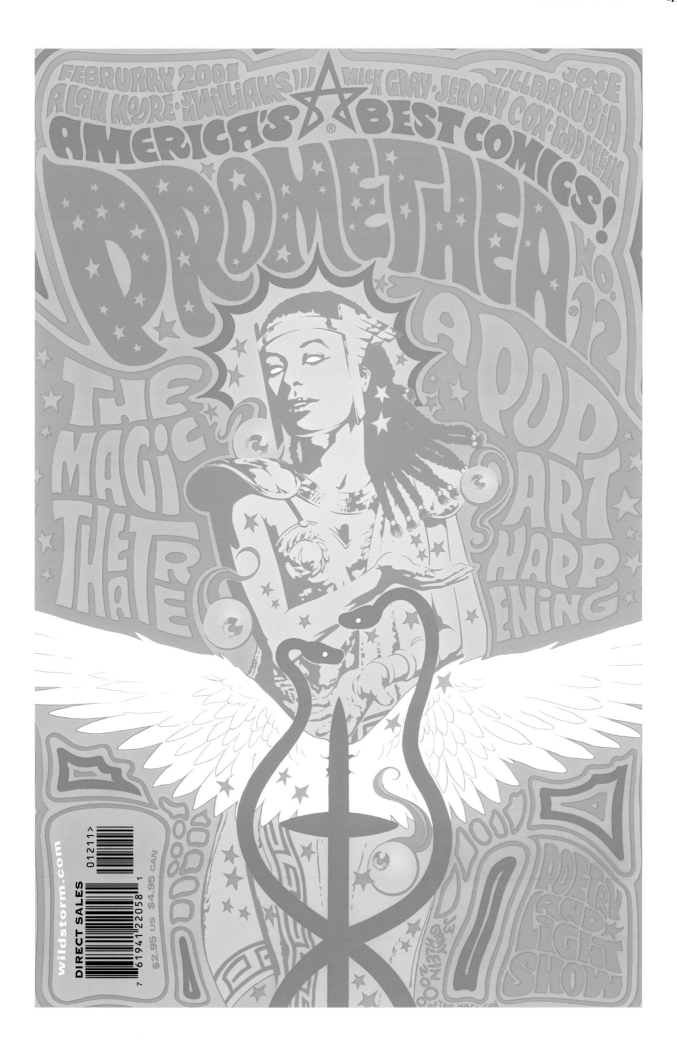

opposite

***Promethea* #32** — February 2005
Art by J. H. Williams III
The cover to *Pronethea*'s final issue is beautiful and abstract;
it might take you a moment to see the character in the art.

right

***Promethea* #19** — April 2002
Art by J. H. Williams III
Here we see have an impressionist Promethea as
Vincent van Gogh might have imagined her.

above

***Promethea* #7** — April 2000
Pencilled by J. H. Williams III, inked by Mick Gray
Here is a clever parody of old-style romance covers.

right

***Promethea* #23** — December 2002
Pencilled by J. H. Williams III, inked by Jeromy Cox
The artists channel Alphonse Mucha,
imagining Promethea as an Art Nouveau goddess.

the Vertigo line was established—his comics writing helped lay its groundwork.

Since its inception, Vertigo has published comics in nearly every genre, most with at least a tinge of dark horror or fantasy, and often crossing genres in surprising ways.

One of the secrets of Vertigo's continued success is the constant reprinting of its material in graphic novel form. Vertigo's graphic novels reach beyond comic book shops, with their typically male clientele, and into bookstores where they reach a larger, often female audience.

And Vertigo's reliance on strong female characters doesn't hurt—with the male or female readership!

Karen Berger is now Vertigo's Executive Editor, making publication decisions for the whole imprint. It's clear she continues to influence the Vertigo line and her choices keep one of DC Comics' most vibrant lines flourishing.

above
Fables #14 — August 2003
Art by James Jean
Bill Willingham's fairy tale characters of Fabletown are not quite what we remember. The reformed shape-shifter Bigby (no longer "Big Bad") Wolf is the sheriff of Fabletown; Snow White (ex-wife of the philandering Prince Charming) is his love interest; and Goldilocks is out for blood.

opposite
Fables #15 — September 2003
Art by James Jean
Snow White and Bigby Wolf find romance as they struggle to escape the henchmen of the evil Bluebeard, who has stranded them in the Cascade Mountains.

oppposite

Bite Club #1 — June 2004
Art by Frank Quitely
Frank Quitely's cover catches the flavor of this saga of sex, death, power, organized crime and betrayal played out against a backdrop of Miami nightlife.

left

Fables #50 — August 2006
Art by James Jean
Snow White marries Bigby Wolf on this gorgeous cover by James Jean, and all of Fabletown—human and inhuman alike—celebrate.

above

Bite Club: Vampire Crime Unit #1 — June 2006
Art by Frank Quitely
Vampire Risa del Toro, new Don of the del Toro crime family, is under investigation for murder. Who would have thought crime scene tape could be so seductive?

left

Y: The Last Man #32 — June 2005
Art by Massimo Carnevale
Yorik and friends cross the Pacific in search of his monkey Ampersand, who has been kidnapped by a Japanese ninja. Of course there'd be pirates!

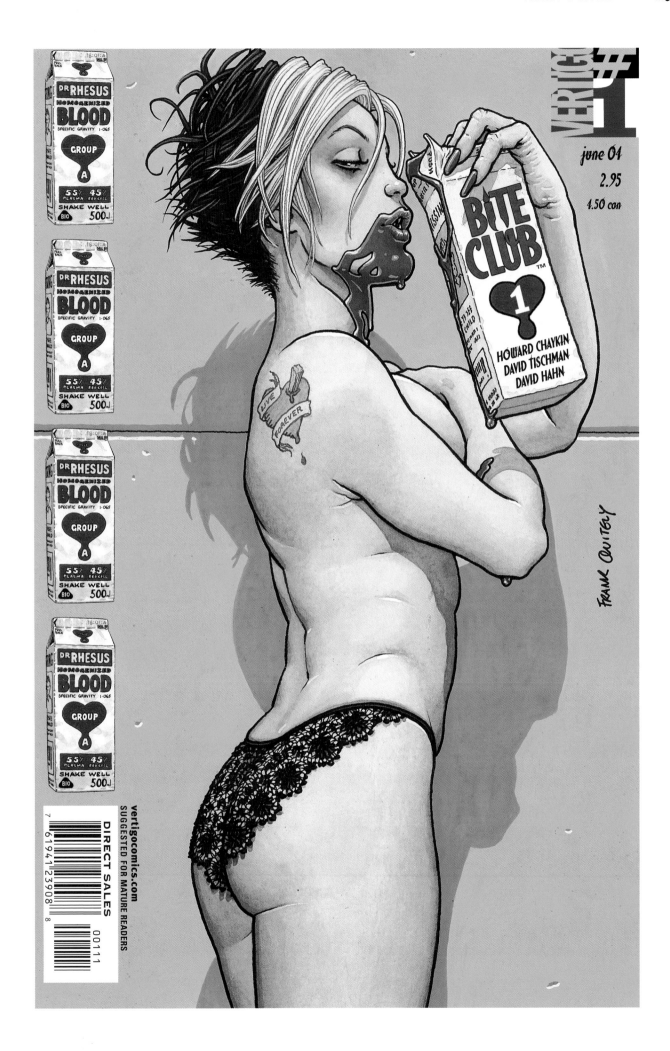

> ## *"I don't understand boys at all."*
>
> —*Triplicate Girl, Legion of Super-Heroes (4th series) #3 (April 2005)*

above

Birds of Prey #65 — May 2004
Pencilled by Greg Land, inked by Jay Leisten
Oracle—a.k.a. Barbara Gordon, who was once Batgirl—leads the
team of super heroines known as the Birds of Prey.
The Huntress, an ex-Mafia princess who fights organized crime, and
Black Canary, a martial artist with a literally stunning voice, are
Oracle's main operatives.

opposite

JSA #74 — August 2005
Art by Alex Ross
The fates of Hawkman and Hawkgirl are inextricably intertwined in
this beautiful cover image by the talented Alex Ross.

There's a new generation of covergirls in the DC Universe, though most have roots in the past. Hawkgirl and Stargirl are new characters with ties to DC Comics' Golden Age, while the heroines of the Legion of Super-Heroes and the Teen Titans are affiliated with Silver Age teams. And teenaged Speedy, once a Titan, is a female riff on Green Arrow's old male sidekick as pre-*Crisis* history is replayed in a modern context. The sorceress Zatanna and the massive warrior Big Barda first appeared during DC Comics' Silver Age but have gained new life in modern continuity, as have the veteran characters of *Birds of Prey*—who have acquired a fresh purpose as members of DC Comics' only all-female team of super heroes.

> ## *"Do me a favor, Hawkman.*
> ## *Remember what I said. We're partners.*
> ## *Nothing more."*
>
> —Hawkgirl, *Hawkman* #2 (June 2002)

For most of her existence, Hawkgirl has been a supporting character for the hero Hawkman.

The original Hawkgirl was a reincarnation of the Egyptian princess Chay-Ara who, with her lover Prince Khufu, was murdered by the jealous high priest Hath-Set. The murder weapon was a knife forged of an alien substance called Nth metal. Transformed by the miraculous properties of the Nth metal, the lovers have been reborn throughout the centuries in different guises, doomed to love and then die at the hands of the murderous Hath-Set, who has pursued them through the ages.

neration

In the Golden Age of comics, Chay-Ara was reborn as Shiera Sanders and became the partner of her reincarnated lover, Carter Hall a.k.a. Hawkman. Soon Shiera, like Hawkman, had a winged costume powered by Nth metal, and she operated under the name Hawkgirl. The duo joined the All-Star Squadron, the Justice Society, and eventually the Justice League. In time, the lovers married.

Then Shiera died—while Hawkman continued to live.

Elsewhere, young and troubled Kendra Saunders attempted suicide. As Kendra's spirit began to leave her body, Shiera's rushed to fill the void, saving Kendra's life and imbuing Kendra with Hawkgirl's powers.

Hawkgirl has now earned an eponymous title and her own separate life as a super hero.

"But don't call me kid. I'm carrying on two legacies. So I'm not just the Star-Spangled Kid—call me Stargirl!"

—Courtney Whitmore, *JSA All Stars* #4 (October 2003)

It took Courtney Whitmore a couple of tries before she got her super-hero persona right.

Courtney is the teenage stepdaughter of Pat Dugan, who long ago was Stripesy, sidekick of the Golden Age Nazi-fighting Star-Spangled Kid. Courtney found the old Star-Spangled Kid costume among her stepfather's belongings and assumed Star's identity. Worried for her safety, Dugan built S.T.R.I.P.E., an armored robot body, and went along on her adventures as protection.

JSA All Stars #2 — August 2003
Pencilled by John Cassaday, inked by Mark Lewis
Another image, this one by John Cassaday, links Hawkgirl and
Hawkman, but here she replaces him in prominence.

below

Hawkman #42 — September 2005
Pencilled by Joe Bennett, inked by Ruy Jose
Hawkgirl fights alone! Kendra, the new Hawkgirl, has taken over the
missing Hawkman's series—note the "patch" on the logo—claiming it
as her own.

left

Hawkgirl #50 — May 2006
Art by Howard Chaykin
Hawkgirl—now with her own official logo—owns the series,
standing alone against the evil that is stalking St. Roch.

opposite

JSA All Stars #4 — October 2003
Pencilled by John Cassaday, inked by Mark Lewis
Stargirl inherited the powerful staff of the older hero, Starman.
Many young heroines have risen to prominence in the DC Universe
by taking on the mantle of retired heroes.

Johns·Goyer·McKone·Faucher·Robinson·Harris #4 (of 8) OCT 2003 2.50 US 4.25 CAN

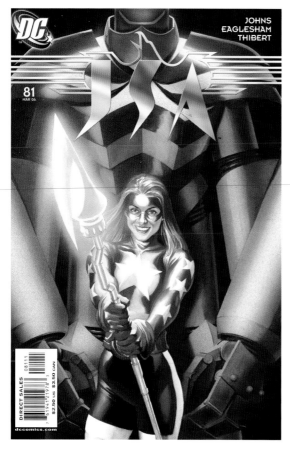

above top

***JSA* #81** — March 2006
Art by Alex Ross
Stargirl, the teenage heroine of the Justice Society of America,
poses before the robot S.T.R.I.P.E. in this charming
cover image by Alex Ross.

above

***Bulleteer* #3** — April 2006
Pencilled by Yanick Paquette, inked by Serge LaPointe
Grant Morrison's *Seven Soldiers* series of miniseries highlighted and
reintroduced many different characters in the DC Universe,
including a female version of the retro Bulletman.

Star's antics so impressed the hero Starman that when he retired he gave her his energy manipulating cosmic rod.

Today Courtney wields the cosmic rod with increasing sophistication and maturity as Stargirl, a member of the Justice Society.

"My name's Zatanna Zatara. I'm a spellaholic."

—Zatanna, *Seven Soldiers: Zatanna* #1 (June 2005)

Zatanna Zatara, a powerful wizard, inherited her sorcerous abilities, although she was unaware of them for a long time. Her father was a famous magician, whose stage illusions hid real magic. Her mother was secretly a powerful witch.

When her father disappeared, teenage Zatanna set out to find him. She met members of the Justice League and along the way she became a magician like her father. In time, she learned to access her own sorcery; she had but to say a word backwards for it to become her magical command.

Zatanna, though a member of the Justice League and a magical consultant to DC Comics' super-hero community, never had her own continuing comic, but she did star in the ambitious *Seven Soldiers* miniseries.

Most recently, as part of DC Comics' *Identity Crisis* storyline, Zatanna used her magic to secretly alter the memories, perceptions, and attitudes of a number of individuals—including Batman and Catwoman. While many heroes felt betrayed by her actions, Zatanna is working to make amends, and this moral lapse has given her character added complexity.

"You're the leader of the Legion of Super-Heroes, aren't you? I'd like to try out for that group!"

—Triplicate Girl, *Superboy* #147 (May–June 1968)

The Legion of Super-Heroes is a team of superpowered teenagers who exist in the far future. Created during the Silver Age, when editors were wild to entice the kid audience, the Legion has become one of DC Comics' most popular teams, with an army of characters and a loyal fan following.

The Legion was given their own series with *Superboy and the Legion of Super-Heroes* in 1973. In 1980, the title became simply *The Legion of Super-Heroes*. While the uninitiated might find these stories confusing, filled as they are with —*ahem!*— a legion of characters and a continuity strewn with time-travel paradoxes, dedicated fans find them exciting and involving.

It probably doesn't hurt that, over the years, *Legion* has been written and drawn by some of comics' best creators. A short list of writer highlights includes Superman co-creator Jerry Siegel; Jim Shooter, who began writing *Legion* as a 14-year-old prodigy and went on to become Marvel Comics' editor-in-chief during the late 1970s and early 1980s; Paul Levitz, one of the Legion's most popular writers and presently DC Comics' President and Publisher; Gerry Conway, who went on to write for television,

DIRECT SALES 00111

$2.99 US $4.00 CAN

right

Zatanna #1 — June 2005
Art by Ryan Sook
When a devastating apocalypse threatens the Earth, Zatanna is one of the Seven Soldiers destined to avert the disaster. This playful cover places Zatanna in a Sorcerer's Apprentice-style dilemma.

below

JLA #118 — Early November 2005
Pencilled by Rags Morales, inked by Mark Farmer
Zatanna hypnotizes the readers, commanding them to forget, just as she meddled with the minds of others in the past. The results of her actions, revealed in the shocking miniseries *Identity Crisis*, are still reverberating through the DC Universe.

right

Green Arrow #52 — September 2005
Art by Cliff Chiang
Zatanna helps out her beleaguered friend Green Arrow in this appealing cover by artist Cliff Chiang.

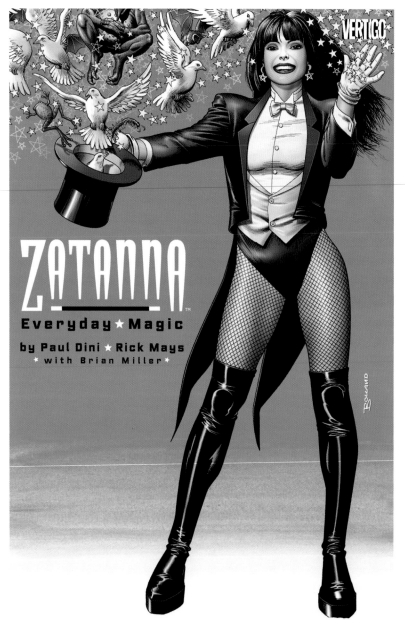

left

Zatanna: Everyday Magic — May 2003
Art by Brian Bolland
A cheerful, appealing cover image opens this amusing tale by Paul Dini and Rick Mays that focuses on Zatanna the magician, on tour in Vegas, as she helps an old lover, sorcerer John Constantine, shake loose a few bothersome demons.

below

Catwoman (2nd series) #50 — February 2006
Art by Adam Hughes
In this issue, Catwoman learns that Zatanna hypnotized her in order to turn her away from evil, a revelation that will rock Catwoman's world for years to come.

left

Birds of Prey #33 — September 2001
Art by Phil Noto
The blonde martial artist Black Canary was Oracle's first operative for the Birds of Prey, DC's first all-female super-hero team. Since then, a rotating roster of agents has formed.

right

Legion of Super-Heroes (3rd series) #113 — March 1999
Pencilled by Alan Davis, inked by Mark Farmer
The Legion of Super-Heroes has always featured a future where
sexism is all but nonexistent. Here dark-haired Shrinking Violet and
blonde Spark act to save their red-haired teammate, the telekinetic
Kenetix. Alan Davis's personality-plus characterizations and crisp
drawing style have made him a favorite among comics fans.

below

Legion of Super-Heroes (4th series) #3 — April 2005
Pencilled by Barry Kitson, inked by Dave McCaig
Triplicate Girl is one of the premier members of the rebooted Legion.
Her three personas, able to operate independently, can then
recombine into a single unit—a useful power indeed!

right

Legion #20 — July 2003
Pencilled by Tony Harris, inked by Tom Feister
Here is the telepath Saturn Girl, one of the Legion's co-founders.

above

Mister Miracle #13

April 1973 — Art by Jack Kirby
Jack Kirby—comics genius and co-creator of most of
Marvel Comics' major super heroes—was not especially known for
his depictions of beautiful women, though he and partner Joe Simon
invented romance comics. During his short time at DC Comics,
Kirby created one of DC's strongest female characters, the
seven-foot-tall Amazon Big Barda. Here she races to the rescue
of her lover, escape artist Mister Miracle.

as did fellow *Legion* writers J. M. DeMatteis and Cary Bates. The *Legion* artists are equally illustrious: *Superman* legend Curt Swan; Dave Cockrum, who would go on to *X-Men* fame at Marvel Comics; Keith Giffen, who plotted the book as well as drew it after Levitz left the series; Mike Grell; Bob McLeod; Jim Starlin; Pat Broderick; and Barry Kitson.

Like all good super-hero teams, the Legion members fight for right and occasionally risk all to insure the safety of the universe. But what makes the Legion special is its family feel, with members who sometimes bicker but always care deeply about each other.

Part of the team's popularity stems from their strong female characters who were always powerful and interesting heroines in their own right—even in the 1950s, when the behavior of a lot of other DC Comics' females had gotten downright silly.

"Listen, you stupid broad! I don't want to clobber you—but, if you keep firing—"

—Big Barda, *Mister Miracle* #17 (January 1974)

The seven-foot tall warrior woman Big Barda was created by Marvel Comics genius Jack Kirby during his short foray into the DC Comics Universe.

During the early 1970s, Kirby created the *New Gods* for DC Comics, featuring larger-than-life heroes and villains caught in a cosmic battle for ascendancy.

Scott Free, the infant son of Highfather of idyllic New Genesis, was exchanged as a hostage to the evil Darkseid, ruler of hellish Apokolips, to forestall a terrible war. Scott, unaware of his true parentage, was raised in an orphanage on Apokolips, fated to be one of Darkseid's enforcers. Instead, young Scott became an expert at escaping the orphanage and, on one of his forays into Apokolips, met the bodacious female warrior Big Barda, leader of Darkseid's elite Female Furies.

The two fell in love, and Barda helped Scott escape to Earth where he became the escape artist Mr. Miracle.

Eventually Barda abandoned Apokolips and joined Scott on Earth, and the two were married. The couple's continuing adventures included membership in the Justice League.

Though Big Barda has never had her own series, she is as appreciated for her tough personality as she is for her large frame. She remains one of those special female characters who is as memorable as the male lead she stars beside.

right

Jack Kirby's Fourth World #2 — April 1997
Art by Walter Simonson
Big Barda is armored up and wielding her mega-rod against
DC Comics' version of Thor, the Norse God of Thunder.
This references cover artist Walter Simonson's acclaimed run on *Thor*
at Marvel. Like Kirby, Simonson's focus in super-hero comics is the
graphic depiction of power.

below

Tales of the New Teen Titans #2 — July 1982
Art by George Pérez
A character who crosses the line from good to evil and back again is
the half-demon Raven. She has many gifts, including empathy and
the ability to teleport long distances, but the haunted and obsessed
Raven is often overwhelmed by her demon heritage.

right

The New Teen Titans #30 — April 1983
Art by George Pérez
In the early 1980s, Marv Wolfman and George Pérez introduced a
teenage girl with geokinetic powers into this super-hero group.
But Terra was secretly a bad girl and a traitor, a shocking twist
that played out over many years and became one of the series'
most famous stories.

Green Arrow #44 — January 2005
Art by Marcos Martín
This stark, arresting cover broadcasts a life-changing
diagnosis for Green Arrow's female sidekick,
the new Speedy.

below
Green Arrow #45 — February 2005
Pencilled by Marcos Martín, inked by Alvaro Lopez
Despite a grueling medical regimen, Speedy hasn't let
her HIV status prevent her from super-heroing.

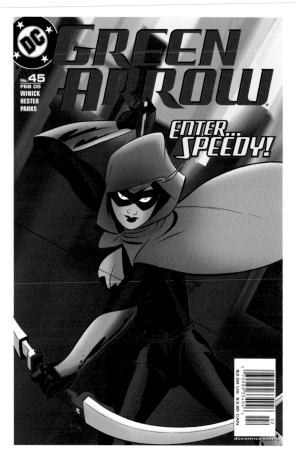

page 198
Teen Titans #8 — April 2004
Pencilled by Mike McKone, inked by Marlo Alquiza
Being the daughter of Trigon the Terrible has some advantages for
Raven—for one thing, death isn't quite so final. Raven's many deaths
and resurrections have added to her reputation as one of the most
mystical and creepy characters of the DC Universe.

page 199
Birds of Prey #67 — July 2004
Pencilled by Greg Land, inked by Matt Ryan
Birds of Prey often showcases female heroes (and villains) who
aren't even members of the team. Here, Huntress, Black Canary,
Oracle, Catwoman, Cheshire, and Lady Shiva mix it up in a
dramatic slugfest of an issue.

"Si . . . and I would have destroyed you all if ze Teen Titans hadn't interfered!"

—Don Matanzas, a rich landowner whose "Conquistadore Robot"
is defeated by the Titans, *Teen Titans* #1 (January–February 1966)

The Teen Titans, a group of superpowered teenagers, first
appeared in a 1964 backup feature. Immediately popular, the
group received its own eponymous series in 1966. But during
the 1970s, the title floundered, was cancelled, revived, and then
cancelled again.

In 1980, Marv Wolfman and George Pérez revived the
Titans with a combination of old and new members.

The stories were character-driven with strong heroines
whose agendas often drove the action. Tales that were a com-
pelling mixture of romance, soap opera, and adventure kept the
Titans in the spotlight for nearly a decade, during which they
rivaled the popularity of Marvel's best-selling *X-Men*.

The team's adventures have lasted under one *Titans* title or
another until the present, though the membership has shifted—
sometimes radically. They also inspired a popular cartoon series
that retold many of their most famous storylines from the comics.
And early members like Wonder Girl and Starfire have grown up
to become major female characters in the DC Universe.

"I think fast, I talk fast. Try to keep up, old-timer."

—Mia Dearden, the new Speedy,
Green Arrow #3 (June 2001)

Life was never easy for Mia Dearden.

A teenager who ran away from an abusive father, Mia was
rescued from a child prostitution ring by the hero Green Arrow.
She became his ward and trained hard at martial arts and archery,
hoping to become his new kid sidekick. Learning that she was
HIV-positive only made Mia more determined to succeed, and
soon her mentor agreed that she was ready.

Mia fought beside Green Arrow as his sidekick Speedy, and
for a while joined the Teen Titans, where she used her trick arrows
to good effect.

Following the events of *Infinite Crisis*, Speedy once again
fights beside Green Arrow. Despite her many difficulties, the re-
silient Mia has never lost her winning can-do attitude.

Mia is not the first Speedy, nor the first to have problems.
(Roy Harper, the original Speedy, became a drug addict and then
recovered in an award-winning, year-long *Green Arrow* storyline
by Denny O'Neil and Neal Adams during the early 1970s.) But as
a teenage girl, Mia is part of a DC Comics' trend in which a young
woman assumes the mantle of an older male hero.

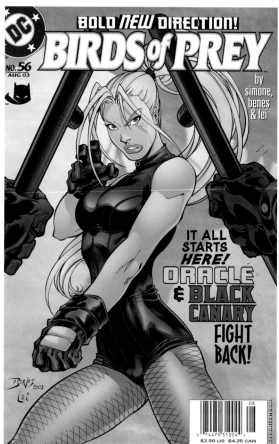

left

Birds of Prey #41 — May 2002

Art by Phil Noto

Here, cover artist Phil Noto visually concentrates on the soap opera aspects of this series, but inside the comic there's plenty of action as the Birds of Prey work to discover who framed Batman for murder.

below

Birds of Prey #56 — August 2003

Pencilled by Ed Benes, inked by Alex Lei

With this issue, Gail Simone began writing *Birds of Prey,* and Ed Benes, known for his sexy women, gave us a tough Black Canary in a costume that includes her traditional fishnet stockings and a long spill of golden hair.

left

Birds of Prey #1 — January 1999

Art by Brian Stelfreeze

This powerful cover by Brian Stelfreeze features Oracle as the brains behind Birds of Prey, in the first issue of their regular series. Black Canary provides the brawn.

"No one tells me what to do!"

—Black Canary, *Black Canary/Oracle: Birds of Prey* #1 (1996)

Birds of Prey first appeared in 1996 in several one-shots and a couple of miniseries by writer Chuck Dixon.

The wheelchair-bound ex-Batgirl Barbara Gordon, after being shot by the Joker and paralyzed, had begun to use her computer hacking skills to detect and research criminal activity, using the code name "Oracle."

In the first *Birds of Prey* miniseries, she recruits Black Canary—an adept martial artist who can direct her "canary cry" as a sonic attack—as her field operative.

The early stories were so successful that *Birds of Prey* became a continuing series in 1999. Initially produced by Dixon and artist Gary Frank, the series was based in Gotham. Oracle and Black Canary were the leads, but the book featured frequent guest appearances by many characters in the Batman universe. Attesting to the series' popularity, in 2002–2003 the WB network aired thirteen live-action episodes of a *Birds of Prey* television show, loosely based on the comic.

Gail Simone took over as series writer with issue #56. Almost at once, Simone enlarged the official team roster, bringing in the Huntress, a hot-headed ex-Mafia princess who had sworn to destroy organized crime in Gotham. Soon the assassin Lady Shiva appeared as a guest star and, when Black Canary retired, Lady Shiva joined as well.

While the roster is sure to change again, DC Comics' only all-female team of super heroines continue the battle for truth, justice—and Woman Power in comics!

Alongside Wonder Woman, Batwoman, Catwoman, Lois Lane, and scores of others, these modern DC Comics' covergirls continue to allure, entice, and enthrall readers from racks in comic book shops, from displays in bookstores, and even, occasionally, from newsstands. Over the years their following has encompassed a wide readership of children and adults who can't get enough of their favorite heroines.

Each of these characters has developed a fan base the envy of many a "real" model or actress. Books like this one are written about them. Websites sing their praises. People at comic book conventions portray them in daring, skin-tight costumes.

Despite their complex histories—or possibly because of them—the fictional lives of these heroines have become the subject of constant discussion on websites across the Internet. Costumes, powers, hairstyles, exploits, motivations, romances, victories, and defeats are alternately praised and condemned by fans who know their heroines and are certain in their own beliefs.

That's what the DC Comics covergirls sell. Not just a thin little book filled with pictures, but an entrée into a community of adventure and fun.

"Come join us! You'll like what you see!" they whisper from the covers of their comics. And over sixty years after comic book covergirls first appeared, readers are still answering their siren call.

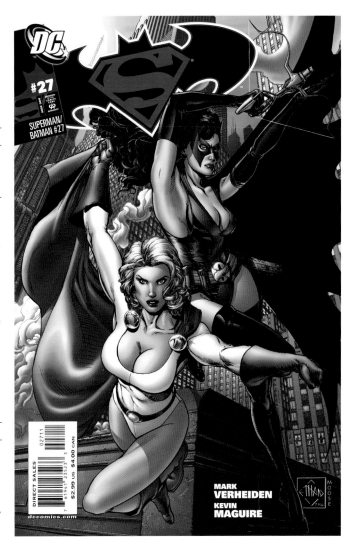

above

Superman/Batman #27 — July 2006
Art by Ethan Van Sciver
Fan-faves Power Girl and Huntress take Superman and Batman's place on the cover of their eponymous series in this dramatic cover by Ethan Van Sciver. (This story was a flashback to Earth-2 before the original Crisis, when the evil Ultra-Humanite trapped the heroes' brains in the heroines' bodies.)

page 202

Birds of Prey #68 — August 2004
Pencilled by Greg Land, inked by Jay Leisten
A day off and a talk with her dad made Oracle realize the three women of her team need lives beyond the pressure-cooker world of super-heroing.

page 203

Birds of Prey #59 — November 2003
Pencilled by Ed Benes, inked by Alex Lei
A portrait shot of the core team.

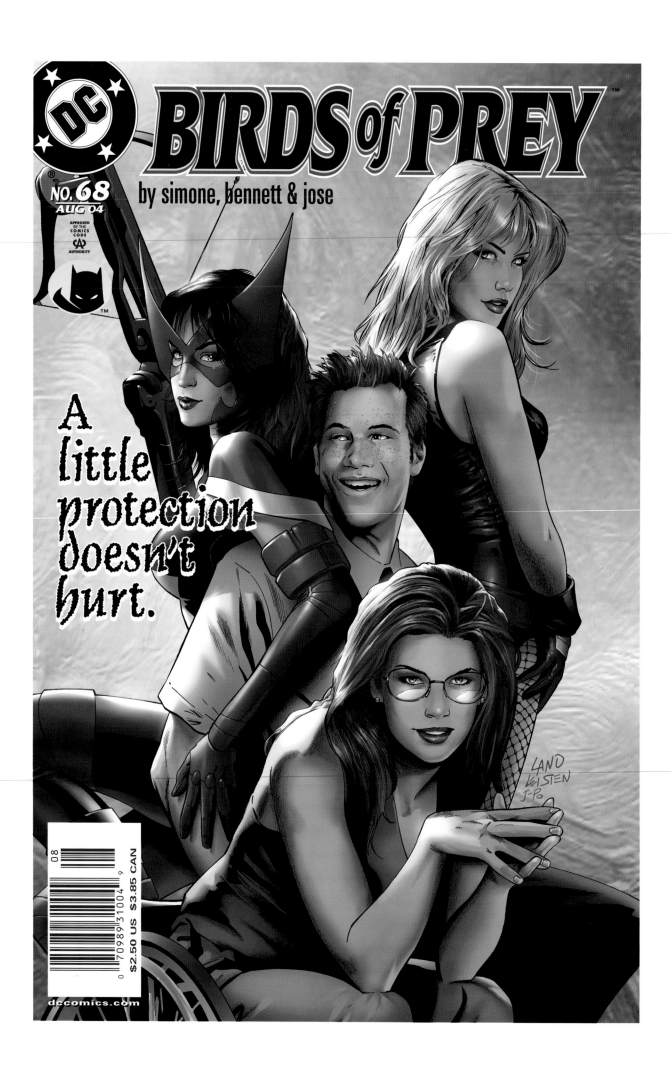

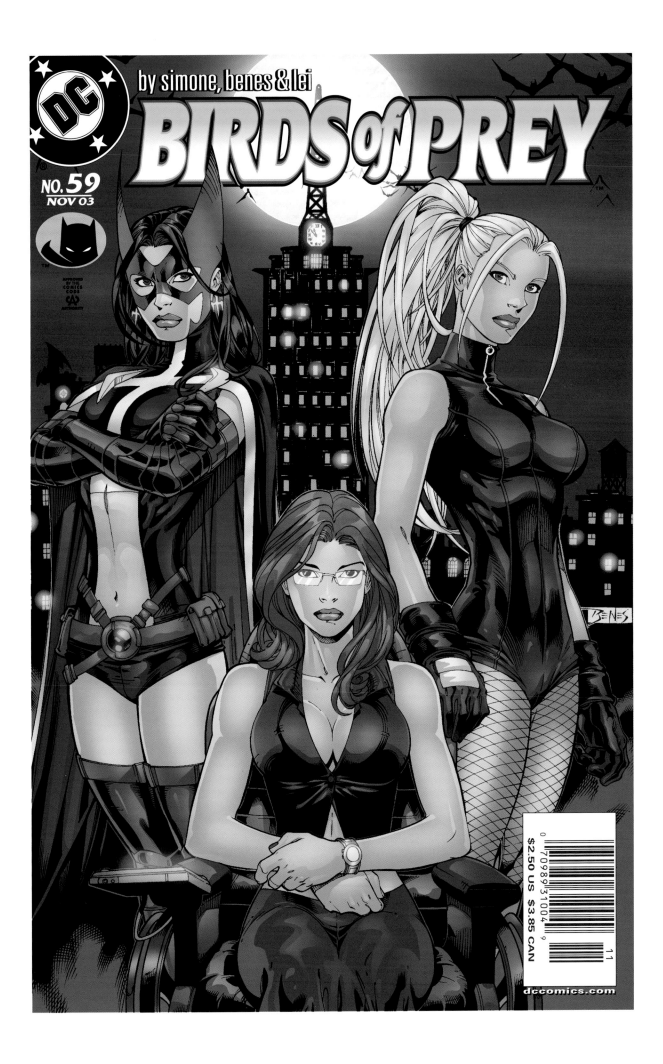

opposite
Birds of Prey #69 — Early September 2004
Art by Mark Texeira
Busted! Huntress is famous for her cavalier attitude, played here for
humor. Inside, the tone is darker as Huntress investigates a cult
involving teenage suicides.

right
Green Lantern #177 — July 2004
Art by Brandon Peterson
The rocky road of romance. In this issue, the green-skinned
meta-human Jade splits with Green Lantern Kyle Rayner.
The popular Jade died tragically during the events of *Infinite Crisis*.

above
Green Arrow #40 — September 2004
Pencilled by Marcos Martín, inked by Alvaro Lopez
The course of love in super-hero comics seldom runs smoothly. Black
Canary has long enjoyed a stormy, on-again-off-again relationship
with Green Arrow. Here, they are off-again.

right
Aquaman #33 — October 2005
Pencilled by Patrick Gleason, inked by Christian Alamy
Despite their own rocky relationship, Mera, reigning Queen of
Atlantis, retains a strong affection for her ex-husband Aquaman, as
he does for her. Here, they appear to be on-again!

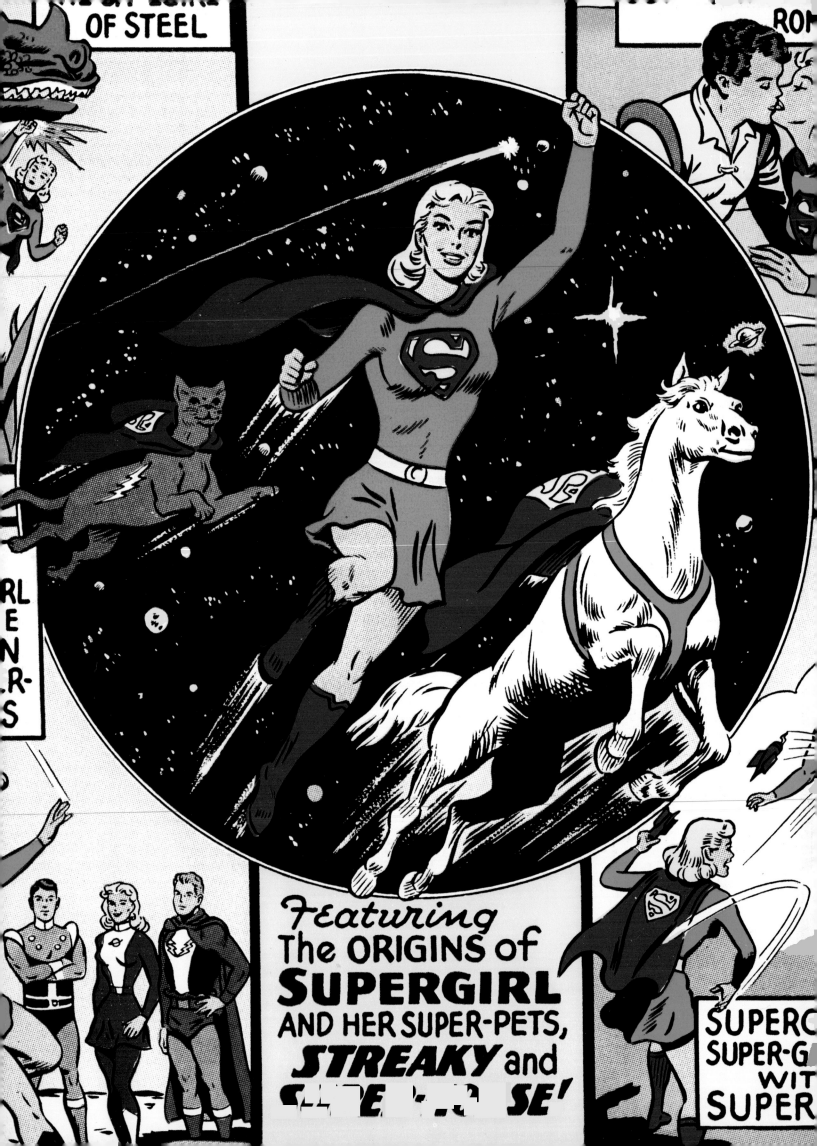

ACKNOWLEDGMENTS

The writers, artists, and editors who created and provide the continuing adventures of our covergirls are a fabulously creative if quirky lot. Without them, this book would not exist.

I have huge admiration for the work of Les Daniels, whose wonderful interviews and careful research inform his beautifully illustrated *Wonder Woman: The Complete History*; *Superman: The Complete History*; and *Batman: The Complete History*. These enlightening narratives are "must reads" for serious comics fans, the media savvy, and the historically inclined.

DK's gorgeous *Ultimate Guide* books by Scott Beatty, featuring Wonder Woman, Superman, Batman, Catwoman, and the JLA, were helpful and attractive resources, as was DK's beautifully realized *DC Comics Encyclopedia*.

DC's historic Archive Editions, featuring full-color reprints of the early appearances of Wonder Woman and many of our other covergirls, made researching historic material a distinct pleasure.

Catwoman: The Life and Times of a Feline Fatale by Suzan Colon provided a quixotic glimpse into the nine lives of Batman's favorite antiheroine.

Last but definitely not least, fansites on the internet, too numerous to name and too wonderful not to acknowledge, provide enormous insight into the special relationship between fictional characters and their real life fans as well as reams of expert information. These sites are spontaneous acts of creativity, scholarship, and devotion. Pick a favorite character and Google her. You won't be disappointed with what you find out there.